The Sculpture of
EDGAR DEGAS

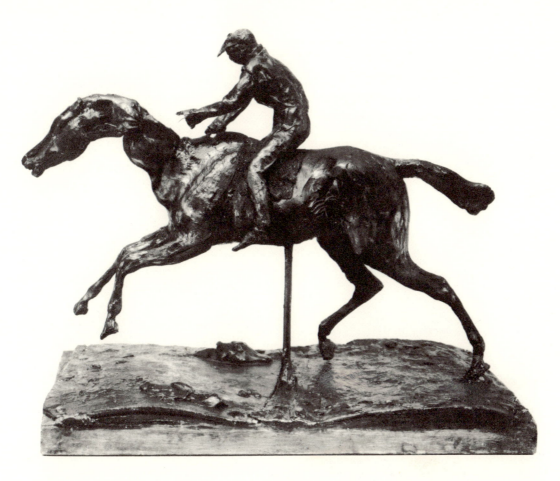

Charles W. Millard · The Sculpture of

EDGAR DEGAS

PRINCETON UNIVERSITY PRESS · PRINCETON, NEW JERSEY

Library of Congress Cataloging in Publication Data

Millard, Charles W
 The sculpture of Edgar Degas.

 Bibliography: p.
 Includes index.
 1. Degas, Hilaire Germain Edgar, 1834-1917.
2. Sculpture, French. 3. Sculpture, Modern—19th
century. I. Degas, Hilaire Germain Edgar, 1834-1917.
II. Title.
NB553.D4M44 730'.92'4 73-2485
ISBN 0-691-03898-8

FOR MY PARENTS

CONTENTS

LIST OF ILLUSTRATIONS

PREFACE

MY INTEREST in the Degas sculpture dates from the mid-1960s, when I was fortunate enough to be able to see the original waxes several times. Struck not only by their beauty but by the complexity of the spatial problems they confronted and mastered, I was curious about their place within the development of nineteenth-century sculpture and decided to make them the subject of my doctoral dissertation, the basis for this work. Once I began investigating their origins and meaning, it became apparent to me that there had thus far been no serious effort to unravel the history of the development of sculpture from Canova to Caro, such as had long since been made for the parallel development of painting. It soon became further apparent not only that sculpture's problems were wholly different from those of painting, but that its progress during the last century and a half was entirely distinct from that of painting and that Degas' work was a microcosm of that progress. Reflecting as it did a thorough knowledge of tradition combined with the most exploratory thinking, his work raised issues that needed to be illuminated before any clear picture could be formed of the transformation of sculpture in the modern world. The first problem was to develop a meaningful critical context in which to see clearly and chronologically the work of the major sculptors of the time. The second was to determine why the work of painter-sculptors, work done, so to speak, with the left hand, was consistently more forward-looking and of at least as high quality as that of professional sculptors during the nineteenth century. Finally, there was the issue of the Degas sculpture itself. Why had such a masterful oeuvre remained hidden for so long? Where had it come from and what, if any, was its influence? What was its relationship to Degas' work in two dimensions?

As my work on these problems progressed it became obvious that they were intimately tied up with more technical issues such as the nature of the materials used by sculptors, the progress from the material in which the sculptor worked to that of the finished work (and, indeed, the question of what exactly constituted a finished work), and the infinitely complex matter of bronze casting methods, patination, etc. Luckily, Arthur Beale of the Fogg Museum's conservation laboratory was both at hand and interested in these issues, and agreed to undertake an investigation of them in relation

to the Degas waxes, to attack from the technical side what I was investigating from the critical and historical. The results of his investigations, to be published separately, have been invaluable to my own thinking. I hope that our combined efforts will contribute something to that history of nineteenth-century sculpture that remains to be written, casting useful light on the fascinating and still murky issue of how sculpture has arrived where it is from where it was when neoclassicism was still a vital style.

I have chosen to translate all foreign language quotations in the text myself, leaving in the original language quotations in the footnotes, poetry, and the idiosyncratic and evocative passage from Jean Lorrain's article "La Danse." Certain of the illustrations are taken from nineteenth-century periodicals to show how the sculpture they represent was known in Degas' time, if not to Degas himself; that of the Louvre *Minerva* represents the figure in the pose it held prior to a recent reconstruction. Others, for which the whereabouts of the subjects are unknown, have had to be taken from more recent publications, and their quality is therefore not all that could be desired. The illustrations of Degas' works have been arranged in as nearly chronological order as possible. Titles for those works have been taken, sometimes in a shortened form for the sake of concision, from John Rewald's *Degas, Works in Sculpture, a Complete Catalogue* (New York 1957). Four abbreviations occur with some frequency: Lemoisne, *Lettres*, Reff, and Rewald. These refer, respectively, to: Paul-André Lemoisne, *Degas et son oeuvre*, 4 v. (Paris 1946) [B. 106]; *Lettres de Degas* (Marcel Guérin, ed., Paris 1945) [B. 7]; Theodore Reff, "The Chronology of Degas's Notebooks," *Burlington Magazine*, December 1965, pp. 606-616 [B. 6]; John Rewald, *Degas, Works in Sculpture, a Complete Catalogue* (New York 1957) [B. 98]. The bibliography is arranged chronologically by date of publication in deference to Lemoisne, whose chronological bibliography I found extremely useful. Bibliographical entries are numbered, and footnote citations refer to these numbers in brackets, preceded by the author's last name and an abbreviated title (e.g., Lemoisne, *Oeuvre* [B. 106] v. I, p. 67).

ACKNOWLEDGMENT

It is impossible to thank everyone who has in one way or another contributed to this book, but it would be thoughtless indeed not to mention those who have been especially helpful.

In Washington, D.C., I am much in debt to Paul Mellon, to Willis VanDevanter, formerly his librarian, and to his staff at the Brick House, especially Beverly Carter. Not only have I been allowed free access to the Degas waxes and been given a complete set of photographs of them, but the hospitality of my reception has far exceeded what might reasonably have been expected. To John Walker, retired director of the National Gallery of Art, my thanks for granting me access to the Cassatt-Havemeyer correspondence.

In New York, Olga Raggio and Clare Vincent of the Metropolitan Museum of Art have both been generous with time and information, as has the late Helmut Ripperger, librarian of M. Knoedler & Co. Margaret Scolari Barr has also been helpful, and Theodore Reff (Columbia University) has been good enough to agree to my using information from the Degas notebooks he is publishing.

· In Cambridge, Massachusetts, Wolfgang Freitag's staff at the Fine Arts Library of Harvard University, particularly William Johnson, have been both patient and tremendously helpful. John Lavin executed the reconstruction of the original Degas relief.

In Princeton, Mary Laing started my manuscript on its way and Margot Cutter, of whose editorial ability I am a grateful and unqualified admirer, saw it through the press.

In Paris, my principal debt is to Madame Louis Gaillochet, the late Monsieur Gaillochet, and to Bertrand Gaillochet, not only for their unfailing hospitality but for substantive help in my research. Jean Adhémar and his staff at the Cabinet des Estampes of the Bibliothèque Nationale, particularly Mademoiselle Villa and Mademoiselle Hébert, of the Réserve of the Cabinet des Estampes, have been most generous with time and information, as have Michèle Beaulieu (Musée du Louvre), Paul Brame, Annie Braunwald (Musée du Petit Palais), Thérèse Burollet (Musée Cognaq-Jay), Charles Durand-Ruel and Emile Gruet of his staff, Cécile Goldscheider (Musée Rodin), Léon

Halévy, Madame Louis Hautecoeur (Bibliothèque de l'Institut), Madame A.-A. Hébrard, Martine Herold, Michel Kellerman, Mademoiselle Nepveu-Degas, Jean Paladilhe (Musée Gustave Moreau), Lydia Palazzolo, Pierre Rosenberg (Musée du Louvre), Denis Rouart, Agathe Rouart-Valéry, Vernon Vig, and the entire staff of the Bibliothèque Jacques Doucet at the Institut d'Art et d'Archéologie. My thanks, finally, to Gérard Lévy and François Lepage whose warmth and hospitality helped make the rigors of a research winter abroad bearable.

The following people in other parts of the world have also materially contributed to my research: Geneviève Becquart (Societé des Amis des Musées de Lille), Jean Sutherland Boggs (National Gallery of Canada), Lillian Browse, James Byrnes (Isaac Delgado Museum of Art), Mina Curtiss, C. A. Elliott (Islington Public Libraries), Albert Elsen (Stanford University), Gerhard Fries, Robert Bartlett Haas (University of California at Los Angeles), Eugenia Parry Janis (Wellesley College), Mrs. Percy C. Madeira, Jr., George Pratt (George Eastman House), Riccardo Raimondi, John Rewald, Sir John Rothenstein, Aaron Scharf, Alain Silvera (Bryn Mawr College), Robin Spencer (University of St. Andrews), Evan Turner (Philadelphia Museum of Art), Lamberto Vitale, John Wilmerding (Dartmouth College), and Harriet Youngk (University of Pittsburgh).

Finally, no work such as this can fail to be deeply indebted to John Rewald's *Degas, Works in Sculpture, a Complete Catalogue* (New York 1944, 1957).

My research was made possible by successive teaching and travelling fellowships from Harvard University.

The Sculpture of
EDGAR DEGAS

*La loi suprème de l'invention est,
et sera toujours, de soumettre la
tradition et la réalité à l'épreuve
laborieuse d'une mutuelle interprétation.*

Gustave Planche

1. ORIGINS AND DATING

THE EXACT date at which Degas began to make sculpture is unknown, although it is probably somewhat later than the date in the middle 1860s hitherto proposed. Certainly, Degas was intensely aware of sculpture from the first moments of his artistic career, not only because he trained himself so thoroughly in drawing from classical sculpture and casts, but because he seems to have had a genuine attraction toward the medium as a career. Pierre Borel quotes a letter to Pierre Cornu, presumably written in the late 1850s, in which Degas says, "I often wonder whether I will be a painter or a sculptor. I will not conceal from you that I am very uncertain [perplexe]."[1] There is no evidence, however, that this youthful perplexity bore fruit in the form of sculptural essays, and apart from two unclear references to sculpture in letters written to the young painter by his father, there is no datable allusion to the subject until 1878. The two letters in question, dated 28 August and 6 October 1858 respectively, when Degas was in Florence, refer to two plasters belonging to Degas which had been damaged in transit and which Monsieur Lévy was having repaired by a molder with some of his own.[2] Lévy, a friend of Degas and Gustave Moreau,[3] was a painter and it seems unlikely that either he or Degas would have sent original plaster sculpture back to Paris from Rome, or that he would have confided such plasters to a professional molder rather than fix them himself. Almost certainly, the plasters were small casts of classical sculpture of the type still sold in art supply stores. Several period examples used by Gustave Moreau and probably acquired about the same time are in the Musée Moreau.

The generally accepted date of Degas' sculptural beginnings—before 1870—was first

[1] Letter from Degas to Pierre Cornu quoted by Borel, *Sculptures* [B. 114], p. 7. I have been unable to locate this otherwise unrecorded letter.

[2] Letters from Auguste Degas to Edgar Degas in a private collection, Paris, which were kindly brought to my attention by Gerhard Fries. The Lévy involved is presumably Emile Lévy (1826-1890), the subject of a double portrait by Degas (Lemoisne 135) and referred to by Le-moisne as a "camarade de jeunesse de Degas," who was in his third year at the French Academy, Rome, in 1857. Degas had been in Rome until 4 August 1858 (Reff, "More Letters" [B. 9], p. 281).

[3] Degas mentions Lévy to Moreau in a letter dated 26 April [1859] as if they were at least good acquaintances (ibid., p. 285).

proposed by Paul-André Lemoisne in 1919, partly on the basis of a reminiscence of Paul-Albert Bartholomé and partly on the basis of Degas' friendship with the animal sculptor Joseph Cuvelier, killed in the Franco-Prussian War. According to Lemoisne, "his long-time friend, Monsieur Bartholomé, remembers having seen him make, very early, before 1870, a completely charming large bas-relief in clay representing, in half-life size, young girls gathering apples; but its author did nothing to preserve his work which later fell literally into dust."[4]

Bartholomé, Degas' closest friend during the last thirty years of his life, could hardly have seen such a relief at the date he claimed, since he was born in 1848, making him less than twenty in the mid-1860s, and he prepared for the law until 1870. He turned to painting after the Franco-Prussian War,[5] exhibiting at the Salon between 1879 and 1885, and took up sculpture in 1887, at Degas' urging, to distract himself from the death of his first wife.[6] He probably first met Degas, a friend of his wife's family, around 1880.[7] As for the connection with Cuvelier, almost nothing is known of it.[8] That Degas knew him is proved by the fact that his name appears in three of Degas' unpublished notebooks.[9] That the relationship was warm is suggested by a letter written

[4] Lemoisne, "Statuettes" [B. 31], p. 110.

[5] These facts have been noted by Thérèse Burollet, "Degas" [B. 158], p. 104.

[6] That Degas was responsible for starting Bartholomé on his career as a sculptor is attested to by Jacques-Émile Blanche, a mutual friend, in *Les Arts plastiques* (Paris 1931), p. 357, Daniel Halévy in *My Friend Degas* (tr. Mina Curtiss, Middletown 1964), p. 23, and Madeleine Zillhardt, also a mutual friend, in *Louise-Catherine Breslau et ses amis* (Paris 1932), p. 71.

[7] See Thérèse Burollet, "Bartholomé et Degas," *L'Information d'histoire d'art*, May–June 1967, p. 119.

[8] Louis Alfred Bernard Joseph Cuvelier, born at Commines 3 December 1833 (Archives départmentales du Nord), killed at the battle of Malmaison 21 October 1870 (*Dictionnaire de biographie française*, v. II, Paris 1960, p. 1434).

[9] Guérin notebook 3 (Reff 1865-1870), p. 13bis, "Boulev Strasbourg 62 Cuvelier;" notebook 8 (Reff 1867-1874), p. 220, "Cuvelier artiste sculpteur à Commines (Nord);" note-book 21 (Reff 1868-1872), p. 157, "Cuvelier chez M. Paude rue St. Merey Fontainbleau près l'obélisque" (unless qualified by the words "Guérin" or "Louvre," the Degas notebooks referred to are those in the Bibliothèque Nationale). Although Reff claims that the entry in notebook 8 refers to Cuvelier before his death, the formality of the notation suggests an entry in an exhibition catalogue at a time either before Degas knew Cuvelier well or after the latter's death. Since the words "artiste sculpteur" are inserted in a bracket, apparently as an after-thought, and since the notation is followed by vertical tote-marks, as if Degas were checking off several items, preparations for the catalogue of a posthumous exhibition are suggested. That such an exhibition may have taken place is suggested by Lemoisne in his catalogue entry for the portrait of Madame Villette: "lorsqu'il [Degas] fit quelques courts séjours à Lille à propos de l'arrangement des oeuvres de Cuvellier [sic] au Musée de Lille, Degas était reçu chez les Villette" (Lemoisne, *Oeuvre* [B. 106], v. II, p. 152).

by Madame Morisot to her daughter Edma in which she says, "Monsieur de Gas [*sic*] was so affected by the death of one of his friends, the sculptor Cuvelier, that he was impossible."[10] That Cuvelier's particular interest in the realistic representation of horses appealed to Degas and, combined with influences from many other sources, helped shape the style of his early horse sculpture, is also beyond doubt (Figs. 2, 3).[11] But the step from these facts to saying that Degas made sculpture of horses only under Cuvelier's influence and stopped doing so soon after his death is too great a one to make, particularly in connection with an artist such as Degas who worked out his ideas over extended periods of time.[12] Rather, it seems likely that Degas may have taken up modelling after Cuvelier's death partly as a sort of memorial and partly in response to emotional pressure of other kinds, as he later counselled Bartholomé to do.

There remains, finally, the argument put forward by John Rewald that the wax *Horse at Trough* (Fig. 9)[13] was executed by Degas as a model for the painting *Mademoiselle Fiocre in the Ballet "La Source"* (Fig. 10), and therefore about 1867, the year of

The present Palais des Beaux Arts at Lille has no record of such an exhibition. That Degas had connections in Lille about 1871-1872 is obvious from a letter he wrote Désiré Dihau from New Orleans, dated 11 November [1872] saying, "Je me ferai pardonner de mes amis de Lille, quand je serai revenu. . . . Si vous n'êtes pas encore allé à Lille en Janvier, j'irai avec vous et je prendrai toutes les allures d'une aimable soumission" (*Lettres* [B. 7], p. 17, letter 1). Since the following paragraph refers to a "cruelle amie," Guérin assumes that the reference is to a contretemps with Marie Dihau, whom he says lived in Lille in the early 1870s and whose family was native there (*Lettres* [B. 7], p. 17, note 2). Finally, Degas is said to have exhibited his *Orchestre de l'Opéra*, in the foreground of which is a portrait of Desiré Dihau, in Lille during 1870-1871 (*Exposition Degas*, catalogue of an exhibition held at the Galerie Georges Petit, Paris, 12 April-2 May 1924).

[10] Quoted by Lemoisne, *Oeuvre* [B. 106], v. 1, p. 67, where it is dated 26 October 1870. The same letter is dated 18 October 1870 in *Morisot* [B. 14], p. 44. If the date of Cuvelier's death given by the *Dictionnaire de biographie française* (21 October 1870) is correct, Lemoisne's date must be accepted.

[11] Cuvelier had been singled out by Colonel E. Duhousset as among the most naturalistic horse sculptors before the advent of photography (*Le Cheval*, Paris 1874, p. 12, and "Représentation instantanée des allures du cheval, au moyen de l'électricité appliquée à la photographie," *L'Illustration*, 25 January 1879, p. 59).

[12] These suggestions were made by Lemoisne, "Statuettes" [B. 31], pp. 110-111. The idea that Degas' origins as a sculptor are tied to Bartholomé and Cuvelier is repeated by him in *Oeuvre* [B. 106], v. 1, p. 127.

[13] Except for the *Little Dancer*, the titles given Degas' sculpture were first assigned at the time of the exhibition of the bronzes in 1921, presumably by Hébrard and Durand-Ruel with Bartholomé's help. In many cases the action performed by Degas' figures is ambiguous, and in every case sculptural configuration takes precedence over represented action, so that their titles must always be taken as denominations rather than as descriptions.

the painting.[14] While there is no doubt that the *Horse at Trough* and the *Mademoiselle Fiocre* horse are in the same pose, it is by no means clear that the sculpture preceded the painting and was a study for it. As with most poses chosen by Degas, both human and animal, that of a horse drinking or feeding recurs again and again. It is encountered most frequently in the notebooks, first in notebook 19 (Reff 1860-1862: Fig. 11), several years before the *Mademoiselle Fiocre*, then in the second of the Louvre notebooks and in Guérin notebook 3, where it is clearly studied for the *Mademoiselle Fiocre*, and finally five times in notebook 24 (Reff 1869-1872), too late for the painting, which was exhibited in the Salon of 1869. In the latter case, Degas has clearly observed a real horse in a pose previously chosen for one of his works, a habit common with him. That the horse represented in this notebook was actually seen grazing, and not on stage, is clear from a notation above one of the sketches which begins, "morning in the meadow, the grass in the shade . . ." (Fig. 12). It is, then, not necessary to suppose that the sculpted horse was a study for the painting, and indeed a good deal in Degas' working method suggests the contrary. Georges Rivière has affirmed so in referring to "some models of horses executed later than the preparatory sketches for the racing pictures,"[15] and the sculpture of Degas' friend Gustave Moreau, which is closest to his in style and conception, was almost certainly executed after the completion of paintings in which identical figures appear.[16]

Degas probably began making sculpture in the 1870s, motivated by a combination of inner and outer forces and by the general ripening of a sculptural tendency noticeable in his work from the beginning. He would certainly have been aware of Moreau's experiments in the medium, almost all of which were undertaken in the decade between 1870 and 1880.[17] He probably also knew Gauguin's first pieces of sculpture, done in 1877,[18] and Renoir's, created at about the same time.[19] Moreover, he would have been conscious of the deaths of several of the major figures of mid-century French sculpture, all of them

[14] Rewald, *Works* [B. 98], pp. 15, 141.

[15] Rivière, *Mr. Degas* [B. 82], p. 141.

[16] Ragnar von Holten, "Gustave Moreau sculpteur," *Revue des arts*, no. 4-5, 1959, pp. 209-210.

[17] Ibid., p. 210.

[18] These were marble portraits of Gauguin's wife and son, both exhibited at the 1880 Impressionist exhibition (cf. Christopher Gray, *Sculpture and Ceramics of Paul Gauguin*, Baltimore 1963, p. 1).

[19] Paul Haesaerts (*Renoir, Sculptor*, New York 1947, p. 19) says that Renoir's early efforts were made about 1875 and included a faience portrait bust of Georges Rivière. Jean Selz (*Découverte* [B. 146], p. 185) mentions only decorative sculpture which he dates 1878.

Romantic heroes of one sort or another. Barye died in 1875 and was given an immense posthumous retrospective exhibition at the Ecole des Beaux Arts. Daumier's retrospective at Durand-Ruel in 1878 drew attention because of the hitherto unknown sculpture that was shown, and that artist's death the following year was preceded only slightly by that of Préault, the most Romantic sensibility among the sculptors of the generation of 1830. Closer to Degas personally, Madame Fromental Halévy, aunt of his friend Ludovic Halévy, exhibited sculpture at the Salons between 1877 and 1880, beginning in the former year with a figure of *Madame Krauss in the Role of Rachel in "La Juive"* and ending in the latter with a bust two meters high for the facade of the new Hôtel de Ville.[20] It may well have been through the Halévys, also, that Degas encountered the animal sculptor Gustave Debrie, who exhibited horse groups at the Salons beginning in 1874, and in 1882 showed a marble portrait of Ludovic Halévy.[21] More important were the personal trials Degas underwent just at the moment he was reaching middle age. There was first the Franco-Prussian War and the Commune, with their deprivations and loss of friends, from which the 1872-1873 trip to New Orleans may well have been an escape. Then there was the death of Degas' father in 1874, which probably sharpened his awareness of his own childless bachelorhood, an awareness that was to find expression in the early 1880s in an interest in children, and, later, in occasional poignant comments in his letters. His consciousness of death seems also to have intensified during this period and may have made him think increasingly of sculpture, the medium of which (bronze) he once described as "for eternity."[22] Finally, the 1870s were crucial for Degas because of the growing pressure placed on his art by his acceptance of the modernism represented by Manet, and his realization that major figure painting of the type he had attempted at the outset of his career was no longer feasible for him. Driven to seek new expressive outlets in other media, he gradually turned during the 1870s and 1880s to pastel, printmaking, and sculpture, all of which offered him less restricting avenues of exploration. Thus, internal pressures that tended toward rupture in both his personal and artistic life and external awarenesses that bore sculpture particularly in upon his consciousness undoubtedly sparked Degas' first attempts at sculpture some-

[20] Cf. Henry Jouin, *La Sculpture au Salon de 1877* (Paris 1878), and *La Sculpture au Salon de 1880* (Paris 1881).

[21] Gustave Joseph Debrie (1842-1932) specialized in animal groups and portraits. His name and address occur on page 7 of notebook 2 (Reff 1880-1884).

[22] Ambroise Vollard, *Degas* (Paris 1924), p. 112.

time toward the middle of the 1870s after his return from the United States. These attempts were the logical outcome of twenty years of interest in three-dimensionality and the visible evidence of his curious belief that sculpture was "a more suitable medium to express profound suffering" than painting.[23]

There are only four documented dates for existing sculpture by Degas, the first of which is 1878, the year he began work on the *Little Dancer* (Figs. 23, 26 and Color Plate). Since the piece was shown in the spring of 1881 at the sixth Impressionist exhibition, it is clear that he worked on it, in the words of François Thiébault-Sisson who knew him during this period, "a good number of years."[24] The date Degas started modelling the figure is established by the age of his model, for in the catalogues of both the 1880 and 1881 Impressionist exhibitions the sculpture is listed as *Little Dancer, Fourteen Years Old* (it was not, as has often been noted, exhibited in 1880).[25] Marie Van Goethem, the model for the *Little Dancer*, would have been fourteen on 17 February 1878.[26] Degas

[23] Daniel Halévy, op. cit., p. 23. In "A Edgar Degas," *Le Divan*, September–October 1919, pp. 209-219, Halévy suggests that 1870 was a crucial year for Degas for somewhat the reasons I have outlined here.

[24] Thiébault-Sisson, "L'Homme et l'oeuvre" [B. 27], p. 3.

[25] These catalogues are reproduced in Venturi, *Archives* [B. 10], v. II, pp. 264 and 265. For the fact that the *Little Dancer* was not shown by Degas in 1880, see Gustave Goetschy, "Exposition des artistes indépendants," *Le Voltaire*, 5 April 1881, p. 2 and Mantz, "Exposition" [B. 19], p. 3. Rewald has correctly refuted claims by various writers that the figure was exhibited at any other time (*Works* [B. 98], p. 145).

[26] The identity of the model for the *Little Dancer* is established by the drawing in the Louvre known as *Quatre études de danseuse* (Fig. 27), which is clearly related to the sculpture and which has at the top, in Degas' hand, the notation "36 rue de Douai Marie." In notebook 2 (Reff 1880-1884) there is the address (p. 4), "Marie Van Gutten 36 rue de Douai." Marie Van Goethem (the orthography of the

name varies considerably, but seems properly to be Van Goethem) was born in Paris, the daughter of a Belgian couple who were tailor and laundress, on 17 February 1864. She was one of three sisters, all of whom were ballet students at the Opéra, and all of whom seem to have modelled for Degas (cf. Panserose, "Paris la nuit: le ballet de l'Opéra," *L'Evenement*, 10 February 1882, p. 3: "Mlle Van Goeuthen.—Quinze ans. A une soeur figurante et une autre à l'école de danse.—Pose chez les peintres.—Va par conséquent à la brasserie des Martyrs et au Rat Mort." This is probably Marie, who would have been seventeen at the time). In notebook 8 (Reff 1867-1874) there occurs the notation (p. 211) "Van guthen Boulevard Clichy. Antoinette petite blonde 12 ans," referring to the oldest of the sisters. The third and youngest, Louise-Joséphine (18 July 1870–15 January 1945), is the only one who made a career of dancing, eventually becoming a teacher in the Opéra ballet school, after which she retired to give private dancing lessons. Unfortunately the claim has been put forward, probably based on her own statements, that it was she who posed

must have started on the nude version of the figure sometime after that date and worked on it through 1879, still not being satisfied with its condition by the exhibition of April 1880. Whether he began the clothed version at the same time is uncertain, but probably the unresolved compositional difficulties which kept him from exhibiting the nude figure led him to think of the clothed version, and it would, thus, have been conceived, if not begun, in the late winter or early spring of 1880 and worked on until a few days after the opening of the April 1881 exhibition.[27] That it was the nude and not the clothed version of the figure that Degas intended to exhibit in 1880 is suggested by the fact that it is the only one of his sculptures for which he made a pedestal, the only one prepared and "finished" as if it were meant to be seen publicly. The wax figure is set onto a plaster base, probably cast in a cardboard box, and a *pentimento* made in the wet plaster by a change in position of the right foot indicates that Degas experimented with the composition up to the last possible moment.[28] Still dissatisfied, he seems to have decided not to exhibit the figure at all and turned to new possibilities—the clothing—for solving the problems that confronted him.

The second of the datable sculptures is *The Tub* (Fig. 92), for which Degas made

for the *Little Dancer* (Pierre Michaut, "Immortalized in Sculpture," *Dance*, August 1954, pp. 26-28), although she would have been only ten at the time it was first mentioned in 1880. Nevertheless, it was probably she whom Mademoiselle Mante remembered as posing for the pastel *Dancers with Long Hair* (Lillian Browse, *Degas Dancers*, London 1949, p. 62) and to whom Coquiot referred as, "Mme Van Goethem, qui posa souvent, danseuse illustre, pour Degas" (Gustave Coquiot, *Degas*, Paris 1924, p. 81). What became of Marie, who was said by Mary Cassatt also to have posed for the seated figure in the Philadelphia painting *The Ballet Class* (copies of unpublished letters of 18 April 1920 and 28 April 1920 from Mary Cassatt to Mrs. Horace Havemeyer in the possession of the National Gallery, Washington), is unknown. She may very well also have been the model for the pastel *Dancer Resting* (Lemoisne 573), in which the figure holds a pose close to that of the *Little*

Dancer and, as in the Philadelphia painting, reads a newspaper.

[27] That Degas was late in adding the *Little Dancer* to the 1881 exhibition was noted by all the critics. On 5 April Gustave Goetschy ("Exposition des artistes indépendants") wrote that "l'artiste m'assuré qu'elle serait exposée demain," but on 8 April Auguste Dalligny noted, "M. Degas doit envoyer aussi une statuette en cire, petite danseuse de quatorze ans, qui n'était pas encore en place ces jours-ci" ("Les Indépendants: sixième exposition," *Le Journal des arts*, 8 April 1881, p. 1). Whether Dalligny had seen the exhibition the previous day is not clear. In any case, the figure had appeared by the 16th of the month (C. E., "Exposition" [B. 15], p. 126).

[28] The foot was turned slightly forward. I am indebted to Arthur Beale for first pointing this out to me.

9

a plinth in June of 1889, and the figure for which was presumably executed shortly before. On 13 June 1889, he wrote to Bartholomé, "I have worked the little wax a great deal. I have made a base for it with rags soaked in a more or less well mixed plaster."[29] This socle of plaster-soaked rags, which still supports the lead basin in which the figure reclines, would have been the finishing touch added by Degas to the sculpture. It is interesting also that the wax succeeds by some three years the pastel versions of the same subject.[30]

The third of the Degas sculptures for which it is possible to establish a documented date is the clay portrait head of Mademoiselle Mathilde Salle (Fig. 117), a dancer at the Opéra of whom Degas executed a pastel portrait dated 1886 (Fig. 120). The clay bust was made in 1892. There are three references to Salle, and two to the clay head, in letters of that summer to Bartholomé, who was simultaneously engaged on a marble half-length portrait of the same sitter (Fig. 119). On 16 August 1892, Degas wrote from Ménil-Hubert, where he was staying with the Valpinçons, "And Salle, you are going to finish with her and she won't want to come back for me!"[31] Somewhat later he ended a letter, "Hello to Salle,"[32] and in an undated letter probably written on 30 August, he reiterated what seems to have been a preoccupation for him at that time, saying, "You don't mention Salle to me? Have you gone on with the bust? And my poor clay?"[33] That the clay head in question is indeed that of Mademoiselle Salle is

[29] *Lettres* [B. 7], p. 135, letter CVIII.

[30] On the basis of its similarity to these pastels, Rewald dated the sculpture 1886 (*Works* [B. 98], p. 146).

[31] This letter is now in the possession of Mrs. Eugenia Parry Janis, Cambridge, Massachusetts. It is quoted in part by Guérin (*Lettres* [B. 7], p. 192, letter CLXX), who does not, however, give the sentence relevant to Salle.

[32] Letter from Degas to Bartholomé dated simply "Vendredi" in the collection of David Daniels, New York, published by Theodore Reff, "Some Letters" [B. 8], pp. 92-93. Reff dates the letter 1890 on the basis of references which suggest Degas' 1890 trip through Burgundy with Bartholomé. Degas also travelled through the northeastern part of France in the summers of 1891, 1892, and 1893, however, as

is evident from other correspondence published by Guérin. Comparison of this letter with that correspondence makes it certain that it was written in 1892, probably on 19 August.

[33] This undated letter is assigned by Guérin to 1893 (*Lettres* [B. 7], p. 196, letter CLXXV). Since at the time the letter was written Bartholomé was still at work on his marble portrait of Salle, which was exhibited in the Salon of 1893, such a date is impossible (cf. Henri Buchot, "Les Salons de 1893: La Sculpture," *Gazette des beaux-arts*, August 1893, p. 119). From internal evidence relative to Degas' travels as they are mentioned in other letters written during the summer of 1892, it is clear that this letter was written then, probably on the date suggested.

10

obvious from comparison with the Degas pastel and, particularly, with the Bartholomé marble, in which both the features and the expression are identical. It is likely that the small clay portrait head (Fig. 115) is a preliminary version of the large one, since the catalogue of the 1921 exhibition at the Galerie Hébrard in which the sculptures were first titled lists them as "first study for the portrait of Mme. S . . ." and "second study of Mme. S. . . ."[34] These titles, which refer to the small and large heads respectively, presumably originated with Bartholomé, who was then alive and had been involved with Hébrard in the preservation and casting of the sculpture.

The remaining small portrait with its head leaning on its hand (Fig. 121) is also datable 1892 and is to be identified with the sculpted portrait of Rose Caron mentioned in letter CLXXV. "As soon as I return, I intend to pounce on [je compte fondre sur] Madame Caron," Degas wrote to Bartholomé, "You must already have made a place for her among your chaste rubbish."[35] That Degas is speaking of sculpture and not of the painted portrait now in Buffalo (Fig. 123) is clear from the second sentence. That the sculpture referred to is the third portrait can be inferred from the presence of the hand. Not only is this unusual at a time when Degas' sculpted portraits concentrated on the head alone, but it introduces a difficult compositional element which could have been avoided. Rose Caron, a singer at the Opéra, was known for the beauty of the movements of her hands and arms, and that Degas was particularly conscious of that fact is indicated by the sonnet he wrote about her and dedicated to her, beginning, "Ces bras nobles et longs," and concluding, "Si mes yeux se perdaient, que me durât l'ouïe,/Au son, je pourrais voir le geste qu'elle fait."[36] Indeed, in 1941 the music critic Pierre Lalo, a friend of Degas' in his old age, wrote of Caron, after invoking the Degas sonnet, "Certain of her attitudes sculpted themselves in lines at once so expressive and so beautiful that the memory preserved an indelible image of them."[37] In the Buffalo portrait, Degas was careful not merely to include but to emphasize the arms, and a pastel close in date to the sculpture (Fig. 124), and of an almost identical pose, may also represent Rose Caron. Finally, the bust was executed at the moment Degas

[34] *Exposition des sculptures de Degas*, catalogue of an exhibition held at the Galerie Hébrard, Paris, May–June 1921, nos. 69 and 70. This was the first public exhibition of the posthumously cast bronzes.

[35] *Lettres* [B. 7], p. 196, letter CLXXV. The last two words are "chastes gravats" in the original.

"Gravats" refers particularly to plaster fragments, and the phrase is no doubt a joking allusion to Bartholomé's pile of discarded models.

[36] *Sonnets* [B. 11], pp. 37-38.

[37] Pierre Lalo, "Rose Caron," *De Rameau à Ravel* (Paris 1947), p. 217. This essay is reprinted from *Le Temps* of 20 November 1941.

11

would have been most conscious of Madame Caron, who had sung in Reyer's *Sigurd*, the role that inspired Degas' poem, in 1885 and 1890, and whose painted portrait is generally dated 1890. The only other identification proposed for the bust in question is the suggestion of Rewald and others that it is "presumably a portrait of Mme. Bartholomé."[38] The source for this identification is uncertain, but it may originate in a notation in the catalogue of the first exhibition of the Degas bronzes in this country to the effect that the head was "probably a portrait of Mme. Barthélemy."[39] Since there is no reason to suppose that Degas ever executed a portrait of Madame Barthélemy in any medium, the name was presumably intended to be that of Madame Bartholomé. Not only is such an identification stylistically unlikely, since the portrait would have to have been done before Madame Bartholomé's death in 1887, but had the bust been a portrait of his first wife, Bartholomé would almost certainly have made sure that that fact was noted in the catalogue of the 1921 Hébrard exhibition, where the piece is listed simply as "Portrait, head leaning on a hand."[40] Almost certainly the bust is the portrait of Rose Caron mentioned in the Degas letter of 1892.

The only other Degas sculpture which can be precisely dated was also a portrait, but was destroyed accidentally by Degas himself immediately after it was finished. Its subject was Hortense Valpinçon, daughter of his good friends the Paul Valpinçons, and it was executed at their Norman chateau at Ménil-Hubert, where Degas seems to have passed part of almost every summer.[41] In 1884 he arrived about the third week in

[38] Rewald, *Works* [B. 98], p. 147.

[39] *Prints, Drawings and Bronzes by Degas*, catalogue of an exhibition held at the Grolier Club, New York, 26 January–28 February 1922, p. 14.

[40] Speaking of Degas' sculpture, Jean Bouret wrote, with no indication of his source, "Bartholomé asked for a bust of his wife (Degas made the attempt, but never finished it)" (*Degas* [B. 148], p. 154). There is a remote possibility that the bust could be a posthumous portrait of Peri Bartholomé after a still extant photograph of her leaning on her hand. The resemblance is slight, however, and there is no reliable information that would lend credence to such an identification.

[41] The pattern of these visits, which seem usually to have begun in August, was that Degas would arrive for a few days and then, either on his own account or at the urging of the Valpinçons, extend his visit to several weeks. Such was the case in August of 1892 when he was anxiously inquiring of Bartholomé about Mademoiselle Salle. Aside from the *Lettres*, the best source of information on the Valpinçon portrait is S. Barazzetti, "Degas" [B. 83], 28 August 1936, pp. 1, 4, on which much of the following is based. Although the article resulted from a series of interviews with Hortense Valpinçon, then Madame Jacques Fourchy, it wrongly suggests that the bust was made in the summer of 1883.

12

August intending to stay approximately two weeks,[42] but by the middle of September he was at work on a half-length portrait bust which occupied him at least until the end of October.[43] It was begun at the urging of the Valpinçons, apparently partly as a ruse to keep Degas in Normandy, and he was given a studio in the park of the chateau belonging to Paul Valpinçon, a painter, in which to work. According to the sitter, "At first attempting only the head, he made a bust and finally that large life-sized sculpture extending to mid-thigh."[44] Degas, who made no mention of anything other than the life-size half-length, described the work to Bartholomé as, "a large bust with arms, in clay mixed with small pebbles,"[45] adding later, "I told you that there are two arms; let it suffice you to know also that, naturally, one of them, that of which one sees the hand, is behind the back."[46] The latter description is accompanied by a quick sketch of the work (Fig. 54). Having finished the bust in easily worked clay, Degas apparently wanted to preserve it in less friable material and began a plaster cast, the history of which is given by Barazzetti:

> The modelling finished, it was a question of making a cast. Degas arrived with a tiny sack of plaster even though the bust was life-size and extended well below the waist. The artist did not want to wait for other plaster to be brought from Paris. Common plaster, as fine as possible, such as one can sometimes find on the spot, was used. Bust and cast broke during the operation. Degas preserved the back for a few months in his Paris studio, wetting it from time to time. This fragment, in turn, fell apart. Of the bust "with arms" nothing remained.[47]

It is indicative that in describing the bust to Bartholomé, Degas should say that "naturally" one of the arms was behind the back, for this position seems to have been one that particularly interested him about this time, and there is possibly a reflection of the Valpinçon bust in the contemporary pastel of a girl with her hands behind her

[42] *Lettres* [B. 7], pp. 82-84, letter LVII, and p. 85, letter LIX.

[43] Letter from Degas to Léontine (Madame Giuseppe) de Nittis, dated "Ménil-Hubert, 21 October 1884," in Mary Pittaluga and Enrico Piceni, *De Nittis* (Milan 1963), p. 270. From its date and Degas' reference to returning to Paris, this letter would seem to have been writ-

ten just before he attempted the plaster cast.

[44] Barazzetti, op. cit., p. 1.

[45] *Lettres* [B. 7], p. 91, letter LXV.

[46] *Lettres* [B. 7], p. 93, letter LXVI. Degas also mentions the work in letters LX and LXIV to Ludovic Halévy, and in letter LXIII to Ernest Rouart.

[47] Barazzetti, op. cit., p. 4.

back (Fig. 55). It is a pose that shows up elsewhere in Degas' sculpture, notably in the *Little Dancer* and the *Schoolgirl*.

The *Schoolgirl* (Fig. 32)[48] is the first of the Degas sculptures for which, although there is no specific date, it is possible to establish an approximate date on the basis of collateral information, in this case sketches in the notebooks. In notebook 2, which is almost entirely devoted to sculpture and which contains the only Degas drawings that can be said to be studies for sculpture in the usual sense, there are three drawings of this figure (Fig. 34).[49] Reff has dated the notebook 1880-1884, and the *Schoolgirl* probably dates toward the beginning of this period, around 1880, not merely because the studies for it occur early in the notebook, but because it is directly related to the righthand figure in the *Portraits in Frieze for Decoration of an Apartment* (Fig. 37), dated 1879, which was exhibited *hors catalogue* at the 1881 exhibition at which the *Little Dancer* was shown.[50] This figure was supposedly posed for by Ellen Andrée[51] and its connection with the *Schoolgirl* is made by the pastel *Woman in a Purple Dress* (Fig. 36), in which the position of the figure is almost identical but in which the hat has been simplified to the less obtrusive and more idiosyncratic shape found in the sculpture.[52] In the sculpture, the book has been moved to the right hand and metamorphosed into an indefinite object resembling a package or portfolio, a change also to be seen in the notebook sketches. Except for the position of the feet, which is slightly more like that of the *Little Dancer* in the sculpted *Schoolgirl* than in the sketches, these drawings rehearse

[48] Catalogued by Rewald as *Woman Walking in the Street* (*Works* [B. 98], p. 158).

[49] Pp. 12, 13, and 19.

[50] Cf. Elie de Mont, "L'Exposition" [B. 17], p. 2: "Ce qui me confond, c'est l'importance que ces messieurs, et M. Degas en tête, donnent à la moindre, à la plus insignifiante de leurs productions.—Voyez les *portraits en frise pour décorer un appartement*! peut-on s'aveugler au point d'exposer une chose pareille, dont la vraie place serait au fond d'un carton? Toutes les petites charges de chanteuses de café-concerts qui figurent là aussi, sans figurer au catalogue, mériteraient au plus les honneurs d'un album de croquis! Elles deviennent ridicules à force de prétension." Also Henry Trianon, "Sixième exposition" [B. 21], p. 2: "M. E. Degas parait

être un de ces naturalistes là. Les envois de son exposition ne contiennent guère que des choses déplaisantes et même repoussantes, des physionomies de bêtes fauves [physionomies de criminels], crayonnées par lui, avec une certaine énergie en pleine cour d'assises, des portraits de femmes qu'il semble avoir tirées parmi les plus laides et les plus voisines de la caricature, et qu'il donne,—étranges échantillons,—comme des croquis de portraits en frise pour la décoration d'un appartement."

[51] Lemoisne, *Oeuvre* [B. 106], v. II, p. 302.

[52] These connections have all been noted by Reff, "Chronology" [B. 6], p. 615, note 134, who also states that the drawing for the *Schoolgirl* on page 19 of notebook 2 is a portrait of Ellen Andrée.

14

the wax figure exactly. That the piece was made during the time Degas was deeply involved in the *Little Dancer* is obvious from the tilt of the head, the expression of the face, the pigtail hanging down the back, and the hand concealed behind the waist. It may even be that work on this clothed figure was a factor in suggesting the clothing of the *Little Dancer*, or that the piece was partly an experiment to gauge the effect of sculpted dress. In any event, the evidence inescapably suggests that the figure was made around 1880.[53]

At about the same time, probably from 1881 until 1882 or 1883, Degas was engaged on a bas-relief which is the most complex of his sculptures both compositionally and historically. It was posed for by his niece Lucie, to whom he wrote about it in a letter dated simply "16 March," said by Reff to be of 1882:[54]

> The bas-relief has been much neglected this winter. I had to make some pictures and other desired articles, without being able to touch it other than for syringe injections to keep the clay damp. I have found a little girl of your proportions and I will be able to fill your place when I begin again on this difficult piece. I had also found another little girl, younger and more boyish, who would have replaced Anne and whom I lost . . . I will have difficulty in replacing her.[55]

This relief in clay is undoubtedly the one with half life-size figures of children gathering apples which was seen by Bartholomé in Degas' studio, and which he later saw fall into dust. It must also be the one to which Renoir referred in saying, "I saw a bas-relief by him [Degas] which he let fall into dust; it was as beautiful as the antique."[56] It is not, however, the existing relief (Fig. 38), which is executed in wax and on a much smaller scale than Bartholomé's comment indicates. Furthermore, the subject of this relief is sufficiently unclear to make it unlikely that anyone seeing it would think of children gath-

[53] Stylistically, as well as for the reasons already given, the figure cannot date from as late as 1910, as suggested by Elizabeth H. Payne, "A Little-Known Bronze" [B. 137], p. 82. Reff dates it 1881 ("Sculpture" [B. 159], p. 279. This article, which publishes a good many of the observations made here, was unfortunately unavailable to me until after the completion of my own work).

[54] Reff, "Some Letters" [B. 8], p. 94. The date

is repeated in Reff's "Sculpture" [B. 159].

[55] Riccardo Raimondi, *Degas e la sua famiglia in Napoli, 1793-1917* (Naples 1958), pp. 276-277. I have corrected Raimondi's reading of the letter from the holograph illustrated by him. Reff suggests that the Anne referred to is Degas' niece Anne Fèvre ("Sculpture" [B. 159], p. 280).

[56] Quoted in Ambroise Vollard, *La Vie et l'oeuvre de Pierre-Auguste Renoir* (Paris 1919), p. 88.

15

ering apples, and its facture is of a breadth and rapidity which suggests Degas' sculptural style of at least ten years later. It is not unlikely that at the moment the clay relief began to deteriorate Degas made a wax reduction of it, altering the composition to suit changes in his ideas as he did so. Thus the present relief would date from an indeterminate time, but almost certainly not before 1890, and would incorporate some but not all of the features of the original.[57] The major changes seem to have been made in the left quarter of the relief. When the wax relief was removed from Degas' studio at his death, there was a pronounced square-edged vertical break at the top of the composition suggesting that the two left-hand figures had been added later, perhaps in lieu of something that had been removed.[58] The line begun by this break runs down the relief without interruption along the side of the left-hand figure almost to the bottom. A smudged patch at the top left center suggests removal or reworking of some of the elements in that area. Further evidence that changes were made is provided by notebook 2, which contains several studies for the relief but none showing the left-hand figures in their present configuration. There is an outline sketch of the existing center figure with notations of proportions which suggest that this may be the figure for which

[57] There are certain similarities between the relief composition and three pastels of Mme. Alexis Rouart and her children (Lemoisne 1450-1452) said by Lemoisne to date "vers 1905" (Fig. 45). It is not impossible that Degas could have copied his relief at the time he made the pastels or shortly before, although a date closer to 1890 seems more probable. There seems, indeed, to have been a veritable explosion of works depicting girls gathering fruit around 1890, the extent of which may appear exaggerated in the light of one's awareness of the Degas. There are at least four versions of *Gathering Apples* by Pissarro, all from the late 1880s, and in 1895 the young Bourdelle created a terra-cotta relief of a seated woman gathering apples, although it is very difficult to imagine that he knew Degas' sculpture. Between 1890 and 1893 Berthe Morisot executed a series of paintings and drawings on the theme of gathering fruit (M. L. Bataille and G. Wildenstein, *Berthe Morisot*, Paris 1961, nos. 254, 274-277, 309, 332, 571-572, and 791-792). Bataille and Wildenstein suggest that at least one of these (no. 275), which bears a strong resemblance to the original left portion of Degas' composition, was carried out with the advice of Renoir, the most vocal admirer of Degas' relief. A different version (no. 254), in the possession of Degas' good friends the Rouarts, features a figure almost identical to the "swinging figure" in Degas' work but seen in reverse. Finally, Degas' close friend Mary Cassatt painted three pictures of fruit gatherers in 1891-1892 (Adelyn Breeskin, *Mary Cassatt*, Washington 1970, nos. 212, 214, 216), the largest being the central panel of a triptych on the subject "Modern Woman." These have clear similarities to Berthe Morisot's pictures and, through them, to the Degas relief.

[58] This break does not show in the wax, which was reworked at some point prior to its leaving France in 1955. It is obvious, however, in the bronze casts, which preserve the original state of the relief.

16

Lucie posed and the sketch that enabled Degas to find a model in her proportions (Fig. 43).[59] There are likewise sketches for the right-hand group and for the child's figure at the extreme left.[60] All three of these sketches, presumably made for the clay relief, relate to the present wax. What may have occupied the left side of the clay relief is suggested by a series of drawings in the same notebook, executed in a rapid style identical to that of the other three studies, of boys climbing trees. Since there are five such drawings, the motif seems to have been one that particularly interested Degas, and as composed in the sketches it would have fit exactly into the left part of the relief composition.[61] Thus, the left edge would have been occupied by a tree trunk with a branch extending diagonally up to the right across the area now smudged. The tree would have supported a young boy, as shown in the drawings, and the present child's figure at the left may well have been in roughly the same position, reaching up into the tree (Fig. 44). Not only would this arrangement have been satisfactory compositionally, it would have made clear the action of the figures, now so obscure, and identified it as children picking apples; the now ambiguous gesture of the center figure would have been that of eating an apple. If this reconstruction is correct, Degas may have made the changes either because the tree was too difficult to render on the smaller scale or was too disruptive of the composition, or simply because he wanted to explore new

[59] A finished drawing of the same figure also exists (*Catalogue des tableaux, pastels, et dessins par Edgar Degas et provenant de son atelier . . .* , 3 v., Paris 1918, v. II, p. 162, no. 279).

[60] Notebook 2, pp. 25 and 29, respectively.

[61] Notebook 2, pp. 37, 45, 184, 186, and 212-213. A separate, more elaborate drawing of this subject also exists. In these sketches Degas seems to have been particularly concerned with precisely where the boy's figure should be cropped at the top, as if he were studying its effect for the top of the relief. In one of the notebook sketches (pp. 212-213) he used a double page to explore this cropping and in the separate study he added a strip of paper at the top to extend the composition. A sketch of a boy seen from the back, with proportions marked off (p. 21), may also refer to the relief, as does a written note in notebook 2 (p. 223), "77

Avenue de Breteuil menuisier pour fond de bas relief." Other notations occur on page 225 which may be relevant to the relief and certainly refer to people who supplied Degas with material for sculpture: "Hutant-cire 60 quai de l'hotel de ville," and "Hocheid rue Odessa 12 marchand de terre glaise." The former is listed at 46 quai de l'Hotel de Ville by the 1881 Didot-Bottin *Annuaire et almanach du commerce* under the heading "cire-modelage" as a "fabr[icant] d'outils pour sculpt[ure]." Hocheid was listed in the same year as having a "four speciale pour la cuisson des oeuvres artistique." Also relevant to the sculpture is the name of Amédée Bertault, 1 rue d'Alleray (p. 224), "mouleur," although there are no casts from this period and Degas may simply have purchased plaster or sought advice from Bertault.

17

compositional ideas involving more openness than had his original conception. What-ever the reason, it is apparent that the present wax relief represents an altered version of a lost clay original, and that that orginal can be reconstructed with the help of the existing sketches made by Degas for its composition.

For Degas' later sculpture, that made between 1900 and 1912, when he was forced to move from his three-floor apartment-studio in the rue Victor Massé and gave up working altogether, there are two principal sources for dates. The first is in connection with the *Seated Woman Wiping Her Neck* (Fig. 141) which seems to have been executed shortly after the turn of the century, although it was a subject that had been explored in pastel well over ten years previously.[62] Writing of Degas as a sculptor, in *Le Temps* in 1921 François Thiébault-Sisson remembered that "the privilege . . . of watching an artist at work was not exactly a common thing. I profited from it some twenty years ago. In the dark cluttered room in the rue Victor Massé, which served him as a studio, the melancholy old man was modelling a figurine. Curled up in a Louis-Phillipe armchair, a young woman, her upper body nude, made the gesture of wiping her neck. Scrutinizing the model through his spectacles, Degas slowly, patiently, with little strokes of his sculptor's tool or his thumb, molded and remolded in red wax the projection of the shoulder."[63]

These seated figures represent the last phase of Degas' stylistic development as a sculptor and must have taken up a good deal of the time he gave to the medium during his last decade. That he also continued and developed motifs first attempted many years before is attested by the memoirs of a former model, the second source for dates after the turn of the century. In December 1910, this model posed for one of the many versions of the *Dancer Looking at the Sole of Her Right Foot,*[64] and she remembered having posed for an identical figure, collapsed in the interim probably from faulty con-struction, "one year earlier."[65] On remarking to Degas that "in the case downstairs there is a statuette in exactly the same pose as that which I am holding at the moment," he replied, "Ah! yes . . . I modelled it ten years ago."[66] Thus, the figures in this pose, of which there presently exist four versions (cf. Figs. 99, 125) and two other related

[62] Cf. Lemoisne 953 and 955-958, dated 1888-1890.

[63] Thiébault-Sisson, "Sculpteur" [B. 34], p. 3.

[64] Michel, "Modèle" [B. 29], 1 February 1919, p. 464.

[65] Ibid., p. 472.

[66] Michel, "Modèle" [B. 29], 16 February 1919, p. 628. The sculpture referred to is almost certainly *Dancer Looking at the Sole of Her Right Foot* (Rewald XLV, Fig. 99), since the model is asking about the existing plaster cast of this figure. Stylistically it would seem to have been modelled somewhat earlier, perhaps around 1890.

figures (*Dancer Holding Her Right Foot in Her Hand*), were executed, at least in part, between 1900 and 1910. Degas himself indicates that he was particularly occupied with sculpture after 1900. In September 1903 he wrote to Alexis Rouart, "One is always here in this studio working in wax: without work, what a sad old age!"[67] In 1906 he referred to himself in a note to Paul Valéry as "an old man of seventy-two whom sculpture isolates and restricts;"[68] and two years later he wrote, again to Rouart, "One will soon be blind. Where there are no fish one must not play the fisherman. And I, who want to play the sculptor."[69] Whatever the hindrances of his failing vision, it is clear that he was able to continue working on sculpture up to the moment he was forced to move,

[67] *Lettres* [B. 7], p. 234, letter CCXXXII.

[68] Unpublished note from Degas to Paul Valéry postmarked 21 August 1906 in the Departement des Manuscrits of the Bibliothèque Nationale, Paris. I am indebted to Madame Florence de Lussy for supplying me with a photocopy of this manuscript.

[69] *Lettres* [B. 7], p. 243, letter CCLXV. The question of Degas' failing eyesight is a perplexing one since it seems to have been in part a neurotic affliction of which he took advantage to shield himself from the world. As early as 1912 André Mycho, son of Marcellin Desboutin, felt obliged to publish an article attacking the myths surrounding Degas in which he quoted the proverb "Il n'est de pire aveugle que celui qui ne veut pas voir" (André Mycho, "Degas," *Gil Blas*, 18 December 1912, p. 1). Jeanne Fèvre, Degas' niece, also underlined the fact that her uncle, "n'a jamais été complètement aveugle" (Fèvre, *Mon oncle* [B. 115], p. 139). As Michael Ayrton has observed, however, it is likely that Degas' blindness "became, as imaginary ills usually do, both organic and severe" (Michael Ayrton, "The Grand Academic," *Golden Sections*, London 1957, p. 63). Certainly his models suffered from it, as he came and went to measure their proportions with the sharp points of his compass (Michel, "Modèle" [B. 29], 1 February 1919, p. 460). In general, however, his condition seems to have been exaggerated by people who took his complaints at

face value. Thus, while the model Pauline was a sympathetic audience for Degas' lament, "Ah, ma fille, que c'est donc affreux de ne plus voir clair! Voilà des années que j'ai du renoncer à dessiner ou à peindre et à me contenter de faire de la sculpture . . . Mais si ma vue continue à baisser, je ne pourrai même plus modeler" (Michel, "Modèle" [B. 29], 1 February 1919, p. 467), Degas himself had written to Alexis Rouart a mere three years earlier, "Je suis toujours ici à travailler. Me voici remis au dessin, au pastel" (*Lettres* [B. 7], pp. 241-242, letter CCXLIII). Contrary to what is often claimed, the impairment of Degas' vision almost certainly had nothing to do with his taking up sculpture. Indeed, Thiébault-Sisson has written that, "Quelques années avant que cet affaiblissement se produisait, la sculpture l'avait tenté. Il s'y donna de plus en plus . . ." (Thiébault-Sisson, "L'Homme et l'oeuvre" [B. 27]). The most interesting fact about Degas' vision in relation to the stylistic development of his sculpture is that its failure caused him increasing difficulty in establishing outlines (Halévy, *My Friend Degas*, p. 22). There is, however, little doubt that until 1912 Degas could accomplish almost anything he wished artistically and that the condition of his eyes played only an ancillary role in the development of his art, particularly as that art was based on years of scrupulous practice and preparation.

for in March 1910 he wrote to Rouart, "There's no end to my confounded sculpture,"[70] and on 26 January 1911 François Fosca and Adrien Mithouard visited Degas in his studio and found that "as we entered, he was working at a wax statuette."[71]

Around this skeleton structure of documented and probable dates, it is possible to construct a general chronology for the rest of the sculpture. The earliest horses, those made before about 1881, which seems to be the first watershed in Degas' sculptural style, certainly include *Horse Standing; Mustang* (Fig. 2); *Horse Walking* (Fig. 7); *Horse at Trough* (Fig. 9); *Thoroughbred* (Fig. 13); and *Horse Walking* (Fig. 15), in roughly that order. This is evident not simply from growing assurance and freedom of facture but from increasing confidence in the rendering of movement, ever Degas' principal concern. This progression from less to more painterly, if the terms can be applied to sculpture, and from less to more movemented is completely in accord with Degas' methodical development and belief in thorough and gradual preparation. Notebook 4 (Reff 1882-1884) contains several sketches of horses and riders (pp. 15ff.) none of which is directly related to work in wax, but all of which evince the same interest in active movement as the later horse sculpture, particularly the galloping horses (cf. Figs. 60, 64). How long Degas continued to model horses is not certain, but such figures probably occupied him until about 1890. In an undated letter to Bartholomé, said by Guérin to be of 1888, he wrote, "Happy sculptor! And I also would like . . . But I have not yet made enough horses. The women must wait in their basins."[72] While it is not clear that the reference here is to sculpted horses, the context suggests that it is. Furthermore, there are a good many pastels of horses dated by Lemoisne between 1885 and 1890, several of which are in poses identical to those used in the sculpture, suggesting that in this case Degas was exploring the same attitudes in both media simultaneously.[73] Finally, there is the testimony of Thiébault-Sisson that "racing scenes . . . [in which his interest was] whetted by the discovery of a photographic process that was instantaneous and scientifically capable of studying the decomposition of movement, occupied him for a fairly long time after intimate scenes and portraits, or ironers, milliners, and laundresses."[74]

[70] *Lettres* [B. 7], p. 245, letter CCXLVIII.

[71] Fosca, *Degas* [B. 38], pp. 7-8.

[72] *Lettres* [B. 7], p. 127, letter C. The reference to women in their basins is probably to pastels, since it is in the plural and since the letter seems to date just prior to *The Tub*.

[73] Cf. Lemoisne 1001-1002, "vers 1889," and Rewald XVII and VI.

[74] Thiébault-Sisson, "L'Homme et l'oeuvre" [B. 27].

20

Degas' interest in photographic motion experiments is also mentioned by Paul Valéry, who says that "he was one of the first to study the true forms of the noble animal in movement by means of the instantaneous photographs of Major Muybridge,"[75] and this interest must have had a fairly important role in the development of his art during the 1880s. Certainly it shows in his sculpture, and helps place the appearance of the most active of the horses sometime after the early eighties (cf. Figs. 60-61, 64-65, 66, 68). Eadweard Muybridge's studies were series of photographs of trotting and running horses taken sequentially, and they first appeared in France on 14 December 1878 in *La Nature* as illustrations to an article on Muybridge by Gaston Tissandier, editor of the magazine and an important photographic amateur.[76] This article was almost certainly read by Degas, since the notation, "Journal: La Nature Victor Masson (année 1878)" appears in notebook 23.[77] A month later, on 25 January 1879, Muybridge's results were given more popular publication in an article in *L'Illustration* by Colonel Duhousset, which was, however, illustrated with line drawings,[78] and by February two sets of the original photographs had been sent by Muybridge to Paris.[79] On 19 April of the same year *L'Illustration* offered its readers a zootrope with rolls made from reductions of the Muybridge pictures so that the original movement could be reconstituted.[80] Muybridge himself visited Paris in 1881 and 1882, and presented his photographs at receptions arranged by Marey, Meissonier, and the *Union*

[75] Paul Valéry, *Degas, danse, dessin* (Paris 1938), p. 70.

[76] Gaston Tissandier, "Les Allures du cheval représentées par la photographie instantanée," *La Nature*, 14 December 1878, pp. 23-26. Tissandier reproduced photographs of horses walking, galloping, and trotting. The 1881 *Globe* article on Muybridge, said by Rewald and others to be the first appearance of the photographs of the trot in France, had no illustrations of any kind (cf. Harlan Hamilton, "'Les Allures du cheval' Eadweard Muybridge's Contribution to the Motion Picture," *Film Comment*, Fall 1969, pp. 16-35).

[77] Notebook 23 (Reff 1878-1879), p. 81. Victor Masson et fils was a Paris bookseller. That the notation refers to the Tissandier article and

not to one on horse motion published two months earlier by Marey is suggested by the fact that the Marey material had already been partly published in a book in 1874, and Degas could have had earlier access to it there.

[78] Duhousset, "Reproduction instantanée," pp. 58-59.

[79] Letter from Eadweard Muybridge to the editor of *La Nature*, published in *La Nature*, 22 March 1879, p. 246. Muybridge also mentions that his agent in France, M. Brandon, had for sale the equipment necessary to take such photographs.

[80] "Prime offerte aux abonnés de l'Illustration," *L'Illustration*, 19 April 1879, p. 260. The notice is accompanied by an illustration of the zootrope.

21

artistique.[81] The audience at the former included Helmholtz and Nadar, and in each case Muybridge projected moving images from a variation of the zootrope that he had devised. Thus, Degas' first exposure to the Muybridge photographs in quantity was probably not before the spring of 1879, and events would have made him most conscious of them during the winter of 1881-1882.[82] In any case, since he always required

[81] See "The Devil," "La photographie instantanée," *Le Globe*, 27 September 1881, p. 2, and Gaston Tissandier, "Les Photographies instantanées de M. Muybridge," *La Nature*, 1 April 1882, pp. 276-277, for these and the following facts. For the history of Muybridge's experiments and their publication, their relationship to the art of Degas, and Degas' involvement with photography in general, cf. especially Aaron Scharf, *Art and Photography* (Baltimore 1969), Van Deren Coke, *The Painter and the Photograph* (Albuquerque 1972), and *Eadweard Muybridge, The Stanford Years, 1872-1882*, the catalogue of an exhibition held at the Stanford University Museum of Art 7 October–4 December 1972, the E. B. Crocker Art Gallery, Sacramento, 16 December–14 January 1973, and the University of Southern California Galleries, 8 February–11 March 1973. All three were unfortunately unavailable to me at the time of my research.

[82] Studies of horse motion had, of course, been made much earlier, particularly by E. J. Marey in France. Marey's recording method was graphic rather than photographic, and had first been applied by him to the circulation of the blood in the early 1860s. In 1868 he published *Du Mouvement dans les fonctions de la vie*, based on a series of lectures he had given at the Collège de France devoted largely to muscular movement, followed in 1872 by "Des Allures du cheval, etudiées par la méthode graphique," *Comptes rendus hebdomidaires des séances de l'Académie des Sciences*, 4 November 1872, pp. 1115-1119. In 1873 there appeared *La Machine animale, locomotion terrestre et aérienne*, illus- trated with graphs of human and equine movement. Drawings extrapolated from the latter by Colonel Duhousset, as well as illustrations of well-known works of art showing horses in correct movement, were used by Marey in his article "Moteurs animés, expériences de physiologie graphique," published in *La Nature* on 5 October 1878, pp. 289-295 (a previous installment of the same article entirely devoted to describing measuring and recording mechanisms devised by Marey had appeared in *La Nature* on 28 September 1878, pp. 273-278). Marey later developed a photographic recording method somewhat different from Muybridge's, and continued to publish works on animal movement through the 1890s. Although Colonel Duhousset was the principal propagandist for animal motion studies in the late nineteenth century, he is today a shadowy and fascinating figure. He was particularly interested in animal representations in works of art and seems to have been a good friend of Meissonier, who was also passionately interested in the Muybridge photographs and made sculpture after them. As early as 1874 Duhousset had published a book on the physiology, proportions, and gaits of horses, with introductory letters from Gérôme and the sculptor Eugène Guillaume. In 1881 he wrote a critique of the horse pictures in the Salon of that year for Duranty's paper *La Vie moderne*, in which Degas had previously allowed his drawings to be used as illustrations, and in 1883 and 1884 he published a series of four articles entitled "Le Cheval dans l'art" in the *Gazette des beaux-arts*. During the 1890s Duhousset published various articles on the realistic representation of

time to study and absorb such influences, his work would not have shown the results of such exposure before the early 1880s. Following the principle of development from less to more movemented poses, one can assign the following horse sculpture to the years 1881-1890, in roughly the following order: *Draught Horse* (Fig. 59); *Horse with Head Lowered* (Fig. 63); *Horse Galloping* (Fig. 60); *Horse Galloping* (Fig. 64); *Horse Galloping, Feet Not Touching the Ground; Horse Trotting* (Fig. 62); *Horse Clearing an Obstacle* (Fig. 66); *Rearing Horse;* and *Prancing Horse.*[83]

It has generally been supposed that Degas began modelling the human figure considerably after he had begun sculpting horses. If, however, the assumption is correct that he began making sculpture only toward the mid-1870s, he must have used human as well as equine models almost from the start, since the *Little Dancer* of 1878 is certainly not his debut as a sculptor of the human figure. Unfortunately, few of the existing pieces seem to antedate the *Little Dancer,* but it is not unlikely that some or several such waxes disappeared due to structural weakness or rough handling during Degas' many moves. At least two, however, may be assigned to this early period, *Arabesque over the Right Leg* (Fig. 18) and *Dancer at Rest* (Fig. 21), both of them on stylistic grounds and the latter also because it seems to be a preliminary stage of the pose of the *Little Dancer.* Repetitions of somewhat the same poses which presuppose greater sculp-

horses and on horses as seen in Assyrian and Classical sculpture, etc. The culmination of his researches was the book *Le Cheval dans la nature et dans l'art* (Paris 1902). Among other people to interest themselves in animal movement was Emile Debost, who published his *Nouvelle étude du cheval,* subtitled "Cinésie équestre," in 1873. His particular interest was not in the accurate representation of movement but in movement as a function of life and in the harmony of different movements. The classicist Salomon Reinach, who knew both Duhousset and Meissonier, was also an amateur of equine movement, and in 1901 published the book *La Représentation du galop dans l'art ancien et moderne.*

[83] Scharf (op. cit., p. 160) suggests, not unconvincingly, that many of Degas' horse subjects showing an awareness of Muybridge's work date after the publication of *Animal Locomotion* in 1887. Two of the galloping horses (Rewald xiv [Fig. 64] and xvii) have jockeys, numbered xv and xviii respectively by Rewald. Rewald vii (Fig. 59) is the only draught horse among Degas' sculpture. Draught horses seem to have interested Degas much earlier, as there are sketches of them in notebooks 16, 12 and 27, all dated 1859-1860 by Reff, but none is of the type of the sculpted horse. Since the attitude of the sculpture is that of a horse pulling against a weight rather than of one hauling a load, it is possible that it may have been made about 1881 just after Degas had first become aware of Muybridge's photographs (cf. Van Deren Coke, *The Painter and the Photograph,* catalogue of an exhibition held at the Art Gallery, the University of New Mexico, in 1964, p. 15).

23

tural ability (Figs. 46, 47) probably date in the early 1880s after the *Little Dancer*. *Arabesque over the Right Leg, Left Arm in Line; The Bow* (Fig. 48); and *Dancer Ready to Dance* (Fig. 51), show certain stylistic similarities which suggest that they belong between the *Little Dancer* and *The Tub* during the mid-1880s. This seems also to have been the period in which Degas first explored the Spanish dance in sculpture, as well as in other media. A sketch of a hand holding a tambourine in notebook 5 (Reff 1879-1883)[84] may relate either to the sculpted *Dancer with Tambourine* or to the pastels known as *The Spanish Dancer* and *Dancer with a Tambourine* executed about 1882, but in any case the sculpture probably dates toward the middle 1880s, as would *The Spanish Dance* (Fig. 69).[85] A drawing of legs found in Degas' studio (Fig. 74) almost certainly is a study for the latter piece, since the notation at the bottom "du pied au nez 45c 1/4," gives almost its exact dimensions. The drawing is marked off with proportions, a preoccupation of Degas' that shows also in his notations relative to the *Little Dancer* and the relief, works of only a year or two earlier.[86] *Dancer Rubbing Her Knee* (Fig. 76) is clearly related in pose to two pastels (Lemoisne 817 and 818), one of which is dedicated as a wedding gift to Hortense Valpinçon, who was married in 1885. That fact and its style date it between 1885 and 1890, the years when Degas probably also produced *Dancer Fastening the String of Her Tights* (Fig. 84); *Grand Arabesque, First Time* (Fig. 87); *Grand Arabesque, Second Time* (Fig. 90); *Fourth Position Front* (Fig. 89); and *Grand Arabesque, Third Time* (Fig. 91). Since there are fewer relevant documents after 1890, the dates of the remaining pieces are considerably less certain and must, for the most part, be based on Degas' stylistic development toward freer modelling and more generalized forms. Certainly the seated figures, one of which

[84] Notebook 5, p. 5.

[85] There is a possibility that *Dancer with Tambourine* (Rewald xxxiv), the size and facture of which make an earlier date feasible, may relate to a ballet-pantomime called *La Fandango* written by Halévy, Meilhac, and Mérante and first produced in November 1877.

[86] Page 1 of notebook 2 is largely taken up with a list of measurements, as follows:

largeur des épaules	30ᶜ
du menton au sommet de la tête	18ᶜ
du genou (au milieu) au talon	43ᶜ
de la tête de l'épaule au bout des doigts	61ᶜ
du sol au coude (le bras pendant)	95ᶜ

These measurements are probably those of Marie Van Goethem, since they are in every case almost exactly one-third larger than the *Little Dancer* (the same measurements, taken from a bronze cast of the sculpture, are, respectively, 21 cm., 15.5 cm., 30 cm., 41 cm., and 63 cm.), although Reff believes they refer to the relief ("Sculpture" [B. 159], p. 285). The relief notation is that referred to on pages 16-17.

Thiébault-Sisson remembered seeing about 1900,[87] must almost all date during the first decade of this century.

There remain traces of a few lost pieces for which there are neither dates nor descriptions. The best known of these is the portrait bust of Degas' friend Zandomeneghi, of which Renoir asked Vollard, "Have you seen the extraordinary bust of Zandomeneghi! Degas always pretended that it was not finished to have an excuse to hide it. . . ."[88] Julius Meier-Graefe had also been told of the bust by a friend of Degas', possibly either Renoir or Vollard,[89] and from Arsène Alexandre we know that it was "life size."[90] Alexandre adds the most interesting detail of all, for in referring to the casting of the Degas sculpture he says that "Hébrard was not able to restore these *dijecti membra pictoris*," suggesting that at least fragments of the bust existed until after Degas' death in 1917. Another such portrait is hinted at in an undated letter from Degas to Madame Boulanger-Cavé in which he says, "I am at a sitting for the bust."[91] Whether this refers to one of the three busts of 1892, to a lost portrait of Madame Boulanger-Cavé herself, or to one of the portrait busts of Degas by Paul Paulin is unknown, and Degas' laconic reference remains the only hint of a possibly lost work. Finally, as some indication of the size of Degas' sculptural oeuvre and of the number of pieces of sculpture that survived him, there is the letter written by his friend and dealer Joseph Durand-Ruel to Royal Cortissoz, art critic of the *New York Tribune*, on 7 June 1919:

> It is quite correct that Degas has spent a good deal of time, not only in the later years of his life, but for the past thirty years, in modelling in clay. Thus, as far as I can remember, that is to say perhaps forty years, whenever I called on Degas, I was almost as sure to find him modelling clay as painting. Degas must have made an enormous number of clay or wax figures, but as he never took care of them—he never had them put in bronze—they always fell to pieces after a few years, and for that reason it is only the later ones that now exist.

[87] See p. 18. On the basis of style, one would place this figure at the very end of Degas' career but, lacking further documentary evidence, it must be given an earlier date because of the Thiébault-Sisson article.

[88] Vollard, *Renoir*, p. 88.

[89] Julius Meier-Graefe, *Degas* (tr. J. Holroyd-Reese, London 1923), p. 60.

[90] Alexandre, "Nouveaux aperçus" [B. 80], p. 169.

[91] Published by Reff, "Some Letters" [B. 8], p. 93. The comment reads "Je suis en séance de buste" in the original.

When I made the inventory of Degas' possessions, I found about 150 pieces scattered over his three floors in every possible place. Most of them were in pieces, some almost reduced to dust. We put apart all those that we thought might be seen, which was about one hundred, and we made an inventory of them. Out of these thirty are about valueless; thirty badly broken up and very sketchy; the remaining thirty are quite fine.[92]

While some of the 150 pieces found by Durand-Ruel may have been different fragments of the same work—*Seated Woman Wiping Her Left Hip* (Fig. 137) lacked its head when first found, for example[93]—there is no present indication of what happened to the uncast pieces, which account for half of those found in Degas' studio. Neither of the inventories mentioned in Durand-Ruel's letter seems now to exist, and the one posthumous studio inventory that does exist mentions only works on canvas and paper.[94] One is finally left with the realization that one now knows not merely a fraction of Degas' original work in sculpture, which must have numbered several hundred pieces, but slightly less than half of what existed immediately after the artist's death, and that there is no apparent way of recovering even a written record of what has been lost.

[92] This letter, the typescript of which is now in the Beinecke Library of Yale University, was printed in part by Cortissoz in his article "Degas" [B. 32].

[93] A photograph of it in this condition exists in the Durand-Ruel archives and was published by Borel, *Sculptures* [B. 114].

[94] Charles Durand-Ruel and Émile Gruet of the Galerie Durand-Ruel kindly discussed this matter with me and showed me the existing inventory.

2. EXHIBITION, CASTING, AND TECHNIQUE

THE *Little Dancer* (Fig. 26 and Color Plate) was not only the sole piece of sculpture that Degas exhibited, it was the only one of which there was a question of sale during his lifetime. Mr. and Mrs. Horace Havemeyer, who owned a great many works by Degas and who were advised by Mary Cassatt, saw the figure in Degas' studio and tried to buy it through Durand-Ruel.[1] Arrangements for its sale seem finally to have broken down because of the difficulty for Degas at that point of putting the wax in good condition. Immediately after the artist's death, however, Mary Cassatt suggested to Mrs. Havemeyer that she once again try to buy the *Little Dancer*, and negotiations for its purchase lasted three years while decisions were made as to what would become of it.[2] Mrs. Havemeyer finally rejected the idea of buying the statuette, and it was cast like the rest of the sculpture, but at a somewhat later date.[3]

Critical reaction to the *Little Dancer* upon its exhibition in 1881 was mixed but generally favorable and not nearly so shocked as many accounts suggest nor as the reaction of the wider public seems to have been. Several critics called the figure ugly, but almost all recognized its power and novelty. "C.E.," probably Charles Ephrussi, noted that it was "of a solid design, bold and penetrating, which shows with infinite shrewdness the person's intimate appearance and profession." He ended his review by saying, "Here is a genuinely new endeavor, an attempt at realism in sculpture. A vulgar artist would have made a doll of this dancer; M. Degas has made of it a strongly-flavored work of exact science in a truly original form."[4]

[1] Louisine W. Havemeyer, *Sixteen to Sixty, Memoirs of a Collector* (New York 1961), p. 255. There is also a reference to this intended purchase in the unpublished Cassatt-Havemeyer correspondence in a letter provisionally dated 1910.

[2] Details of these negotiations are contained in the unpublished Cassatt-Havemeyer correspondence beginning with a letter dated 2 October [1917] and extending through one dated 18 May 1920.

[3] The reasons for Mrs. Havemeyer's refusal to buy the *Little Dancer* are not clear. The unpublished Cassatt-Havemeyer correspondence suggests that the price may have been too high, but a letter from Mary Cassatt to Durand-Ruel hints at some unacceptable condition to the sale (Venturi, *Archives* [B. 10], v. II, p. 138).

[4] C. E., "Exposition" [B. 15], p. 126.

The critic of *Le Pays*, Paul de Charry, praised the "extraordinary form and realism" of the sculpture.[5] Paul Mantz, in a long and perceptive critique in *Le Temps*, too well known to need extensive quotation, referred to Degas as "the true, the only sculptor of the Impressionist Academy," and to the *Little Dancer* as having been "dictated by the spirit of a Baudelairean philosopher," concluding, "M. Degas is uncompromising. If he continues to make sculpture and if he maintains his style, he will have a small place in the history of the cruel arts."[6] The warmest and most prophetic review was written for the *Courrier du Soir* by Nina de Villars, who concluded,

> Around me they said: it's a doll. How difficult it is to accustom the public to look without anger at something it has not already seen the day before.
>
> But let the artist be reassured: the work that is misunderstood today will one day perhaps be in a museum looked upon with respect as the first formulation of a new art.[7]

That Degas was attempting something wholly new was also recognized and stressed by J.-K. Huysmans, who referred to the *Little Dancer* as "the only really modern attempt that I know in sculpture," and went so far as to say, "The fact is that, at the first blow, M. Degas has thrown over the traditions of sculpture as he has long since shaken off the conventions of painting."[8] Jules Claretie, who had seen the exhibition too early to include mention of the *Little Dancer* in his column for *Le Temps*, was careful to rewrite his appreciation in order to describe the figure, calling the face "unforgettable,"[9] and a month later he went out of his way to call attention to it in an article on Paul Renouard.[10] Those who wrote negatively of the work generally criticized its realism and imputed ugliness, and the most critical among them, Bertall, added a political twist. "We saw groups of adepts, nihilist men and women," he wrote, "gape with pleasure before this dancer and her muslin skirt. That, at least, is an innovation.

[5] De Charry, "Les Indépendants" [B. 18].

[6] Mantz, "Exposition" [B. 19], p. 3. The phrase used in the first quotation is "académie intransigeante," "intransigeant" being the general critical appellation for artists participating in the Impressionist exhibitions.

[7] De Villars, "Exposition" [B. 20].

[8] Huysmans, "L'Exposition" [B. 25], pp. 252 and 250. I have been unable to locate where this

article originally appeared, although a note prepared for the first edition of the book in 1883 says that its contents were written for *Le Voltaire* and *La Réforme*.

[9] Claretie, *La Vie* [B. 23], p. 150. The review of the Impressionist exhibition had originally appeared in *Le Temps* on 5 April 1881, p. 3.

[10] Claretie, "M. Paul Renouard et l'Opéra," *Gazette des beaux-arts*, May 1881, p. 436.

New horizons seem to open for costumers and milliners."[11] Henry Trianon urged that the *Little Dancer* be put "in a museum of zoology, of anthropology, of physiology . . . but in an art museum, come now!"[12] "Comtesse Louise," who went somewhat further by assuring her readers that the figure would be placed in the Musée Dupuytren, called it "a little fifteen year-old Nana, dressed as a dancer, before which imbeciles are enraptured."[13] Despite these caustic and, for the most part, misdirected criticisms, Degas had the satisfaction of knowing that the longest, most detailed reviews of his sculpture were written by critics who were at once enthusiastic and among the most respected of their profession. He must also have taken considerable solace in the fact that his fellow artists were impressed with his efforts. Jacques-Emile Blanche reported that Whistler, "carrying a bamboo maul-stick by way of a cane, uttered sharp cries and gesticulated in front of the case which enclosed the wax figurine,"[14] and Renoir praised the figure enthusiastically to Mary Cassatt, later calling Degas "a sculptor capable of rivalling the ancients."[15] Indeed, Jean Renoir reports that his father once said, "After Chartres I see but one sculptor . . . it's Degas."[16]

Although Degas never again exhibited his sculpture, he seems to have thought from time to time about having some of it cast, as he was constantly being urged to do by Bartholomé, whom he once addressed in a letter as, "My dear friend and perhaps founder."[17] Degas' model Pauline remembered his having spoken enviously of how often Bartholomé had plaster casts made from his work, and wishing that he too could do so:

> Oh, how I would also like to be able to have a molder come! But there's no end to my sculpture: nothing happens to me but accidents.

[11] Bertall, "Exposition" [B. 16], p. 1.

[12] Trianon, "Sixième exposition" [B. 21], p. 2.

[13] Comtesse Louise, "Lettres" [B. 22], p. 3. The Musée Dupuytren, founded by the French surgeon of that name, is a museum of pathological anatomy formerly housed in the remains of the refectory of the Cordeliers at the Ecole de Médecine.

[14] Jacques-Emile Blanche, *Propos de peintre: de David à Degas* (Paris 1919), v. I, p. 54.

[15] Ambroise Vollard, *La Vie et l'oeuvre de*

Pierre-Auguste Renoir (Paris 1919), p. 88. Renoir's comment to Mary Cassatt is referred to in the unpublished Cassatt-Havemeyer correspondence. For Renoir's repeated praise of the Degas sculpture, see also Venturi, *Archives* [B. 10], v. II, p. 137, and Jeanne Baudot, *Renoir, ses amis, ses modèles* (Paris 1949), pp. 39 and 102.

[16] Jean Renoir, *Renoir* (Paris 1962), p. 69.

[17] *Lettres* [B. 7], p. 127, letter CI.

But you have already had figures cast, remarked Pauline. In the case downstairs there is a statuette in exactly the same post as that which I am holding at the moment.

Ah yes, said Degas, I modelled it ten years ago. That's the last time the molder came here. . . .[18]

According to Lemoisne, after repeated exhortations by Henri Rivière and Bartholomé, Bartholomé "ended with permission to bring his molder to see him [Degas], and it's thanks to this insistence that some of these statuettes were able to be preserved for us."[19] In fact, there exist three plaster casts of pieces by Degas: *Dancer Looking at the Sole of Her Right Foot*; *Spanish Dance* (Fig. 73); and *Woman Rubbing Her Back with a Sponge, Torso* (Fig. 110). The first of these is probably the piece seen by Pauline, and the wax for it and for the *Spanish Dance* still exist (Fig. 99, 69). The *Torso* exists only in the plaster, however, and the original was no doubt destroyed in the casting process.[20] Lemoisne says that the casts were made "about 1900,"[21] a date confirmed by Pauline's recollections. They were probably taken by molders working for A.-A. Hébrard, Bartholomé's founder and the man who was later charged with casting Degas' sculpture in bronze. They are the only casts known to have been made during Degas' lifetime, except for the ill-fated attempt by Degas himself to cast the portrait of Hortense Valpinçon.

Almost immediately after the sculpture was discovered in Degas' studio at his death, the decision was taken to cast it in bronze.[22] Bartholomé's part in this decision and in the slight repairs that were undertaken is not clear, but was probably less than is sometimes claimed.[23] Rewald was told by a member of the Degas family that the heirs

[18] Michel, "Modèle" [B. 29], 16 February 1919, p. 628.

[19] Lemoisne, "Statuettes" [B. 31], p. 115. Casting his sculpture in bronze seems to have been too great a step for Degas, who is reported to have said of the idea, "C'est trop de responsabilité de laisser derrière soi quelque chose en bronze, cette matière qui est pour l'éternité" (Ambroise Vollard, *Degas* [Paris 1924], p. 112).

[20] Its destruction and certain peculiarities in the modelling suggest that it may have been clay.

[21] Lemoisne, "Statuettes" [B. 31], p. 115.

[22] By the late spring of 1918, Mary Cassatt was speaking of the forthcoming casting in her letters to Mrs. Havemeyer (unpublished Cassatt-Havemeyer correspondence), and the decision had undoubtedly been taken several months earlier.

[23] In 1918 Paul Gsell wrote that, "Bartholomé craignit qu'une bombe de gotha ne tombât sur le petit peuple de cire qu'avait engendré son ami. Il fit transporter ces fragiles chefs-d'oeuvre dans la cave du fondeur Hébrard" (Gsell, "Statuaire" [B. 28], p. 374). He had this information from Bartholomé himself, however, and it is still unclear how much Bartholomé exaggerated his own role in the casting, an affair which seems to have sparked egoism and passions from all

had been approached directly by Hébrard for authorization for the casting.[24] Be that as it may, Bartholomé was almost certainly the original contact between Degas and Hébrard, and would have been responsible for Hébrard's knowing of the sculpture.[25] Pending the end of the war the waxes were removed to Hébrard's basement, whether to the basement of the Galerie Hébrard at 8 rue Royale or to that of the foundry on the Avenue de Versailles is not entirely clear.[26] Immediately after the armistice, Hébrard began construction of a special studio for the casting and contacted his master founder, Albino Palazzolo, who had returned to his native Italy for the duration of hostilities.[27] On his arrival, Palazzolo's first job was to put the waxes in condition for casting, a job which involved strengthening the figures, removing unnecessarily protruding bits of armature, etc.[28] In general, the absolute minimum was done to assure the safety of the

involved. Certainly, Mary Cassatt believed that Bartholomé was out to aggrandize himself and wrote vituperatively of him to Mrs. Havemeyer (unpublished Cassatt-Havemeyer correspondence) and to Durand-Ruel (Venturi, *Archives* [B. 10], v. II, p. 137).

[24] Rewald, "Reply" [B. 104], p. 48.

[25] This distinction was claimed by Pierre Lalo for himself when he wrote, "Adrien Hébrard, qui connaissait par moi leur existence [i.e. of the waxes], avait eu l'heureuse fortune d'en acquérir la propriété . . ." (Pierre Lalo, "Degas" [B. 93], p. 404). This is almost certainly not so. Degas himself seems to have visited the Hébrard foundry several times, sometimes with Bartholomé and sometimes alone, to learn about technical matters and observe casting techniques. Adhémar ("Bronzes" [B. 130], p. 35) indicates that these visits took place after 1910, although Degas' awareness of the foundry must have dated to the time when he had the plaster casts made.

[26] Adhémar, "Bronzes" [B. 130], p. 35, suggests the latter; an unpublished letter from Dikran Kelekian to Mary Cassatt dated 5 August 1919 suggests the former (unpublished Cassatt-Havemeyer correspondence).

[27] That a special studio was built is clear from a letter dated 4 December 1918 from Jeanne

Fèvre to Mary Cassatt in the unpublished Cassatt-Havemeyer correspondence. Palazzolo's daughter, Mademoiselle Lydia Palazzolo, kindly showed me two undated letters to her father from Madame Serrière, director of the Galerie Hébrard, urging him to return to Paris at once for "delicate" work.

[28] Although both Gsell ("Statuaire" [B. 28], p. 374) and Madeleine Zillhardt ("Monsieur Degas" [B. 113], 2 September 1949, p. 4) maintained that Bartholomé repaired the waxes, a claim no doubt made to them by Bartholomé himself, the truth seems to be that "the preservation of these works is due entirely to [Palazzolo]" (Adhémar, "Bronzes" [B. 130], p. 70). Bartholomé also intimated that he had served a similar function forty years earlier for the *Little Dancer*, to which Lemoisne referred as "cette statue, que le maître Bartholomé se rappelle avoir opérée, la veille du vernissage, de quelques bouts de fers recalcitrants . . ." (Lemoisne, "Statuettes" [B. 31], pp. 111-112, repeated in Lemoisne, *Oeuvre* [B. 106], v. I, p. 128). This, however, is patently untrue since (1) the figure was not ready for the vernissage, (2) Bartholomé would probably just have met Degas in 1881, and (3) Bartholomé would not have had the technical competence to assist Degas with

figures during the mold-taking process.[29] The casting was probably begun toward the end of 1919[30] according to a variation of the *cire perdue* process, particularly well adapted to delicate work, that Palazzolo had learned in Italy. The process is described by Adhémar as follows:

> Palazzolo covered the figures with earth, then he enveloped the whole with a coat of plaster, then he removed the earth and poured in its place a specially prepared gelatine, which he then allowed to harden, thus obtaining a gelatin mould. He extracted the original wax figures unharmed and poured wax into the mold reinforcing it with a central core of sand. The duplicate wax figure, being expendable, was cast by the ordinary lost-wax method with the advantage that the resulting bronze cast could be compared with Degas' original wax and given the same tone and finish.[31]

Although the contract between Hébrard and the Degas heirs called for twenty-two casts of each piece of sculpture—one each for Hébrard and the heirs, and twenty for sale—"they [Hébrard, Palazzolo, and Bartholomé] decided to make a bronze master cast of each figurine,"[32] so there now exist twenty-three sets of the bronzes. Each cast

sculpture until well after 1887 (cf. Burollet, "Degas" [B. 158], p. 104). Louis Vauxcelles has suggested what was probably the true extent of Bartholomé's involvement in Degas' sculpture in maintaining that "Bartholomé—pas plus que Henri Rivière—malgré ce qu'on répète volontiers, n'eut de conseils à donner à son ami, sauf sans doute en ce qui concernait les armatures des maquettes" ("Degas" [B. 71], p. 2).

[29] The bronzes represent almost exactly the condition of the waxes as they were found in Degas' studio, except for such necessary repairs as the restoration of the head to *Seated Woman Wiping Her Left Hip* (Fig. 137), etc. The condition of the *Little Dancer* during this period is not clear. Lafond (*Degas* [B. 33], v. II, p. 66) claimed that the arms of the figure had fallen off, and there are indeed serious cracks below the left shoulder and at the right wrist which might lead one to this conclusion. Lemoisne, however, wrote that it was found in "bon état" ("Sta-

tuettes" [B. 31], p. 113), and Mary Cassatt, who had not seen the figure but had discussed it with Jeanne Fèvre, consistently wrote Mrs. Havemeyer that it was in perfect condition (unpublished Cassatt-Havemeyer correspondence), until told by Joseph Durand-Ruel that it was not. Durand-Ruel, however, may have been referring to its general unkemptness and not to any specific damage. Both Lydia Palazzolo and Arthur Beale of the Fogg Museum Conservation Department have expressed doubt that the arms could have fallen because of the structure of the armature, and Mr. Beale feels that the existing cracks are caused by shrinkage in the wax. Photographs of the *Little Dancer* probably taken in 1918 show it with the arms attached (Durand-Ruel archive).

[30] Cf. Rewald, *Works* [B. 98], p. 28.
[31] Adhémar, "Bronzes" [B. 130], p. 70.
[32] Ibid. What must be a preliminary version of the contract is now in the possession of

is stamped with the legend "cire perdue A. A. Hébrard" in relief, and incised with the signature "Degas" and with an Arabic number written as the numerator of a fraction the denominator of which is a letter indicating the set of which the piece is part. Since there were seventy-three pieces cast, the numbers run from one to seventy-three, and the letters from A to T for the twenty sets intended to be sold.[33] The set intended for the heirs bears the indication "Her D" in lieu of a letter,[34] that which served as master set bears the word "modèle," and the set intended for Hébrard bears no indication whatever except for the numerical marking, the signature, and the founders mark. Exactly how long the casting took is not certain, although Hébrard's original estimate that it would take one year for the molds to be made and one year for the casting seems to have been exceeded by a good deal.[35] Palazzolo remembered that the casting was not finished until 1932.[36] In any case, one complete set was ready for exhibition by 1921,[37] and the sculpture was steadily available from that date onward. As for the quality of the casts, one has the critical judgment of Thiébault-Sisson, who knew the waxes, à propos the 1921 exhibtion of the bronzes:

> It was a singularly delicate task to give bronze form to these fragile marvels while keeping their accents intact and rigorously abstaining from recourse to the intervention, often so treacherous, of the restorer. The founder acquitted himself of it to his glory. No trickery

Mademoiselle H. Nepveu-Degas. It specifies the number of casts to be made of each sculpture but not the number of pieces of sculpture involved, which was seventy-three. The *Schoolgirl* has had a shadowy history, and seems to have been cast originally in only a very small edition *hors série* for the Degas family (Rewald, *Works* [B. 98], p. 158, for this and the following facts). The wax came into the possession of Knoedler and Co., New York, in the middle 1950s, and in 1956 they ordered it cast in an edition of twenty, two unnumbered, the remainder numbered from three to twenty.

[33] Rewald says that in set A *The Bow* received the number 24 in lieu of 34, so that the set has two numbers 24 and no number 34. Pages 164-165 of his catalogue consist of a table correlating the numbers given the sculpture by the founders and those assigned by him.

[34] The mark "Her" appears on some casts in lieu of "Her D."

[35] This estimate is given in the letter from Jeanne Fèvre to Mary Cassatt referred to above (unpublished Cassatt-Havemeyer correspondence). Hébrard may have meant that one set would be finished after two years, as it was.

[36] Adhémar, "Bronzes" [B. 130], p. 35.

[37] *Exposition des sculptures de Degas*, catalogue referred to in note 34, chapter 1. The set exhibited was probably set A, which was that first shown in the United States in 1922 at the Grolier Club (see chapter 1, note 39), was subsequently purchased by Mrs. Havemeyer, and is now largely in the Metropolitan Museum.

distorts the figures. Nothing that was lacking was replaced; nothing incomplete was finished. They came out of the casting identical to the work itself as realized by Degas, and these seventy-two lost-wax casts are not merely faithful reconstitutions of the discoveries of style and movement made long before by the artist in waxes of various colors; thanks to glistening patinas, which, being due to natural oxidations, will never alter, they reproduce their colored aspect as well. In the slightest pieces these delicate and subtle harmonies add to the grace of the models and assure them a perpetuity of which the wax was incapable.[38]

The casting of the *Little Dancer* presented special problems and was not undertaken until at least well after the casting of the other pieces had been begun and possibly even after it had been finished.[39] Indeed, until 1920 it was uncertain whether the piece would be sold separately and never cast at all.[40] The process employed was somewhat more complicated than that used for the other sculpture, and involved making plaster casts from which molds for the secondary waxes were taken.[41] How many bronzes were made of the *Little Dancer* is not certain, although there were probably twenty-three, as with the other sculpture. At least some of the casts were set on wooden bases into which the signature "Degas" was burned, and the Hébrard cachet and that indicating the cast number were added to these bases.[42] The figures were dressed after the original by Jeanne Fèvre.[43] Although the complete casting undoubtedly took several years, at least one bronze had been finished by 1923, when it was shown in an exhibition at the Metropolitan Museum in New York.[44]

[38] Thiébault-Sisson, "Sculpteur" [B. 34].

[39] Cf. Vitry, "Sculptures" [B. 70], p. 126. The wax original had been exhibited at the time of the Hébrard show in 1921.

[40] See page 27. Mary Cassatt apparently tried to retard or prevent casting of the piece, hoping for its purchase by Mrs. Havemeyer (Venturi, *Archives* [B. 10], v. II, p. 138).

[41] A note in the archives of M. Knoedler and Co., New York, indicates that Palazzolo made two such plasters. One may be that now in the possession of Paul Mellon, although it is the opinion of Arthur Beale that this figure had no part in the casting process. The second is probably that now owned by the Joclyn Art Museum, Omaha, Nebraska.

[42] It is not clear whether all the casts of the *Little Dancer* originally had such bases. If they did, many have since been removed, complicating the identification of the number of casts made.

[43] Rewald, *Works* [B. 98], p. 144. The Louvre cast is an exception (cf. Pierre Michaut, "Immortalized in Sculpture," *Dance*, August 1954, p. 28).

[44] J. B., "Sculptures" [B. 48]. This was the first exhibition of a bronze of the *Little Dancer*.

Since the completion of its casting, the Degas sculpture has been dispersed to museums and private collections throughout the world. Complete, or almost complete, sets of seventy-three pieces are in the Louvre, the Ny Carlsberg Glyptotek, Copenhagen, the Museu de Arte, São Paulo, the Metropolitan Museum, New York, and the collection of the Hébrard heirs, who also own the plaster casts of *Dancer Looking at the Sole of Her Right Foot* and *Spanish Dance*.[45] The original waxes were said to have been lost in the casting, except for that of the *Little Dancer* which was believed to be in the Louvre,[46] until they were sold by the Hébrard heirs to Paul Mellon through Knoedler and Co., New York, in 1955.[47] Having been stored in a basement for more than twenty years between the casting and their sale, the waxes required a considerable amount of restoration; this was undertaken by Palazzolo before they were sent to the United States.[48] Mr. Mellon, who also acquired the plaster *Torso*, presented four of the waxes to the Louvre (*Horse Standing, Grand Arabesque* [Rewald XXXIX], *Fourth Position Front* [Rewald LV], and *Dancer Looking at the Sole of Her Right Foot* [Rewald LX]), and has the remaining sixty-four at his home near Washington.[49]

If the casting of Degas' sculpture was particularly difficult the fault was the artist's, for his methods were anything but orthodox. Although he seems to have cared about the condition of his sculpture to the point of keeping it in glass cases[50] and to have

[45] The Louvre owns set P (cf. 1931 Orangerie catalogue [B. 70], p. 130), the Ny Carlsberg Glyptotek set R (cf. Rostrup, "Samlingers" [B. 118], p. 6), the Metropolitan Museum set A (lacking Rewald XXIII and XXIV), and the Hébrard heirs the set marked "modèle." I have been unable to ascertain the number of the São Paulo set (cf. Bardi, *Brazil* [B. 136], pp. 262, 264-266).

[46] Rewald, *Works* (1944 edition [B. 98]), p. 16.

[47] Rewald, *Works* [B. 98], p. 158.

[48] This information was kindly given me by Lydia Palazzolo.

[49] The waxes of *Dancer Moving Forward* (Rewald XXVI), *Dancer Looking at the Sole of Her Right Foot* (Rewald IL), *Dancer Putting on

Her Stocking* (Rewald LVIII), and *Woman Getting out of the Bath* (Rewald LIX) are said by Rewald to have been destroyed in the casting. For the Louvre donation see Pradel, "Quatre cires" [B. 138].

[50] Almost every description of Degas' studio refers to sculpture, including the *Little Dancer* and plaster casts, carefully protected under glass vitrines. Cf. particulary Walter Sickert, "Degas," *Burlington Magazine*, November 1917, p. 184; the same author's "The Sculptor of Movement" [B. 45]; Michel, "Modèle" [B. 29], 1 February 1919, p. 464; Lafond, *Degas* [B. 33], v, II, p. 66; and Zillhardt, "Monsieur Degas" [B. 113], 2 September 1949, p. 4, and 9 September 1949, p. 5.

35

sought advice on technical problems, he wanted most to be able to work rapidly and to study and restudy his favorite poses. Vollard recalled:

> One day he said to me of a *Dancer* which was in its twentieth transformation:
>
> "This time I have it. One or two more short sittings and Hébrard (his founder) can come." The next day I found the dancer once again returned to the state of a ball of wax. Faced with my astonishment [Degas said]:
>
> "You think above all of what it was worth, Vollard, but if you had given me a hatful of diamonds my happiness would not have equalled that which I derived from demolishing [the figure] for the pleasure of starting over."[51]

Degas' habit of putting aside partly finished pieces with the intention of returning to them later meant that a good deal of his sculpture was neglected over long periods of time, and George Moore recorded seeing "much decaying sculpture" in his studio.[52] Even the pieces under glass were not entirely safe, witness Madeleine Zillhardt's recollection of "maquettes falling to pieces in their glass cases. . . ."[53] This deterioration was due partly to Degas' flexible armatures, which were generally made of multi-strand wire, sometimes over hemp, secured to a rigid metal rod attached to a wooden base.[54] Although the armatures themselves caused no difficulty, the fact that they allowed easy movement of the figures built up over them meant that they promoted eventual cracking, particularly at joints. Nor did the way in which Degas used his modelling materials help the stability of his figures. Most of his sculpture is executed in wax and plastilene,

[51] Vollard, *Degas*, pp. 112-113. This and the anecdote about not casting the sculpture in bronze are repeated with slight variations in Vollard's *Souvenirs d'un marchand de tableaux* (Paris 1937), p. 303, and *En écoutant Cézanne, Degas, Renoir* (Paris 1938), p. 134.

[52] Moore, "Degas" [B. 24], p. 416. Concerning Degas' habit of putting pieces aside for later work, see Michel, "Modèle" [B. 29], 1 February 1919, pp. 471-472.

[53] Zillhardt, "Souvenirs" [B. 66], p. 100.

[54] Movable armatures had also been used by Barye (Théophile Silvestre, "Barye," *Histoire des artistes vivants*, Paris 1856, pp. 204-205), and Moreau modelled one of his figures over an

articulated wooden lay figure (Ragnar von Holten, "Gustave Moreau sculpteur," *Revue des arts*, no. 4-5, 1959, p. 209). In this connection, Luc-Benoist has said of Barye's figures, "Pour les rendre plus souples, plus facilement modifiables, il avait supprimé l'armature interne, il l'avait rendue extérieure. Il pouvait ainsi transformer les poses, allonger, tordre les muscles de ses bêtes qui étaient maintenues en place de l'extérieur par un système de fils tendus au milieu d'une cage" (*La Sculpture romantique*, Paris 1928?, p. 152). Degas used an analogous armature for *Arabesque over the Right Leg* (Fig. 46).

usually in combination.[55] In many of the figures, the materials seem so inextricably mixed as to suggest that Degas kept a tub into which he emptied his used materials and from which he drew to create new figures. While this method and his movable armatures gave Degas the rapid, flexible system he desired, the mixture of materials with different drying rates probably encouraged cracking, and certain discolorations in the figures may be due to leeching of the oil in the plastilene by the wax. Uneven coloration may also result in part from differences in color between the wax and the plastilene, and in part from darkening caused by light or settling dust.[56] For his portraits Degas used clay which built bulk form easily and rapidly, but was friable and must have been relatively unsympathetic to him since it had to be kept constantly damp. It can be assumed that more pieces in clay have been lost than in other materials; those that remain, however, are now in fairly stable condition.[57] Degas seems never to have created directly in plaster.

The problem of preservation inherent in the nature of Degas' materials was complicated by his habit of introducing into his sculpture what Pierre Lalo has called, "the strangest materials: corks, matches, sponges, or cloth plugs. . . ."[58] The corks he used with increasing frequency to create bulk rapidly or to fill out a mass of wax that would otherwise have been structurally unsupportable.[59] They caused serious problems by working their way to the surface, leaving holes in the sculpture. The model Pauline remembered Degas lamenting on one such occasion:

"Must I be such a fool as to have put corks in this figure! Imbecile that I am, with my mania for wanting to save a few pennies! Look at the back completely ruined! . . ."

She [Pauline] knew that at the first opportunity he would put the bits of cork back so as not to have to use too much plastilene, the price of which he judged excessive. And when, because of having pushed the arm or the leg forward or backward, one of these

[55] *Dancer Fastening the String of Her Tights* (Fig. 84), *Grand Arabesque* (Rewald xl), and *The Masseuse* (Fig. 139) seem to be all plastilene, whereas *Grand Arabesque* (Rewald xxxvi) seems to be plastilene over a wax base. Something appears mixed material may be due to subsequent restoration. For these and most of the technical details concerning the sculpture I am indebted to Arthur Beale.

[56] This darkening occurs mainly on the tops of the figures.

[57] A crack around the face of the large portrait of Mademoiselle Salle suggests that it may have come off at some point, and even now small pieces of clay seem to be working themselves loose.

[58] Lalo, "Degas" [b. 93], p. 404.

[59] The latter is the case with the skirt of *Dressed Dancer at Rest*.

round bits reappeared at the surface at a place where he least expected it, he would begin his lamentations again. . . .[60]

As for matches, Degas seems to have used them as props for figures with inadequate armatures. Bartholomé, always aware of the structural deficiencies of his friend's sculpture, noted that "if an arm is out of balance and in danger of falling, he puts a bit of match in it! In this way he has lost things extremely beautiful in their movement, but he doesn't care; it's distressing!"[61] Although real sponges may have been used by Degas in several of his bathing figures, only two of those that remain show evidence of such an addition. The plaster *Torso* almost certainly held a sponge in its right hand originally, and the figure in *The Tub* seems still to do so. Finally, the cloth in which Degas dressed some of his figures has itself been subject to deterioration but has otherwise not affected the waxes. In the case of the dressed jockey (Fig. 64)[62] and all but the skirt and hair ribbon of the *Little Dancer*, this cloth has been protected by a coating of wax which also helps integrate it with the figure of which it is part.[63] Wax also protects and in-

[60] Michel, "Modèle" [B. 29], 16 February 1919, p. 623.

[61] Jeanniot, "Souvenirs" [B. 79], 1 November 1933, p. 300.

[62] One jockey (Fig. 64) is dressed in a cap and racing costume of real cloth which may originally have been brightly colored in the manner of racing silks. It sits on a piece of cloth which serves as a saddle cloth over the back of the horse. A fabric pattern impressed in the wax on the back of another galloping horse (Rewald VI) suggests that it, too, may originally have had such a cloth and perhaps also a rider.

[63] Rewald says that Degas "dressed the statuette originally in a linen bodice, which he later covered almost entirely with wax" (*Works* [B. 98], p. 144). That the ribbed-silk bodice was waxed from the outset, however, is apparent from Huysmans' description of it as "un blanc corsage dont l'étoffe est pétrie de cire" (Huysmans, "Exposition" [B. 25], p. 251). The same treatment was given the pinkish ballet slippers, made in a coarse material that resembles linen, but not the skirt, made of two different kinds of

gauze. There is some doubt as to the number, color, and placement of the ribbons originally adorning the *Little Dancer*. Almost certainly the pigtail was tied with a broad pale green satin ribbon (Huysmans, ibid.; de Villars, "Exposition" [B. 20], p. 2), as it still is. Mantz' statement that the *Dancer* had "un ruban bleu à la ceinture" is probably an inaccuracy resulting from faulty recollection of the green ribbon tied low on the pigtail. Huysmans' reference to the "cou raide, cerclé d'un ruban porreau," suggests that there may have been a neck ribbon, although such ribbons seem to have been uncommon in reality and the ones Degas introduced into his paintings were usually black. If such a ribbon existed, Degas must have removed it as it would probably not have come free of the wax of its own accord. There is no present indication on the wax that there was such a ribbon, although there still exists a small ribbed-silk ribbon used to tie the hair above the large ribbon and partially concealed in the braiding. If this had been more obvious originally it might have been remembered as a neck ribbon. The

tegrates the wig, probably of horsehair, of the *Dancer*.[64] The other foreign materials that Degas added to his sculpture—the lead tub and plaster-soaked rags of the reclining bather and the bright green pottery inkwell used as a tub in *Woman Washing Her Left Leg* (Figs. 92, 131)—have caused no problems either to the condition of the sculpture or in the casting.

probability is that in all essential details the *Little Dancer* is the same today as it was in 1881.

[64] The name "Mme Cusset cheveux des poupée 119-r-St Denis" occurs in notebook 2, and it is presumably she, listed in the 1880 Didot-Bottin *Almanach* as a "fabr[icante] de perruques pour poupées," who made the wig. One wonders whether the "Cassanet, fabr[icant] de poupées habillées" at the same address may have had something to do with the dressing of the *Dancer*.

3. THE PLACE OF DEGAS' SCULPTURE IN HIS OEUVRE

THE NATURAL assumption that Degas conceived and used his sculptures as maquettes for his paintings and pastels, as Poussin and others were said to have done before him, was made almost the moment the figures became known and it has persisted.[1] As early as March 1919 *Vanity Fair* reported that "Degas was in the habit of making wax models for the figures in his better known canvases,"[2] and at the time of the Hébrard exhibition Arsène Alexandre coupled Degas and Meissonier as two artists who "devoted themselves to these materializations of their pictorial thought, to copy them or to be inspired by them at their ease before the canvas, palette in hand."[3] The situation is complicated by the fact that Degas does seem to have used articulated wooden lay figures of horses to study various poses, and may even have had a life-sized stuffed horse in his studio.[4]

[1] Lemoisne, assuming that all Degas' figures of horses were modelled before the death of Cuvelier in 1871, states that they were subsequently used as models for paintings, although he does not suggest that they were made for that purpose (Lemoisne, "Statuettes" [B. 31], p. 111). Comparing Degas' method with that of Tintoretto and Poussin, Hugo Troendle does make such a suggestion in "Tradition" [B. 60], p. 244.

[2] "Sculptor" [B. 30], p. 50. The valueless text and captions of this page of photographs of the sculpture cannot alter the fact that it was the first publication of the waxes in this country and the second anywhere in the world.

[3] Alexandre, "Sculptures" [B. 35]. For the Meissonier figures, which were used as studies for paintings, see chapter 6, note 9.

[4] Of a visit to Degas' studio, Vollard reported that "Degas avait pris sur une tablette un petit cheval de bois: Lorsque je reviens du champ de courses, voilà mes modèles; comment pourrait-on faire tourner comme on veut dans la lumière des chevaux vrais?" (Ambroise Vollard, *Degas*, Paris 1924, p. 58). He later wrote that John Lewis Brown had remembered Degas using "des petits chevaux de bois pour modèles" (Ambroise Vollard, *Souvenirs d'un Marchand de tableaux*, Paris 1937, p. 41; the English edition mentions among the contents of Degas' studio 'little wooden horses with which the artist composed his pictures of race-courses,' p. 178). The stuffed horse was first mentioned by Gustave Coquiot, who referred to a "cheval-mannequin grandeur nature" in Degas' studio (Gustave Coquiot, *Degas*, Paris 1924, p. 36; Coquiot repeated this reference in "Degas," *Des Gloires déboulonnées*, Paris n.d., p. 78). Coquiot's "cheval-mannequin" is presumably the same horse referred to by Louisine Havemeyer, who wrote that "the moths had eaten their way into the very entrails of the horse which had served [Degas] as a model" (Louisine W. Havemeyer, *Sixteen to Sixty, Memoirs of a Collector*, New York 1961, p. 247). It is strange that no other writer has mentioned this striking dummy.

Since in his complex working method Degas drew on materials and ideas from an almost infinite variety of sources it is not impossible that his sculpture did at times serve toward the creation of works in other media. There is no indication, however, that this was the motive for its creation, either initially or at any later time. Indeed, it is perfectly clear that the sculpture was an end in itself worked on for the problems it alone presented, and that, in a very real sense, it was the logical culmination of various earlier trends in Degas' art. To understand this, and the place of the sculpture in Degas' total oeuvre, it is helpful to review his development as a painter and draftsman.

Degas' conventional early training had accustomed him to attempting pictures in which sculpturally-conceived figures were set into elaborate perspective constructions and performed, in general, heroic actions. The *Semiramis* of about 1860 is such a picture (Fig. 1), with elaborate views down, out, and to the side that would have daunted even an older and more academic artist. That it and, indeed, all the large multi-figure compositions of these early years, remained unfinished is an indication not only of the complexity of the spatial problems Degas set himself, but of his ultimate lack of interest in creating vast stages on which his figures could play out their scenes as well as in the detailed finish necessary to make such stages convincing. Of particular interest is the way in which the *Semiramis* figures are conceived as if they were a carved relief. Not only is Degas interested in their palpability, but he has arranged them in a clear horizontal progression that dictates the shape of the entire composition, placing the principal figures in pure profile, the isocephalic cluster of background figures in full face, and the two attendant women in three-quarter view, linking the other two groups and suggesting movement. Their position between the background group and the foreground figures already hints at the curious effect of a single motion seen in successive stages that Degas was to exploit in his later work.[5] As Degas' art developed during the 1860s under the impact of Manet's modernism, his pictorial spaces became shallower, his color flatter and darker, and his views of figures increasingly close. The number of figures in his compositions was drastically reduced, and Degas turned from approximations of Salon machines to portraiture, evincing continuing interest in the three-dimensionality of the human body. The Bellelli family portrait, begun even before the *Semiramis*, already shows the start of this development in that its represented space is extremely shallow

[5] There are two types of this successive effect. In one, a single pose is seen from several points of view; this is generally exploited in drawings in which the poses overlap. In the other, several successive poses are seen separately; this is usually exploited in painting or pastel, or the poses are combined to imply a single motion, as in the sculpture.

41

and its figures stand out clearly against the background. In order not to close its space entirely, Degas included part of a doorway at the left and a mirror at the right, and used a recessive blue ground. The mirror, a device used by Degas more than once again, helps create spatial ambiguity, at once asserting surface and giving depth, as Manet was to discover in his *Bar at the Folies Bergère*. The contorted poses which increasingly interested Degas and which play such an important role in the *Medieval War Scenes*, exploit somewhat the same ambiguity. Since they could not be read as profiles such poses tended to establish depth, but since they were easy to move around as shapes the relationships of which were dictated more by compositional demands than by naturalistic necessity, a procedure usually used in relation to the picture surface, they could simultaneously be used to emphasize flatness.

Thus, Degas sought from the outset to flatten his compositions as much as possible while maintaining sufficient pictorial space to accommodate the bulk of his figures. He tried various devices, such as the window in the double portrait of himself and de Valernes, to relieve the increasing pressures, both coloristic and spatial, that his backgrounds put on his figures, but there is no doubt that those backgrounds constantly threatened to push the figures out of their compositions. To overcome this, Degas began using diagonal arrangements, as in the 1873 *Pedicure* and many of the ballet rehearsal pictures, and sharp upward or downward views, as in *Miss LaLa at the Cirque Fernando*. These devices functioned, like his contorted poses, both to create pictorial space and to flatten it. They also tended to subvert conventional directionality, a tendency that Degas promoted by reversing normal drawing procedure. "I repeat to myself every morning," he wrote to Henry Lerolle, "that one must draw from bottom to top, beginning with the feet, that the form is far better drawn upwards than downwards. . . ."[6] More effectively, he found ways of exerting counterpressure on his figures from the picture plane inward, largely by using lighter and more intense colors and a more broken and obvious facture. These devices were united when, during the 1880s, he turned almost exclusively to pastel as his major pictorial medium, for the colored strokes of the chalk at once defined three-dimensional volume and held that volume to the surface on which it was represented (cf. Fig. 124). By this time, local color, perspective devices, and the planar recession suggested by conventional draftsmanship were no longer necessary to Degas' synthetic art, which managed to compress space to almost total flatness

<hr>

[6] *Lettres* [B. 7], p. 219.

while maintaining the palpability of the human figure. If Degas' early compositions were relieflike in that they presented sculpturally conceived figures arranged parallel to the picture plane, his later ones touched a far more advanced and significant concept of relief in using the very means by which three-dimensional bulk was achieved to hold it to a two-dimensional surface. "The last groups of dancers that he executed in pastel are already sculpture," wrote Paul Gsell. "They are bas-reliefs. The light, very simple and clear, makes the poses stand out. The fragments that are massed with force by the lighting and the color balance harmoniously. After having been a meticulous analysis, the art of Degas became an audacious synthesis."[7] Most important, it was a synthesis achieved through the constant effort to accommodate the sculptural tendency of his art.

If Degas' compositions were always partly concerned with sculptural matters and his figures constantly threatening to take on a three-dimensional life of their own, his draftsmanship was no less indicative of this important trend in his art. The commonly repeated suggestion that Degas was a supreme neoclassical draftsman is not entirely borne out by the evidence. Probably the purest neoclassical line is that of Flaxman's prints, and its main function is to separate and to define. It is thus an edge, a dividing line that makes represented figures stand apart from their backgrounds and from one another. Ingres' line, which derives from this tradition, functions in addition as something beautiful in itself. By recording the continuous graceful gesture of the artist's hand it embodies a kind of abstract beauty, an effect that eventually generated its own academicism, inspiring the detached and flowing line of the *art nouveau*. Despite his academic student efforts and his lifelong admiration for Ingres, this is not the kind of line that Degas developed. In his early years he tried to use line neoclassically as edge, but he was never consistently successful in doing so nor does he ever seem to have been interested in creating a beautiful line in the Ingresque sense. In the drawing of the Donatello *David* (Fig. 33), for example, Degas' line functions reasonably well as contour but almost not at all as a thing of abstract beauty: the lines of the right arm and hip are broken and angular, and that of the right thigh is too flat to be more than basically descriptive. Even more telling is the comparison of the line defining the right leg of the figure in the *Jephtha* study (Fig. 83) with the same line in Ingres' *St. Symphorien* study (Fig. 82). Ingres has clearly made certain anatomical sacrifices to the continuity of his line, while Degas has not only refrained from doing so but has empha-

[7] Gsell, "Statuaire" [B. 28], p. 375. As early as 1902 Arsène Alexandre had called Degas "un peintre sculptural" ("La Collection de M. Henri Rouart," *Les Arts*, June 1902, p. 8).

sized discontinuity to make the figure more forceful. This awkwardness, which recurs in Degas' drawing, indicates as profound a lack of interest in accepted linear functions as he seems to have had in accepted painterly finish. The line that interested Degas, and which he cultivated from the start but allowed to flower only later in his career, is suggested by About's definition of drawing as "the art of simulating relief on a plane surface by means of light and shadow. It is not, as they think in college and some other places, the art of tracing a contour with the point of a nail."[8] It is a connecting rather than a separating line, and as used by Degas it at once unites compositions across their surfaces and implies a back to objects and figures of which only the fronts are seen, suggesting not merely the abbreviated three-dimensionality of a relief but complete three-dimensional identity. In the words of R. R. Tatlock, Degas "would not see a contour as if it were the edge and the end of something."[9] In his early work, Degas had two methods of developing this connecting line and suggesting continuity beyond and behind the viewer's field of vision. The first was by thickening or smudging the line to suppress its function as edge. The second was by shading, by drawing not single lines but parallel groups of lines that suggested sculptural roundness. To help these devices along and to make his figures stand out more forcefully, Degas frequently used watercolor wash or toned paper. Gradually, he deveolped entire compositions by shading, which then lost its identity as shading in the normal sense and became tonality. Degas' use of pastel not only made such facture easier, but it gave color a generative role to play, enabling Degas at once to draw, color, and develop his compositions tonally. The subtly encrusted shadings of the late pastels simultaneously dealt with the planar pictorial surface in terms of its totality and created palpable three-dimensional form. Although Degas never surrendered this two-dimensional creation of three-dimensional form, the increasing flatness of his pictorial compositions dictated that three-dimensional problems be explored in their own terms. "Do you believe that the *trompe-l'oeil* of drawing and painting can satisfy me?" he asked.[10] His sculpture, then, is not merely an excursion into an accessory medium, but the necessary realization of his major artistic concern, the culmination of the principal tendency of his art.

Degas' sculpture is so intimately related to his previous work in other media, and grows so naturally out of that work, that it is not unfair to consider it as a kind of three-dimensional drawing. Janneau has observed that Degas "modelled wax directly, before

[8] Edmond About, *Nos Artistes au Salon de 1857* (Paris 1858), p. 11.

[9] Tatlock, "Sculptures" [B. 47], p. 150.

[10] Quoted in Thiébault-Sisson, "Sculpteur" [B. 34].

nature, as he drew; under his intelligent thumb the ductile material substituted itself for a sketchbook,"[11] and Degas himself is reported to have said, "I make drawings in wax."[12] It must be understood, however, in what sense this is meant, for it in no way implies that Degas' sculpture is linear in either conception or execution. Quite the contrary, since volume and its reconciliation to a flat surface was one of his principal two-dimensional concerns, the sculpture was conceived volumetrically from the outset. Although one may occasionally talk of outline in the early pieces,[13] or of the drawing of the face of the *Little Dancer*, meaning line in its more conventional sense,[14] the quality Degas developed in his draftsmanship is also that which he developed in his sculpture. The fact that his drawing consistently connected parts of his compositions, that it implied both two and three-dimensional continuity, and that, in a very real sense, it had no end, is the exact equivalent of the continuity of his sculptural surfaces. Outline is of no importance whatever after Degas' initial sculptural efforts, and everything in his figures is contrived to connect and to lead around. As Degas said of his work in another medium, "everything in a picture is the interrelationships."[15] Beginning with an armature, which might be considered a linear drawing, he proceeded to thicken it until its identity as line had disappeared. That thickening was constantly calculated in terms of relationships of parts to one another and of solids to voids, and the effect is precisely that attributed to Rodin by Paul Adam:

> Bodies do not at all stop at the exact limit of their lines. Even though that line exists and manifests itself in absolute purity, it always emanates a little of the being beyond its limits; and this projection, materially inappreciable but able to be felt, gives his figures the virtue of uniting with space. The philosophy of his pantheistic art always renounces the clear separation of the individual and his surroundings.[16]

Similarly, Degas' predilection for rising configurations in his drawing is exactly what was expressed most fully in his sculpture, and the extreme cropping and distortion of the late drawings to create a highly charged series of pictorial elements on the surface of the page is analogous to Degas' sculptural distortions, which create a highly charged

[11] Janneau, "Sculptures" [B. 37], p. 353.
[12] Romanelli and Van Vorst, "Degas" [B. 78], p. 56.
[13] See chapter 6, p. 76.
[14] Renoir made such a reference (Ambroise Vollard, *La Vie et l'oeuvre de Pierre-Auguste Renoir*, Paris 1919, p. 88).

[15] Quoted in Daniel Halévy, *My Friend Degas* (tr. Mina Curtiss, Middletown 1964), p. 53. The original French of this statement is "Tout est relation dans un tableau" (Daniel Halévy, *Degas parle*, Paris 1960, p. 63).
[16] Paul Adam, "Les Salons de 1896: la sculpture," *Gazette des beaux-arts*, June 1896, p. 451.

series of spatial experiences. For these reasons, Jorge Romero Brest saw in Degas, as opposed to Renoir, Gauguin, and even Daumier, Matisse, and Picasso, "an authentic sculptor. All of which is demonstrated simply by the power he had to breathe life into a volume and the space surrounding it without having recourse either to surface values or to linear patterns."[17]

There is, finally, the question of the extent to which Degas' sculpture is finished. While it is perfectly clear that his sculpture is the product of some of the most highly developed spatial thinking of the nineteenth century, it is also clear that only certain pieces are finished in a conventional sense. This roughness of facture and apparent incompleteness is quite different from the unfinished quality of many of Rodin's figures, which is an intended part of their power and total effect. The roughness of much of Degas' sculpture has partly to do with his habit of putting figures aside for later work, and even of demolishing certain pieces with which he was unsatisfied,[18] and, thus, with his characteristic perfectionism. On a more important level, it relates to the general development of his art at the end of his life. For the last twenty years of his career the sketch, both drawn and sculpted, became increasingly important to Degas. With the triumph of modernism over his earlier academic ambitions, he seems to have realized that highly finished works by academic artists frequently suffered from extreme lifelessness, and that their best works were often their sketches, informed by a meticulously trained talent but executed quickly enough to preserve some vital spark. Insofar as Degas had trained himself academically he shared this tendency, and must have realized the superiority of his rapidly executed works to his more ambitious paintings. From the 1870s and, particularly, the 1880s he was able to accept that realization fully, and to devote himself almost entirely to making sketches, but in such a way and at such a level that his works became finished and fully-developed artistic statements in the most meaningful sense. His sculpture, thus, is a series of sketches in only a limited way. More important, it is the artistic equal of his work in other media and represents, in a real sense, the culmination of all his work.[19] In the words of Wilhelm Hausenstein, "The sculpture of Degas fully realizes his painting."[20]

[17] Brest, "Peintres sculpteurs" [B. 124], p. 283. This article is the most perceptive statement of Degas' relationship to sculptural modernism.

[18] Vollard, Degas, pp. 112-113. The story is repeated with some variation in Souvenirs, p. 303.

[19] This fact reinforces the probability that, in the case of similar works in different media, the two-dimensional versions precede the three-dimensional.

[20] Hausenstein, "Degas" [B. 42], p. 275. André Levinson has also seen that "les figures peintes par Degas sont d'essence moins picturale que plastique" ([B. 116], pp. 10-15).

4. ASPECTS OF FRENCH NINETEENTH-CENTURY SCULPTURAL STYLE

THE RELATIONSHIP of Degas' sculpture to French nineteenth-century sculpture in general is a complex and subtle one. In a superficial sense, that relationship is almost nonexistent. Degas exhibited only one of his figures once, his sculpture was unknown to all but those who had access to his studio, and he produced no school, nor was he deeply involved with the more prominent sculptors of his time. Even after his death, his sculpture was slow in coming to public attention and slower still in being seen for what it was. "No one gathered the heritage of Degas."[1] In a more profound sense, Degas' sculpture is a very paradigm of the development of sculpture in nineteenth-century France, a résumé of its statements and problems, its exploratory and conservative strains. Degas' vast artistic and intellectual awareness and the conflicting strains in his personality were the bases on which this syncretism was built. Using a conventional method and avant-garde means he arrived at results that were far in advance of their time. To understand how he brought this about it is necessary to see with some clarity the progress of sculpture in France between Canova and Rosso.

French nineteenth-century sculpture was fed by three streams. The first of these—what might be called the grand tradition in sculpture—was that flowing from Michelangelo which specialized in the production of monumental and architectural sculpture. It dealt principally in the heroic human figure and used as material whatever it found most appropriate; marble, stone, or bronze. Many of the best sculptors of the century belonged to or were touched by this tradition. Rude and Rodin were its direct legatees. Carpeaux belonged entirely to it at the outset of his career, although his sculpture evolved under the influence of other ideas. David d'Angers and Barye, although they each belonged more completely to somewhat different traditions, show the effects of it. So also does Fremiet, while Etex, Cortot, and a host of lesser architectural sculptors tried their best to be worthy of it. In general, it was this tradition which inspired the sculptors commissioned to execute the seemingly infinite number of architectural decorative schemes generated under Napoleon III. Such architectural projects were perforce relieflike

[1] Bazin, "Sculpteur" [B. 72], p. 301.

47

—witness Rude's heroic composition for the Arc de Triomphe, Barye's groups for the Louvre, or the various figures commissioned for the Madeleine—but the Michelangelesque tradition also produced more fully three-dimensional work, as Fremiet's animal groups suggest. The tradition was, finally, one without a body of theoretical or critical writing to support it and existed solely because of the direct influence of Michelangelo's greatness on the sculptors who followed him. As the century progressed, it was increasingly undermined by newer and less purely sculptural ideas.

Taking the nude human form as its ideal and marble as its material, the Academic neoclassical strain in French nineteenth-century sculpture was far and away the most prominent and powerful sculptural influence throughout the century. It had roots well back in the eighteenth century, but came into particular prominence during the Revolution and the Empire when the political links it was able to establish and its relevance to the rush of contemporary archaeological discoveries gave it official sanction. Canova, who is in many important respects a French sculptor—not least in that he allowed himself to be guided by Quatremère de Quincy—was the David of sculptural neoclassicism, the most rigorous and consistent, as well as the greatest, of its exponents. His followers, Bosio, Bartolini, and others, worked principally in France, and it was there, even more than in Italy or Germany, that neoclassical style held sway. For the first quarter of the nineteenth century neoclassical sculptural style, directly under Canova's influence, was relatively pure. That is to say, a clear attempt was made to imitate the then known masterworks of Classical sculpture both in style and intent. The desired end was a static and idealized nude, noble in gesture and execution, conceived essentially as a relief with a certain number of viewing points of which that from directly in front was the most important. There are, nevertheless, constant and important Rococo reminiscences in the sculpture of these years which suggest that the sculptors' native inclinations and immediate artistic heritage fought against total commitment to the style and conceptions favored by neoclassical theorists. Canova's *Cupid and Psyche*, for example, or Bosio's group of Louis XVI with an angel for the Chapelle Expiatoire, have affinities with prerevolutionary eighteenth-century style, and the complexity of their respective movements is greater than neoclassical purism would have desired. This mixture of ideas was typical of the development of academic classicism for the remainder of the nineteenth century, and relatively few sculptors produced the unadulterated classical imitations that the theorists preferred. During the second third

48

of the century, neoclassicism was infected with a sort of debased naturalism that resulted in sculpture such as Clésinger's *Woman Bitten by a Snake,* exhibited at the Salon of 1847. This work, with its highly finished marble surface and its interest in the human nude, now seems the direct academic descendant of earlier neoclassical style, although it struck contemporaries as "one of the most charming statues of the modern school"[2] because of the naturalistic rendering of the flesh. The combination of a highly polished and abstracting style with exact representation of naturalistic detail gave much nineteenth-century sculpture the air of lascivious eroticism with which it has often been charged.[3] Some sculptors, such as Pradier, maintained a more orthodox neoclassical style or combined neoclassicism with a monumental style, but the middle of the century saw a softening in the rendering of flesh and materials that persisted at least until the appearance of Falguière's *Diana* and is ultimately responsible for the *mollesse* of much *fin de siècle* academic sculpture. During the last part of the century the marriage of academic neoclassicism and naturalism tended to give way to an amalgamation of academic neoclassicism and a Rococo revival, producing a great deal of small sculpture in which vestiges of neoclassical style could be seen, but in which the scale and interest in anecdote reflected the spirit of the previous century. As with its earlier interest in naturalism, academicism was here taking over sculptural ideas first explored by more experimental sculptors and turning them to its own ends. Jean Selz has called this development, "an evolution which consisted in replacing one academicism with another academicism. The type of subjects could change, but the techniques of execution always remained subject to the rules of the *école.*"[4] Both Dalou and Carrier-Belleuse were caught up in this eighteenth-century current, and it affected the early Rodin. It is, however, increasingly difficult to generalize the development of sculpture in nineteenth-century France, for the host of revival styles absorbed by academicism—Gothic, Florentine Renaissance, etc. —ended in a pervading and confusing eclecticism.[5] As has been noted, better academic sculptors tended to marry neoclassical style, or its remains, to other interests in the hope of infusing their work with life. The vast number of minor talents, on the other hand, turned out the work of increasingly archaeological exactitude and glacial lifelessness that

[2] Théophile Thoré, *Salons de T. Thoré: 1844, 1845, 1846, 1847, 1848* (Paris 1868), p. 534.

[3] As early as 1834 Gabriel Laviron had commented that "le genre érotique triomphe à l'Institut" (Gabriel Laviron, *Le Salon de 1834,* Paris 1834, p. 129).

[4] Selz, *Découverte* [B. 146], p. 77.

[5] This heterodoxy was noted about 1890 by Louis Gonse in *La Sculpture et la gravure au XIXe siècle* (Paris n.d.), p. 98.

has given to nineteenth-century sculpture the bad name from which it has suffered since the turn of the century.

While the statue—the standing human figure, nude or draped *à l'antique*—was the highest form for which an academic sculptor could strive, it was precisely to the problem of producing pieces of sculpture that were not statues that the third of the major sculptural currents of the nineteenth century addressed itself. That third current, derived from the Berninesque tradition of the French eighteenth century, was the nineteenth century's major continuous, as opposed to manufactured, link with a sculptural heritage.[6] Throughout the century it was allied with a series of abortive efforts to create a contemporary sculptural vocabulary and, as might be expected, it opposed almost everything academic sculptors and theorists stood for. It demanded, first of all, a sculpture conceived in three dimensions rather than one resulting from pictorial training and modes of vision. Writing of Pradier's *Three Graces* in the 1831 Salon, Gustave Planche noted:

> . . . he is mistaken, like Canova, in following in the composition a graphic idea rather than a sculptural one. Now in my opinion this is a grave fault, and cannot but have unfortunate results; it is never without considerable detriment that one mistakes the special attributes of the instrument one employs. Look how, almost at the same time, the Italian sculptor paints in marble and the head of the last French school, David, sculpts on canvas. Both, for different reasons, have merited the celebrity which they have earned; both have worked with perseverance to regenerate the art they profess. But the way on which they set out was a false and violent way; each of them dead, no one has walked there further.[7]

Fifteen years later, Baudelaire, in one of his few statements on sculpture, called the art "vague and unseizable, because it shows too many faces at once," and pointed

[6] Bernini was the *bête noir* of the academic theorists. Speaking of him, Louis and René Ménard wrote, "C'est à lui que se rattache toute la théorie de la décadance dans l'art moderne" (Louis and René Ménard, *De la Sculpture antique et moderne*, Paris 1867, p. 271). It should be noted that for the nineteenth century the word *moderne* in relation to sculpture invariably had the connotation given it by Guizot, who wrote that "quand je dis *modernes*, j'entends notre histoire depuis plusieurs siècles, tout ce qui se rattache aux idées, à la religion, aux moeurs que nous pouvons appeler les nôtres" (Guizot, *Etudes sur les beaux-arts en général*, Paris 1852, p. 67).

[7] Gustave Planche, *Etudes sur l'école française* (Paris 1855), v. I, p. 83.

out that "it is in vain that the sculptor strives to find a unique point of view; the viewer, who turns around the figure, can choose a hundred different points of view. . . ."[8] Several artists turned to small-scale sculpture as an aid to the expression of multiple points of view—one thinks at once of Dantan's caricatures and Barye's animals—and such sculpture became one of the hallmarks of the sculptural avant-garde. "Talent is not measured by the dimension of the work . . . ," Alexandre Decamps noted in 1835.[9] Since small sculpture was most easily worked in clay or wax, and since these materials preserved the freshness of the sculptor's spontaneous idea, they were those most valued and most used by the Romantic sculptors.[10] Wax, particularly, was usually preliminary to dark-finished bronze which made bulk form stand out at the expense of detail and tended to suppress views in favor of more diffuse, all-around effects. As subjects, Romantic sculpture preferred fugitive or movemented actions,[11] exotic themes or those with social overtones, and animals. The latter were the Romantic sculptural theme par excellence. As landscape helped ease the way toward a new painting, animal sculpture showed sculptural possibilities beyond those of the human figure. "The animal sculptors are the landscapists of the statuary art," wrote Edmond About in 1855,[12] and the Goncourts pointed out in the same context that "nature takes the place of man. That is the evolution of modern art."[13] When it did deal with the human figure, Romantic sculpture demanded that it be dressed in contemporary clothing. Writing of the *Larrey*

[8] Charles Baudelaire, "Salon de 1846," *Curiosités esthétiques, l'art romantique et autres oeuvres critiques* (Paris 1962), p. 188. Later, in 1859, Baudelaire suggested how the confusion in which contemporary sculpture found itself allowed the triumph of academicism. "Quand le but naturel d'un art est méconnu," he wrote, "il est naturel d'appeler à son secours tous les moyens étrangers à cet art" (op. cit., p. 388).

[9] Alexandre D. . . . [Decamps], *La Musée, revue du Salon de 1835* (Paris 1834 [sic]), p. 72.

[10] The denomination Romantic is used here to distinguish sculptors belonging to what I have called the third current in nineteenth-century sculpture. This follows Luc-Benoist's *La Sculpture romantique* (Paris 1928?), the best book on any aspect of French nineteenth-century sculpture yet published. As for the use of wax as a sculptural material, Benoist notes that it was Barye who "a remis la cire à la mode" (p. 151).

[11] Maxime du Camp identified movement with Romanticism in speaking of German literature. "Ce qu'on a appelé en France le mouvement romantique," he wrote, "c'est-à-dire le retour à la verité et à la nature . . . remplaca la déclamation par la passion, la facture conventionnelle par le mouvement, le pathos par la pensée" (*Les Beaux-Arts à l'exposition universelle de 1855*, Paris 1855, p. 349).

[12] Edmond About, *Voyage à travers l'exposition des beaux-arts* (Paris 1855), p. 251. Maxime du Camp also drew this parallel at the same time (op. cit., p. 272).

[13] Edmond and Jules de Goncourt, "Salon de 1852," *Etudes d'art* (Paris 1893), p. 139.

of David d'Angers, Planche noted, "the model must be dressed in the sculptor's work as he was dressed [in life]; the costume must give the date of the subject."[14]

A sculpture approximating that sought by the Romantics had already been developed in the late eighteenth century, but it had been discredited not so much artistically as morally and politically by what was considered its frivolousness and by its connection with the ancien régime. The survival of sculptors such as Clodion, however, guaranteed the continuation of the style into the early nineteenth century, and sculptors seeking a vital tradition on which to base their work realized that it was to be found not in appeals to the remote past but in the work of their immediate predecessors. Small scale, freshness of facture made possible by rapidly worked materials, the exploration of spatial relationships, and use of anecdotal subjects drawn from contemporary life were all to be found in the figures of Clodion and his contemporaries, as well as in the widely disseminated Sèvres groups.[15] It was precisely these things which attracted Romantic sculptors to the vitality of the Berninesque tradition, and in a very real sense the constant attempt of avant-garde sculpture during the nineteenth century was to rediscover the eighteenth-century tradition that had been placed under such heavy attack by the Academy. In the words of Luc-Benoist, "The further one goes, the more one will realize that in sculpture, as in all the other domains of art, Romanticism has merely renewed the tradition of the eighteenth century; that, moreover, is why it could go far."[16]

Although there had been attempts to find an alternative to sculptural neoclassicism as early as the figures of Géricault, which married the eighteenth-century tradition to that of Michelangelo, sculpture was almost ten years behind painting in making any significant public statement of a Romantic esthetic. There had been tentatives toward a new sculpture in the 1820s, with the medievalizing works of Félicie de Fauveau, and in 1831, when Duseigneur's *Roland furieux*, its subject taken from the proto-Romantic Ariosto, broke with academic canon by presenting a reclining bronze figure in a contorted pose, but it was not until the Salon of 1833 that a large group of innovative sculpture was shown, arousing short-lived hopes that sculpture had at last come abreast of painting. In

[14] Gustave Planche, *Portraits d'artistes* (Paris 1853), v. II, p. 117.

[15] Arsène Houssaye referred to Clodion in 1860 as "ce sculpteur dédaigné comme les Watteau et les Boucher, mais dont les moindres terres cuites payeraient aujourd'hui beaucoup de marbres académiques" ("Sculpteurs du XVIIIe siècle. Clodion—les duMont—Le Moine—Slodtz," *L'Artiste*, 1 April 1860, nouvelle série, v. IX, no. 6, p. 121).

[16] Luc-Benoist, op. cit., p. 12.

52

that year, Rude exhibited his *Neapolitan Fisherboy* and Duret his *Neapolitan Dancer*, both spatial conceptions of great sophistication which represented adolescent figures in uncanonical poses. Etex and Préault made their debuts in the same Salon, the former with his *Cain*, the most interesting work he ever executed and a forerunner of the Carpeaux *Ugolino* and the Rodin *Thinker*. Préault had the temerity to exhibit a broadly worked group of *Two Poor Women* and a relief called *Begging* of which critics noticed the Dantesque inspiration, calling its protagonist a "proletarian Ugolino."[17] Barye's animals, including a life-sized lion, clearly established him, as André Michel was later to write, as "the great sculptor of that generation and of the century."[18] These works, together with others by Moine and Triqueti and a gladiator by Daumas, assure the 1833 Salon of a place in the history of nineteenth-century sculpture equivalent to that held by the Salons of 1819 and the early 1820s in the history of painting. Unfortunately, its influence was of much shorter duration, largely because of inescapable Academic control of sculptural education and sculptors' dependence on official commissions, both conditions that were aggravated by the technical unwieldiness of sculptural production. Etex, Moine, and Duret soon fell into wholly conventional mannerisms, while Préault maintained himself by executing public commissions in a more acceptable style than that in which he continued to work his small sculpture and funerary reliefs.[19] Barye, who never compromised his style, was forced to resort to widespread marketing of small bronzes for home decoration and at best was able to execute works as elaborate as the table centerpiece commissioned by the Duc d'Orleans. Although the Salon of 1834 contained works by Barye, Maindron, and Duseigneur, as well as Préault's sensational relief *The Slaughter*, and the Salon of 1839 was enhanced by Maindron's *Valleda*, its subject taken from Chateaubriand, subsequent Salons saw progressively less Romantic sculpture, and both Barye and Préault later were to keep from, or be kept from, exhibiting for extended periods of time. In 1846, Théophile Thoré noted that "our age is not

[17] Jean Reynaud, "Coup d'oeil sur l'exposition de sculpture," *Revue encyclopédique*, March 1833, p. 580.

[18] André Michel, "Exposition universelle de 1889: la sculpture," *Gazette des beaux-arts*, September 1889, p. 302.

[19] The importance of funerary sculpture to the nineteenth century has not yet been fully explored. Not only was death among the most important of Romantic themes, but in private tomb commissions the artist was generally freer than usual to explore creatively and hence made works of higher than usual quality. As Luc-Benoist has written, "La vraie, la belle statuaire contemporaine gît sur les tombeaux. La mort est un thème romantique par excellence; il fut réussi" (op. cit., p. 114).

one of marble and bronze,"[20] and by 1859 Ernest Chesneau was able to write of the Salon:

> I looked around me in vain; I found no strong nature, no spirit artistic enough, audacious enough, to follow courageously its own inspiration. Everyone borrows, either from the Greeks, the Romans, the Italians, the Flemish, or the moderns; everyone imitates, everyone copies. . . . Here then, counting carefully and adding Messieurs Corot and Clésinger, are the only artists of these times. They are six: Messieurs Delacroix, Corot and Courbet for painting; Préault, Barye, and Clésinger for sculpture: six individualities.[21]

If painting was at that very moment producing a Manet and preparing a Cézanne, a Monet and a Van Gogh, sculpture was producing but few works of real importance, and those few were destined to remain largely unexhibited and without issue. Departing from Dantan, whose caricatures had been beloved of the Romantics,[22] and probably from Préault, Daumier created a small body of sculpture that was among the best of the nineteenth century, but it was left to Degas to create a sculptural oeuvre that represented a significant realization of Romantic sculptural principles. Beyond that, the latter half of the nineteenth century saw a steady fragmentation of sculptural effort, most of it highly conventional, and a single great sculptor—Rodin—who arrived at the sort of style sought after by the Romantics only at the very end of his life.

[20] Théophile Thoré, op. cit., p. 191.

[21] Ernest Chesneau, *Salon de 1859* (Paris n.d.), p. 167. This article, worded slightly differently, originally appeared in the *Revue des races latines* for 1859, pp. 11-168. An even more pointed and extended statement on the state of mid-century sculpture was made by Maxime du Camp, op. cit., pp. 17-19.

[22] This popularity had depressed Clésinger on his arrival in Paris in 1838. "Ce qui m'attriste profondément," he wrote, "c'est que . . . tout le monde, même les gens de goût, courent plutôt après une hideuse charge de Dantan qu'après quelque chose de beau et de grandiose" (quoted by A. Estignard in *Clésinger, sa vie, ses oeuvres*, Paris 1900, p. 23).

5. DEGAS AND THE CLASSICAL TRADITION

IF DEGAS remained largely untouched by the Michelangelesque strain in nineteenth-century sculpture, he was heavily under the formative influence of the neoclassical, particularly in the first decade of his career. From his earliest student days he submitted to a rigorously academic discipline of copying earlier works of art. His interests covered the entire range of art history—Egypt, Assyria, the Orient, Classical Greece and Rome, and Renaissance Italy—but, in the best neoclassical manner, centered on Greek and Renaissance works.[1] Reff has identified 580 such copies, drawn and painted, and suggests that many more are as yet unidentified and others probably lost.[2] Indeed, Degas' output was so large that Reff is able to suggest convincingly that "his activity throughout the 1850s may be described as essentially that of a copyist."[3] As good academic practice dictated, Degas copied from plaster casts of Classical sculpture, particularly that from the Acropolis (Figs. 67, 79, 112), and he was able to acquire for himself reduced plaster casts of well-known works to which to refer when he was back in Paris, but his extensive travels also allowed him liberal access to Classical originals, or works then thought to be original, in the museums of Naples, Rome, and Florence.[4] One of the notebooks used by Degas in 1856 is almost entirely given over to notes and sketches

[1] For Degas' copies, see Theodore Reff, "Degas's Copies of Older Art," *Burlington Magazine*, June 1963, pp. 241-251; "New Light on Degas's Copies," *Burlington Magazine*, June 1964, pp. 250-259; "Addenda on Degas's Copies," *Burlington Magazine*, June 1965, pp. 320, 323; "Further Thoughts on Degas's Copies," *Burlington Magazine*, September 1971, pp. 534-541. Also John Walker, "Degas et les maîtres anciens," *Gazette des beaux-arts*, September 1933, pp. 173-185, and Gerhard Fries, "Degas et les maîtres," *Art de France*, 1964, pp. 252-259.

[2] Reff articles cited in note 1 above. There are also a good many tracings, some of which are pasted into the unpublished notebooks.

Many of the copies in the notebooks were first identified by Jean Sutherland Boggs in "Notebooks" [B. 5]. See also Reff "Chronology" [B. 6].

[3] Reff, "New Light," p. 250.

[4] Copies after Classical originals and plasters are noted in the articles cited in note 1. For the plaster casts owned by Degas himself, see chapter 1. Such casts were, and still are, sold through the salesrooms of museums as well as commercially. For those sold by the Louvre, see the *Catalogue des plâtres qui se trouvent au bureau de vente du moulage, Palais du Louvre* (Paris 1864). Plaster casts appear in the paintings *Coin d'atelier* (Lemoisne 9, 1855-1860) and *L'Amateur* (Lemoisne 138, dated 1866).

made from Classical sculpture in Rome and Naples. That he intended to use these sketches in his own work is indicated by his note: "Sculpture museum on the Capitoline —first floor gallery—Old woman holding an urn and weeping—I must make something of it later."[5] That he also saw and used Greek terra-cottas is indicated by a note in notebook 11 (Reff 1856): "In the terra-cottas at the Louvre there are in the cases several bits of bas relief which would be very suitable."[6] This thorough training, based on his deep attraction to the technical accomplishment of academic style, left a store of images in Degas' extraordinary visual memory which constituted an iconographical warehouse on which he drew to the end of his life.[7]

Although Degas' awareness of the repertoire of Classical poses manifested itself in his painting and drawing from the beginning, the poses he used at first were often static and relieflike, as in those he chose for the *Semiramis* (Fig. 1).[8] Gradually, more movemented poses appeared, and by the time he began making sculpture Degas' interest was in the most active of the Classical poses, or in the liveliest treatment of conventional poses, usually represented by small bronzes and terra-cottas. Such small figures seem to have legitimized his academic interests for him at a moment when he was giving himself increasingly to the modernism of Manet and the avant-garde, and they formed a bridge for him between a desired perfection of Classical form and the vitality that so often seemed lacking in academic work.[9] It is, thus, no surprise that the poses of small-scale

[5] Louvre notebook *RF* 5634, p. 1 verso.

[6] Notebook 11, p. 36. A sketch of a small Classical terra-cotta is published in Lemoisne, *Oeuvre* [B. 106], v. II, p. 18, no. 39.

[7] Fairly late in life Degas spoke with admiration to Robert de Montesquiou of Moreau's reception room, filled with copies after the old masters (Robert de Montesquiou, "Preface" to the catalogue of the *Exposition Gustave Moreau* held at the Galerie Georges Petit, Paris, in May 1906). On Degas' own use of images derived from his youthful copying, see especially Reff, "New Light," pp. 256-257.

[8] Cf. Reff, "New Light," p. 256.

[9] Rodin also found vitality, and therefore a viable Classicism, in small Greek sculpture. In 1902 he wrote Clara Rilke of the " 'Tanagras', sources impérissables de vie," that he had seen in the Louvre (Rainer Maria Rilke, *Lettres 1900-1911*, H. Zylberberg and J. Nougayrol, Paris 1934, p. 54). That Tanagra figurines revitalized the Classical past for a nineteenth century surfeited, as it felt, with bloodless neoclassical copies, is clear from Duranty's statement that "leur apparition a été une *délivrance*" (Edmond Duranty, "Les Statuettes de Tanagra," *La Vie moderne*, 17 April 1879, p. 32), and from Eugène Véron's comments (*L'Esthétique*, Paris 1878, pp. 232-233) that "à coté de la sculpture religieuse et héroïque il exista presque de tout temps en Grèce un autre genre de sculpture, tout à fait différent, et qu'on pourrait appeler la *sculpture réaliste*. . . . Les monuments de ce genre de sculpture sont très nombreux. On en a découvert dans ces derniers temps des multitudes, des terres cuites principalment . . . dont

Classical sculpture, and of the major monuments that lay behind them, should appear in Degas' sculpture, nor that he should have taken up sculpture at precisely the moment the most generally popular Classical terra-cottas, the Tanagra figurines, first drew widespread attention.

Although small Greek terra-cottas had been known well before the first large cache of Tanagra figurines was uncovered in 1873,[10] it was the Tanagras that captured public attention. This was partly, no doubt, due to their high artistic quality and the vigor of their modelling, partly because they appeared at the moment when a flourishing academicism forced modernist artists to search for new and viable manifestations of the past, and partly because of their immediate and widespread dissemination. Not only were they at once visible in museums and dealers' shops, but they were exhibited in major expositions, including the Exposition Universelle of 1878,[11] and articles about them appeared throughout the 1870s.[12] Among the most indicative of those articles was that by Degas' friend Edmond Duranty in *La Vie moderne* for 17 April 1879, which made the connection between Tanagra figures and modern life explicit in the following terms: "They had at last finished that eternal bath for which, until then, all Greek statues seemed to be preparing themselves, and were dressed to go out. They came to us with hats, fans, pelisses, wrapped in cloaks, ready, in a word, to stroll on the Boulevard des Italiens, and there is even a family resemblance to be seen between them and the young Parisian ladies."[13] This naturalism, which Higgins sees as "the hallmark of the style" and "a real attempt to overcome the frontality to which sculpture and the minor arts were so long prone,"[14] would certainly have attracted Degas no less than the Classical

l'infinie diversité ne s'accorde guère avec les étroitesses de l'admiration académique et du code qu'elle prétend imposer à tous les arts au nom de l'idéal qu'elle a cru découvrir dans la sculpture grecque, et dans lequel elle a fini par l'emprisonner elle-même, sans égard pour les démentis que lui infligeaient les oeuvres de caractère tout opposé."

[10] Prosper Biardot's *Les Terres-cuites grecques funèbres* (2 v.) was published in Paris in 1872. For the discovery of the Tanagra figures, see R. A. Higgins, "The Discovery of Tanagra Statuettes," *Apollo*, October 1962, pp. 587-593.

[11] Cf. Oscar Rayet, "L'Art grec au Troca-déro," *Gazette des beaux-arts*, 1 August 1878, pp. 105-125; 1 September 1878, pp. 347-370, reprinted in *L'Art ancien à l'exposition de 1878* (Paris 1879), pp. 51-104. Also Henri Lechat, "Tanagra," *Gazette des beaux-arts*, 1 July 1893, pp. 5-16; 1 August 1893, pp. 122-139.

[12] Cf. Oscar Rayet, "Les Figurines de Tanagra au Musée du Louvre," *Gazette des beaux-arts*, April 1875, pp. 297-314; June 1875, pp. 551-558; July 1875, pp. 56-68.

[13] Duranty, op. cit., p. 32.

[14] R. A. Higgins, *Greek Terracottas* (London 1967), p. 97.

foundation on which the figures were built. Nor would his involvement with dancers, dating from the 1860s, have made him less susceptible to the charms of Greek terracottas. As Spire Blondel wrote of them in 1884, "one pose captured the artists who modelled these figurines, says M. Philippe Burty: it is that of the dancer, head and shoulders lightly thrown back, who thrusts her legs forward making the folds of her dress rustle; or else that of the woman getting out of her bath and wrapping herself shivering in a long and delicate wool robe."[15] The description could as well have been written of the sculpture of Degas.

That Degas was indeed involved with small Greek sculpture and not simply with the more monumental masterpieces he had copied in his youth is abundantly clear from two drawings dated 1884 and 1886, respectively (Figs. 56, 57).[16] The first is a portrait of Madame Henri Rouart contemplating a statuette that is almost certainly a Tanagra figure. The second is a standing portrait of Hélène Rouart *en Tanagra*, enveloped in a shawl and holding a palm fan. The connection between the two drawings, and the identification of the statuette as a Tanagra and the standing figure as Hélène Rouart, is made by a drawing in which both compositions are combined (Fig. 58).[17] It would have been through the Rouarts that Degas made extensive first-hand contact with Tanagra figurines, for they were collected by Alexis Rouart, whose etched portrait by Helleu shows him standing in front of a mantel on which several such figures are arranged.[18] Thus, Degas' youthful copying, which etched the major poses of Greek sculpture in his memory, and his clear awareness of terra-cotta figurines during the 1870s and 1880s, which bridged the philosophical gap between academic classicism and modernism for him, lay beneath his sculptural efforts from the beginning. Along with poses derived from his knowledge of Renaissance sculpture and of small bronzes, both Greek

[15] Spire Blondel, *L'Art intime et le goût en France* (Paris 1884), p. 18.

[16] It is also clear from the fact that when Degas wished to praise a Classical subject rendered by Daumier he said, ". . . c'est exprimé comme à Tanagra" (Jeanniot, "Souvenirs" [B. 79], 15 October 1933, p. 171).

[17] Jean Sutherland Boggs has noted these facts in *Portraits by Degas* (Berkeley 1962), p. 67. See also Boggs' "Mme. Henri Rouart and Hélène by Edgar Degas," Los Angeles County Museum, Art Division *Bulletin*, Spring 1956, pp. 13-17.

[18] Degas owned an impression of this print which was item 198 in the *Catalogue des estampes anciennes et modernes . . . composant la collection Edgar Degas* (Paris 1918). The Rouarts had owned Tanagra figurines from the moment they first appeared on the market (Paul-André Lemoisne, "Collection de M. Alexis Rouart," *Les Arts*, March 1908, p. 2).

and Renaissance, these facts influenced the iconography of almost his entire sculptural oeuvre.

Among the sculpted horses, it is principally the earliest that make direct reference to Classical and Renaissance sources, for as Degas became increasingly interested in equine movement and purely sculptural problems, he had recourse more and more to the poses, hidden from earlier artists, that were revealed to him by photography. What may be the earliest surviving horse (Fig. 2), which has clear affinities with the standing horse in the *Semiramis* (Fig. 1), is in a pose identical to one copied from a Classical relief in a student drawing (Fig. 5) that was later observed from life in a sketch in one of the Louvre notebooks (Fig. 4).[19] It is, thus, possible to see that from the very outset Degas was in the habit of choosing in life poses he had previously committed to memory from copying works of art. The *Horse Walking* (Fig. 7), while clearly taken from life, is in a pose close to one common in Classical and Renaissance monuments, notably Verrocchio's *Colleoni* (Fig. 8) and the St. Marco horses (Fig. 16).[20] Another, livelier version of the same pose (Fig. 15), mouth open and head tossed lightly to the side, seems directly related to the latter and recalls Gsell's comment that "by the pride of their carriage his thoroughbreds bring to mind the chargers that gambol on the frieze of the Parthenon, or the bronze horses of St. Mark's, or even the mount of Colleoni."[21] Even the later horses in active movement do not escape the influence of Degas' academic training, as a comparison of the *Horse Clearing an Obstacle* (Fig. 66) with an early drawing after a cast taken from the Parthenon frieze (Fig. 67) shows. It is, however, the early horses that exhibit Classical influence most directly and since there are few of them surviving and, indeed, relatively few Classical models on which they could draw, one must turn to the human figures to see Classical influence most actively at work on Degas.

Degas' sculpted dancing figures have regularly, seemingly subconsciously, evoked Classical comparisons from those who have written about them. Gsell wrote that "inevitably one thinks of the airy spirits to whom the coroplasts of Myrina gave flight";[22]

[19] Louvre notebook RF 5634 ter (Reff 1865-1867), p. 27.

[20] Degas' acquaintance with the Colleoni is attested by a drawing of the pedestal on page 35 of notebook 13 (Reff 1855-1856) labelled, "piédstal [sic] de la statue équestre de Colleoni à Venise par Alexandre Leopardo 1495," undoubtedly made from a print or photograph.

Curiously, he seems not to have drawn the Verrocchio itself.

[21] Gsell, "Statuaire" [B. 28], p. 378. Degas' thorough knowledge of the Parthenon sculpture is indicated by the number of copies listed by Reff.

[22] Ibid., p. 376.

Rivière that "very classic, Degas' statuettes recall the Greek dancers represented in the bas-reliefs of the best period";[23] and Degas himself is reported to have said that in using dancers for models he "purely and simply followed the Greek tradition, almost all antique statues representing movements and equilibriums of rhythmic dances."[24] The works themselves, particularly the earliest, give substance to these comments. *Arabesque over the Right Leg* (Fig. 18), while clearly modelled from a dancer, is so like a Classical Eros that Gsell first published it with the title "Cupid."[25] It brings to mind nothing so much as the small bronze Eros from the collection of the Comte de Caylus now in the Cabinet des Médailles of the Bibliothèque Nationale (Fig. 19), particularly in the fact that Degas has raised the arm and leg on the same side of the body, a fault of sculptural and naturalistic balance that he corrected in later versions of the same pose. The long line flowing along the left side of the body from the tips of the fingers to those of the toes also recalls the similar line in the Louvre's *Borghese Warrior* (Fig. 20), which Degas had drawn several times as a student,[26] and the general balance of the two figures is similar. A more static figure (Fig. 21) is almost directly copied from the pose of a small bronze of which Gustave Moreau owned a plaster cast (Fig. 22), and which Degas obviously knew. It is a pose he repeated and developed not only in other sculpted *Dancers at Rest*, but in pastels and drawings, and one which is clearly related to the *Little Dancer*.

While the *Little Dancer* itself (Figs. 23, 26 and Color Plate) is not directly related iconographically to Classical sculpture, it raises issues that were of great concern to academic and neoclassical theorists in the nineteenth century. It is as if Degas, rather than copying a Classical model, wanted to embody several important Classical principles in contemporary terms. The first of these has to do with proportion, always a preoccupation of academic teaching, for which the Classical canons were constantly being extrapolated from works of Greek sculpture. For Degas, correct proportion meant not simply faithfulness to the model—and it is entirely possible that he chose his models for their proportions—but a more orthodox concern for relationships in size among various parts of the body. Although the list of dimensions for the *Little Dancer* shows concern only that the proportions of his model be exactly transcribed to the sculpture,[27] there is a study for one of the relief figures on which Degas has noted how many heads go to make up

[23] Rivière, "Mr. Degas" [B. 82], p. 160.

[24] Henri Hertz, *Degas* (Paris 1920), p. 37.

[25] Gsell, "Statuaire" [B. 28], pp. 376, 378.

[26] Reff, "New Light," p. 258.

[27] Cf. chapter 1, note 86.

the length of one side of the body and how many fit between the waist and the foot of the other side (Fig. 43). In a similar sketch for the *Spanish Dance,* Degas seems to be trying to make the length of the torso equal to that of the legs (Fig. 74). Degas' concern for proportions, manifested as early as the first of the notebooks dating from 1853,[28] was clearly important to him all his life, as a model's unhappy experience with his measuring calipers in 1910 shows.[29] While he seems never to have developed a set of proportions that he applied systematically, nor even to have arrived at a set identical to those generally described as the Classical norm, he was more than usually concerned with what Charles Blanc described as "the fixed relationship of the limbs to each other and of each limb to the entire body in such a way that given the measurement of a single part, both the measurement of the other parts and that of the whole could be inferred from it."[30]

By far the most important of the academic concerns reflected in the *Little Dancer,* however, is that of polychromy. Throughout the nineteenth century, Romantic sculptors concentrated on ways to unify their work, in part by using monochrome materials that suppressed coloristic and textural differentiation, leaving polychromy to their more conventional confreres. From the moment the importance of colored sculpture was asserted at the beginning of the century until its great popularity during the 1880s and 1890s, polychromy was the prerogative of the Salons.[31] The first and greatest nineteenth-century statement of a sculptural esthetic based on the use of paint and different colored materials was Quatremère de Quincy's *Jupiter olympien,* published early in the century soon after archaeological findings confirmed that Greek sculpture was originally painted or constructed from various materials. Quatremère's book, the aim of which was to re-introduce the use of polychromy, was essentially a justificatory exposition of the history of polychromatic sculpture, and it stated its creed at the outset:

> The unity of a monochrome material, be it marble or bronze, never offered to art either that which captivates the senses to the same degree, nor that which charms the eyes

[28] Notebook 14 contains a good many notes on proportions, systems of measurement, etc. Boggs says that these are based on Jean Cousin's *Livre de portraiture* published in Paris in 1642 ("Notebooks" [B. 5], p. 166, note 7).

[29] Cf. chapter 1, note 69.

[30] Charles Blanc, *Grammaire des arts du dessin* (Paris 1867), p. 38.

[31] In 1892 Edmond Pottier noted that, "La grande nouveauté des Salons modernes est la polychromie" (Edmond Pottier, "Les Salons de 1892: la sculpture," *Gazette des beaux-arts,* July 1892, p. 26).

so much, as the varied spectacle of all the lavish ornaments on the thrones whereon sit those gods of gold and ivory.[32]

While the *Jupiter olympien* was clearly the first theoretical step toward the classical figures in silver and gold, mixed highly-colored marbles, and mixed metal and stone that peopled the Salons of the nineteenth century, not to mention the chryselephantine reconstructions made for aristocratic private consumption, it also stimulated a number of more modest efforts in painted plaster and colored wax. By the 1880s the public was seeing objects such as the tinted wax and paste plaques of Henri Cros which were visual proof of Spire Blondel's contention that "the art of wax sculpture, which is related to goldsmith's work and the miniature, is, when it is treated with care and delicacy, like a diminutive version of antique polychrome statuary."[33] Quatremère himself had pointed out that alongside the ancient chryselephantine monuments there had existed a strain of more popular polychromy:

> The method of using real fabric to fashion representations of statues found particular authority at Rome in the antique use of *imagines*, or family portraits, just as likenesses in wax and imitation draperies were made of famous people at their funerals.[34]

In the case of both major and minor polychromed works, it was a firm academic tenet that the color be native to the materials used, as specified by Blanc:

> One must, then, clearly distinguish . . . between natural polychromy and artificial polychromy. The one makes use of materials of which the indelible color is suitable for the requisite permanence of monumental works. The other, using ephemeral and changeable colors, applies that which passes to that which endures.[35]

[32] Quatremère de Quincy, *Jupiter olympien*, p. ix. Quatremère tried constantly to persuade Canova to make his sculpture more polychromatic either by textural variation or by the introduction of secondary materials.

[33] Spire Blondel, "Collections de M. Spitzer, les cires," *Gazette des beaux-arts*, 1881, v. II, p. 289. Blondel was one of the principal proponents of wax polychrome sculpture. His lengthy article "Les Modeleurs en cire," appeared in the *Gazette des beaux-arts* in May 1882, pp. 493-504; September 1882, pp. 259-272; and November 1882, pp. 429-439. Interest in wax sculpture seems to have been particularly high at this time. On 30 January 1878 Anatole de Montaiglon delivered a lecture at the *Union centrale* on the "Histoire de la sculpture en cire," and one reads constant references to the painted wax portrait bust in the Musée Wicar at Lille, then thought to be a Renaissance masterpiece, which Degas would certainly have known.

[34] Quatremère de Quincy, *Jupiter olympien*, p. 14.

[35] Blanc, op. cit., p. 461.

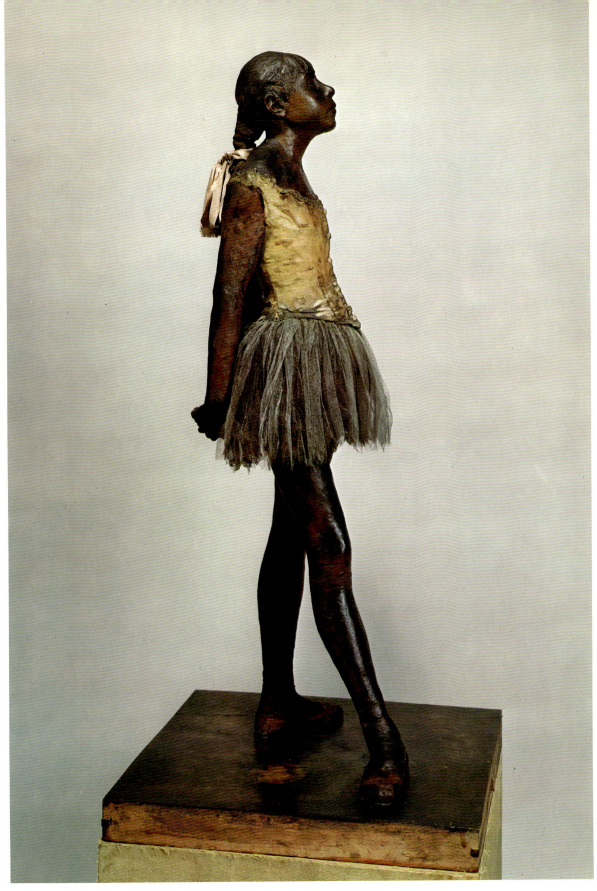

DEGAS, *Little Dancer* (clothed)

Thus, by creating a figure which incorporated not only real materials of different colors (pink, green, and two shades of white) but also widely varying textural effects (smooth satin, ribbed silk, and mesh gauze, among others), Degas dealt directly with one of the leading academic preoccupations of the nineteenth century, and one that was constantly being justified on the basis of its Classical antecedents.[36] Degas continued to experiment with colorism in his sculpture—*The Tub* (Fig. 92) incorporates white plaster-soaked rags, a dull gray lead tub, and a red-brown wax figure, and in the stooping bather (Fig. 131), a bright green pottery inkwell is added as a tub—and was the only sculptor of his century to do so successfully in modernist terms. Although many avant-garde critics attacked the generally unsuccessful sculptural polychromy of the Salons as unnatural,[37] sculptors themselves saw that such purely academic means could be used toward a wholly contemporary end. "We accept," wrote Emile Soldi in 1882, "all procedures which can widen the range of art, from the use of marble mixed with metals, so happily realized in the busts of M. Cordier, to the artistically combined use of real fabrics placed on a sculpture, like the dancer of M. Degas. Each time the attempt recurs in an artist's sensibility, it is necessary, it is useful, it is to the benefit of art."[38]

[36] Lemoisne referred to the material of the *Little Dancer* as "cire peinte et étoffe" ("Statuettes" [B. 31], p. 112), and Rewald says that Degas "intended to tint the wax to make it look even more lifelike" (*Works* [B. 98], p. 17), perhaps referring to Huysmans' allusion to its "tête peinte." Huysmans was probably speaking poetically of the general polychromatic effect, however, since no other writer mentioned paint or added color, which would have been contrary to the figure's esthetic effect. Having examined the wax closely, Arthur Beale believes that it was never painted or tinted.

[37] Writing of Clésinger's *Cleopatra before Caesar* in the Salon of 1869, Ernest Chesneau observed that "le démon de l'archéologie a tenté M. Clésinger qui a succombé, qui s'est donné a lui tout entier, cette fois, et sans réserve. Ces déformations monstrueuses de la beauté sont accomplies au nom de je ne sais quelle malsaine érudition" ("Salon de 1869. Sculpture. II," *Le Constitutionnel*, 18 May 1869, p. 3). The figure

was made of different colored marbles and enriched with gold jewelry and a gold and ivory lotus flower made by a prominent Parisian goldsmith.

[38] Emile Soldi, "La Sculpture au Salon de 1882," *La Nouvelle revue*, 15 June 1882, p. 925. Although Soldi exhibited regularly at the Salons, his article is perhaps the most impassioned plea for a modernist sculpture during the latter years of the century. He saw such a sculpture arising in the work of Falguière, Dalou, Frémiet and others and proclaimed that "la nouvelle école de sculpture vivra, parce que le sentiment souffrant et mystique du moyen âge s'évanouit avec la foi religieuse, parce que la révolution et l'empire se sont trompés en voulant ressusciter le goût de l'antiquité et en faire la loi d'autres pays et d'autres sociétés, parce que la grandeur du pastiche grec était de la pauvreté, sa simplicité de la maigreur" (ibid., p. 900). Soldi was one of the few writers on art with sufficient wit to realize that "il n'y a pas de lois

If Degas' polychromy exploited a major Classical and neoclassical idea, it was the Baroque that supplied him with real models of a viable sculpture to which clothing had been added. At least two critics who saw the *Little Dancer* in 1881 were reminded of the clothed religious figures most frequently seen in country and Spanish churches,[39] and it is images close to these in time and intent that Degas knew intimately. The painted wax figures built over cork and wire armatures and carefully dressed in miniature versions of real clothes that were an integral part of the Neapolitan crèche must have been known to Degas from his many trips to visit his Neapolitan family and, in fact, he owned several himself.[40] The finest of these figures, still made and used today,

en art" (ibid., p. 899).

A third way in which the *Little Dancer* may reflect Degas' conventional training is in the treatment of the hair, forehead, and, particularly, the nose. In a curious passage in his *Grammaire*, Charles Blanc discusses the character of the forehead and nose, and their respective importance to the total physiognomy, as follows: "La preuve que le nez peut n'être pas étranger au système de l'esprit, c'est que, d'un homme fier, nous disons: 'Il porte le nez haut,' et que nous trouvons un air piquant et de spirituelle malice au nez retroussé d'une jeune femme. . . . L'antiquité regardait le front haut comme nuisant à la beauté du visage, par la raison que dans la fleur de la jeunesse le front est bas, et qu'il s'élève ensuite en se dépouillant de ses cheveux. De nos jours encore, les Circassiennes, qui font profession d'être belles et qui peuplent les harems de l'Orient, ramènent leurs cheveux sur le front pour le faire paraître plus petit" (pp. 397-399). The description of the *Little Dancer* in the *Chronique des arts* is practically a paraphrase of Blanc, referring to "un nez vulgairement retroussé . . . et un front caché par des cheveux qui tombent presque sur de petits yeux à demi fermés" (C. E., "Exposition" [B. 15], p. 126), and one knows that these features were particularly important to Degas. Jeanne Raunay remembered of him that "dans un visage, un seul trait lui importait, et c'est le nez qu'il préfèrait, qu'il preferait aux yeux même" ("Souvenirs" [B. 69], 15 March 1931, p. 268), and Duranty published a letter from Degas in which the latter chose nose shapes as a metaphor for artists' attitudes toward modernism and antiquity (*La Nouvelle peinture*, Paris 1946, pp. 28-29).

[39] Cf. Villars, "Exposition" [B. 20], p. 2, and Huysmans, "Exposition" [B. 25], pp. 250-251. More recently, Sylvia Shipley has pointed out this parallel in "Bronze" [B. 96], p. 4.

[40] Lafond lists among the contents of Degas' apartment, "des poupées napolitains" (*Degas* [B. 33], v. I, p. 118). On the history and character of these figures, see Georgina Masson, "The Neapolitan Presepio of the Eighteenth Century," *Connoisseur*, March 1952, pp. 28-31, 58. Cf. also Eugène Piot's reference, in connection with sixteenth-century wax sculpture, to the "grand nombre, . . . en Italie, de petits portraits modelés avec soin, qu'on renferment dans des boîtes et dont les vêtements et la coiffure . . . donnaient ample satisfaction aux femmes . . ." ("Les Sculpteurs en cire," *Beaux-arts illustrés*, 3e année, 2e série [1879], p. 250. Reprinted from "La Sculpture à l'exposition rétrospective du Trocadéro," *Gazette des beaux-arts*, 1 November 1878, pp. 811-840, in which a lengthy passage is devoted to polychrome wax sculpture).

date from the eighteenth century and combine sculptural power, literal naturalism, and theatrical vitality in a way that must have appealed tremendously to Degas. Most important, they would have supplied him with real precedent for dealing with a major problem that no one before him in his place and century had successfully resolved.

The *Schoolgirl* (Fig. 32), executed about the same time as the *Little Dancer*, owes more to the Renaissance than to either Classical Greece or the Baroque. The pose is copied almost without change from that of the Donatello *David*, a figure Degas had sketched, probably early in 1859 (Fig. 33).[41] The left hand behind the back, the right arm hanging at the side, and the retraction of the left leg are all directly taken from Donatello, and it is interesting that in modifying the sculpture from the drawing *Portraits in Frieze for Decoration of an Apartment* (Fig. 37), Degas has altered the hat to a less feminine but sculpturally more satisfying shape that closely approximates that found in the *David*, and reveals the face more fully.

Degas' relief (*Children Gathering Apples*, Fig. 38) has close ties with Classical work, and the very idea of executing a relief has in itself more academic overtones than that of creating fully round, spatially involved free-standing figures. As early as 1855 Degas was attracted to, and copied, the Ghiberti reliefs in Florence,[42] and in the early 1880s he seems to have purchased a series of photographs of the Della Robbia *cantoria*.[43] Although his own relief bears no direct relationship to either of these works, his pre-occupation with the dancing and singing children of the Della Robbia may have had some effect on his choice of subject. More important as sources, particularly since

[41] A similar sketch by Gustave Moreau in the Musée Moreau is labelled, in Moreau's hand, "Donatello-David-Offices-Florence Mars 1859." In March 1859 Degas was with Moreau in Florence (see Reff "More Letters" [B. 9], p. 284) and they may well have sketched the David together. Claude Roger-Marx has said of the *Little Dancer*, "Elle a la caractère d'un Donatello" ("Sculpteur" [B. 75], p. 1050).

[42] Cf. Reff, "Chronology" [B. 6], p. 610, notebook 10. Reff suggests that Degas made his sketches of the Ghiberti reliefs from plaster casts in Lyon, but he would certainly have known the originals from his many visits to Florence.

[43] Pages 6 and 218 of notebook 2 (Reff 1880-1884) contain references to the *cantoria* fol-lowed by lists of numbers, some of them crossed out. The numbers seem to refer to catalogue listings of commercial photographs, such as those sold by Alinari, of which Degas was trying to obtain a complete set. His awareness of the Della Robbia reliefs dates at least to 1856, when he sketched one, or a plaster cast of one, in Louvre notebook RF 5634 (Reff, "New Light," p. 258). It should be noted that the left-hand putto in the relief between the leftmost two consoles of the *Cantoria* is very close in pose to the child reaching into the tree in Degas' relief, and that the two running figures on the right hand reliefs of the *Cantoria* parapet are not dissimilar from Degas' early "Cupid" Dancer.

Degas' relief shows children picking and eating fruit, are the Bacchic reliefs usually found on Classical sarcophagi. The pose of Degas' central figure, legs spread apart and right arm raised to the head, is the standard one on sarcophagus reliefs for Bacchus or Silenus, who generally also occupies the center of the composition.[44] It is likewise that of the Munich *Sleeping Faun*, which Degas must have known (Fig. 42).[45] The seated figures at the right, one with its arms around the other who seems to strain to get away, are a combination common in Classical groups of nymphs and satyrs and one that also occurs on sarcophagi.[46] The left-hand group of an adult embracing a child is, similarly, common in Classical reliefs. By adding this group later and eliminating the figure of a boy climbing a tree, Degas would have made his Classical references more orthodox and more explicit. His relief in its final form is perhaps most similar to a fine small Classical relief in the Louvre which shows a Bacchic figure leaning on a child at the left, a seated figure in a pose similar to that used by Degas in the center, and a reclining figure at the right (Fig. 40). It was a work that Degas could easily have known, particularly by the date at which his relief composition was probably altered.[47]

The curious pose of *The Bow* (Fig. 48) is directly related to a dancelike pose found in Greek terra-cottas which seems to derive from the figure of a striding huntress (Artemis-Diana: Fig. 49) and was often used for figurines of Eros (Fig. 50). The same

[44] Cf. Salomon Reinach, *Répertoire de la statuaire grecque et romaine*, v. 1 (Paris 1897), p. 34, figure 155.

[45] A *Sleeping Satyr* in Naples is in almost the same pose. It is reproduced in Maxime Collignon, *Mythologie figurée de la Grèce* (Paris 1883), p. 265.

[46] Cf. Reinach, *Répertoire*, v. III (Paris 1904), p. 40.

[47] A relief of Helen, Aphrodite, Eros, and Paris in Naples also exhibits compositional similarities to Degas' work. It is presided over by a small figure raised above the others, one hand outstretched, the other raised to its head. At the left the group of Helen and Aphrodite is unclearly articulated in such a way that Aphrodite appears to be sitting on Helen's lap. At the right, a small winged Eros peers up into the face of Paris (?—the figure is labelled Alexander), on whose shoulder he rests his hand. The relief is reproduced in Walter Raymond Agard, *Classical Myths in Sculpture* (University of Wisconsin, 1951), p. 43. The theme of women and children gathering fruit has a long and respectable history. By the Middle Ages it had been taken over for representations of the *Anna samt Sippe* theme (cf. the panel by the Master of the Braunschweig Diptych in the Bührle collection, Zurich). In the Baroque and Rococo it regained its Bacchic and mythological overtones, only to be secularized by the nineteenth century. Corot exhibited a picture on the subject in the Salon of 1842 and it was taken up at about the same time in sculpture by Chardigny in a relief, *Gathering Olives*, now in Marseilles. For its appearance around 1890, see chapter 1, note 57.

huntress pose is related to the *Dancer Ready to Dance* (Fig. 51) which is, however, more clearly dependent on a Greco-Roman marble *Minerva* in the Louvre (Fig. 52).[48] Degas seems first to have studied a similar pose in his drawing of the Vatican *Apollo Sauroktonous* (Fig. 53).[49] The Herculaneum bronze *Dancer* in Naples (Fig. 70) may well have something to do with Degas' *Spanish Dance* (Fig. 69), as may also the marble *Marsyas* from the Lateran museum (Fig. 71), but the extreme hip-shot pose of the dancer and the distension of the limbs suggest another influence that demonstrates how catholic was Degas' awareness of older art. It is not at all unlikely that the conception of the *Spanish Dance* owes a great deal to the standard representation of Siva Nataraja popularized by the Indian bronzes that began to appear in Europe somewhat prior to the time Degas' figure was made (Fig. 72).[50] William Rothenstein, in fact, recalled that Degas "owned some casts of an Indian dancing figure, a *nataraja* or an *apsara*,"[51] and Germain Bazin, writing of the Degas sculpture in 1931, was moved to remark that "a self-same rhythmic wave runs, like a frieze of Apsaras, through these bodies disjointed by the dance, whose sinuous relief perhaps has a parallel only in Hindu sculpture."[52]

An even more astonishing demonstration of Degas' synthetic powers is the figure rather awkwardly entitled *Dancer Rubbing Her Knee* by both Hébrard and Rewald (Fig. 76).[53] The pose clearly owes a great deal to that of a woman fastening her sandals found in Greek terra-cottas (Fig. 77), which is, in turn, a popularization of the Nike pose from the temple of Athena Nike on the Acropolis that Degas had copied in his youth (Figs. 78, 79).[54] Degas, however, has introduced a curious detail by placing an object in the hand that his figure holds behind its back (Fig. 80). What this object is is by no means clear, but the probability that it is an apple brings to mind Guido Reni's

[48] The Louvre figure has been restored to a different pose since the nineteenth century.

[49] Reff lists a drawing of the Louvre *Apollo Sauroktonous* in "New Light," p. 258. The pose is also close to that of a bronze Dionysus in the Louvre (cf. Maxime Collignon, *Histoire de la sculpture grecque*, Paris 1897, v. II, p. 296).

[50] There was a large Indian section at the 1878 *Exposition Universelle*, and Degas' good friend Edmond Duranty wrote the description of it for the book, *L'Art ancien à l'exposition de 1878* referred to above.

[51] William Rothenstein, *Men and Memories* (New York, n.d.), v. I, p. 104. Cf. also v. II, p. 251. Rodin, too, expressed an interest in the figure of Siva; see his "La Danse de Çiva," *Ars Asiatica, III, Sculptures Civaïtes* (Paris 1921), pp. 9-13.

[52] Bazin, "Sculpteur" [B. 72], p. 301.

[53] Cf. Hébrard exhibition catalogue cited in chapter 1, note 34 and Rewald *Works* [B. 98], p. 152.

[54] Reff lists two such copies ("New Light," p. 258).

Atalanta and Hippomenes in Naples (Fig. 81) of which Degas' figure seems to be a three-dimensional synthesis. More curious still is the similarity of the pose and action of Reni's Atalanta to that of a figure in Ingres' *Martyrdom of St. Symphorien* (Fig. 82). Degas had copied the latter composition and owned some of Ingres' preparatory drawings for it, one of which depicts a pose almost identical to that of one of the most studied figures in Degas' own unfinished *Daughter of Jephtha* (Fig. 83).[55] This elaborate chain of artistic influence, of which Degas was probably not conscious, suggests only slightly his ability to bring the most diverse sources to bear on his art as well as the range and depth of his assimilation of visual experience.

The *Dancer Fastening the String of Her Tights* (Fig. 84) may well be related in pose to a small Classical bronze well known to the nineteenth century (Fig. 85). So popular was it that when it required restoration in 1907, Rodin himself, having been introduced to the piece by Clemenceau, undertook the job.[56] Degas had earlier copied a similar pose from an engraving after Michelangelo's *Battle of Cascina* (Fig. 86). *Grand Arabesque* (Fig. 87), which is related to *The Bow* and therefore to the monumental Artemis-Diana pose, has its closest analogue, like *The Bow*, in an Eros terracotta (Fig. 88). *The Tub* (Fig. 92), one of Degas' most idiosyncratic pieces of sculpture, has a somewhat more complex ancestry. Classical terra-cottas of reclining figures of Venus bathing do exist but they are unusual and unlikely to have been known to Degas.[57]

[55] Studies for this figure are found in notebooks 25 and 26, and the Durand-Ruel archives contain photographs of at least two drawings of it from the atelier. Obscure as it now seems, the stooping figure in the *St. Symphorien* caught the attention of many when the painting was exhibited, witness Charles Perrier's statement that "tout le monde reconnaît que dans cette foule compacte qui se presse autour du saint, il y a des études d'une force étonnante—témoin cet enfant qui se baisse pour ramasser une pierre . . ." ("Eposition universelle des beaux-arts. III. La peinture française.—M. Ingres," *L'Artiste*, 3 June 1855, série 5, v. xv, no. 5, p. 59).

An almost identical pose in reverse was used by Ingres for the figure picking up the body of Acron in his *Romulus Triumphant over Acron*, which was to be seen at the Ecole des Beaux-Arts, where it still is, after 1867. The position of the legs of this figure is extremely close to that found in a Roman relief fragment, now in Copenhagen, that had been copied by Ingres (cf. Daniel Ternois, "Napoléon et la décoration du palais impérial de Monte Cavallo en 1811-1813," *Revue de l'art*, no. 7, 1970, pp. 68-89).

A similar pose also occurs in the foreground of Poussin's *Camillus and the Schoolmaster of Falerii* in the Louvre, and the ultimate source for all these examples seems to be a warrior type such as was found on the frieze of the Mausoleum at Halicarnassus.

[56] Jean Babelon, *Choix de bronzes et de terres cuites des collections de Janzé et Oppermann* (Paris 1929), p. 28.

[57] Cf. René Ginouvès, *Balaneutikè* (Paris 1962), pl. IV.

Much more probable as a source are the painted dishes made by Bernard Palissy and his circle in which a bathing Venus reclines in what is at once her tub and the dish itself.[58] During the time Degas was beginning to make sculpture, Palissy's work was enjoying a period of renewed popularity, and the bronze statue of Palissy by Barrias now outside St. Germain des Prés was created in 1880 and shown in the Salon of that year.[59] Palissy's work would also have exemplified a viable polychromy to Degas, but it must be admitted that his own figure probably owes more to contemporary precedents and is, finally, the most wholly original of all his sculpted works.

Far less original than *The Tub* is the *Dancer Moving Forward* (Fig. 97), very nearly a copy of the Naples *Dancing Faun* (Fig. 98) which Degas may have known not only in the original but through reduced plaster casts such as that owned by Gustave Moreau. Under equally strong Classical influence is the pose of a figure looking at the sole of her right foot that Degas repeated many times (Figs. 99, 125). It is derived from a type found in small terra-cottas (Figs. 100, 126) and its ultimate ancestor is perhaps the most famous of Classical types, the Spinario (Fig. 103).[60] It was a pose Degas repeated more canonically in drawing and pastel during the 1890s (Fig. 102), the period when he seems first to have attempted in sculpture the theme of a model looking at the sole of her foot.[61] *Dancer Putting on Her Stocking* (Fig. 104) is clearly related to a drawing of a Classical figure from Degas' student days (Fig. 106) and repeats a pose inherited by the eighteenth century as that of a dancing faun (Fig. 105). *Dancer Adjusting the Shoulder Strap of Her Bodice* (Fig. 111) recalls both a well-known small bronze (Fig. 113) and another of the Herculaneum dancing figures (Fig. 114) and is related to a pose Degas had studied from the Parthenon frieze many years before (Fig. 112). Perhaps the two most canonically Classical figures among all the Degas sculpture are the *Woman Arranging Her Hair* (Fig. 107) and the *Torso* (Fig. 110). Their respective

[58] Two such *drageoirs* are in the Dutuit collection of the Petit Palais, and at least one is in the Louvre (cf. M.-J. Ballot, *La Céramique française*, Paris 1924, pl. 41).

[59] Cf. O. Rayet, "La Sculpture au salon," *Gazette des beaux-arts*, June 1880, pp. 537, 542. The inventory of Degas' studio in the Durand-Ruel archive lists, as no. 877, a portrait of Palissy. The medium is not indicated.

[60] François Fosca called what is probably the first of Degas' versions of this figure (Rewald

XLV) a "digne soeur de l'antique *Tireur d'Épine* . . . où Degas a mis toute la grâce fougueuse d'un bronze grec" ("Sculpteur" [B. 36], pp. 373-374). Although the Spinario is generally a male figure, female versions are not unknown and the Musée Jacquemart-André has a *Tireuse d'épine* attributed to Puget.

[61] So clear is the resemblance of Lemoisne 1089 to its Classical model that it is given the title *L'Épine*. Lemoisne 1236-1237 bis are variations on the same pose.

types, both Aphrodites, are so well known as to need no illustration, and it is only necessary to note that the *Woman Arranging Her Hair* is also among the poses studied by Degas as a student (Fig. 108).[62] A curious fact connected with the torso suggests that Degas was not only quite conscious of its Classical allusions but may have altered his work to strengthen the effect. The torso originally had a head, as the present break at the neck shows. The lines of that break suggest that the head was twisted off—that it was not lost accidentally in the casting but was intentionally removed.[63] If so, the change, like that in his relief at approximately the same time, would have been an open recognition by Degas of the Classical affinities of his work. It would also have been completely in keeping with the belief of his time that in antique monuments "what matters . . . is not the whole, it is the fragment."[64] Degas did not neglect the whole, however, and there are clear reminiscences of Classical terra-cottas even in the latest and most elaborate of his sculptural explorations, the seated figures (Figs. 134, 135).

It is clear, then, that the iconographical basis of Degas' sculptural oeuvre is the repertoire of poses he knew from monuments of the past, largely those of Classical Greece and Renaissance Italy. For almost the first decade of his artistic career he copied such monuments from the original, from casts, and from prints, and their con-figurations worked themselves so thoroughly into his memory that they recurred through-out his life, not only in his sculpture but in work in all media. These configurations were of particular importance to his sculpture partly because many of the monuments he originally copied were themselves pieces of sculpture and partly because the quan-tities of small Classical bronzes and terra-cottas that appeared at the very moment he began to model in wax freely repeated the same poses. More important than the fact that Degas used and transformed Classical models, however, is the fact that his method was rigorously academic in that he proceeded from art to nature. What he saw in nature, as represented by the poses he chose for his sculpture, was wholly conditioned by what he had earlier seen in Classical and Renaissance art. Until instantaneous photography revealed more relevant positions to him, his horses were observed in the stances of those of Venice and Athens, and while there is no doubt that his dance positions were care-fully observed in real life, what is most telling about them is that they were chosen in

[62] Cf. Reinach, *Répertoire*, v. ii, pt. 1 (Paris 1897), p. 341 for Classical comparisons.

[63] I owe this observation to Arthur Beale.

[64] Maurice Tourneux, "La Sculpture moderne à l'exposition universelle," *Gazette des beaux-arts*, January 1901, pp. 51-52.

70

preference to an almost infinite number of other poses. There is no reason endemic to the ballet why Degas should have chosen the positions he did—they are not, for example, held longer than other positions nor more easily observable on the stage.[65] It is clear that he saw them because they corresponded to Classical images previously engraved on his memory, and that in doing so he was following the most orthodox of academic procedures. Winckelmann himself had written, "When the artist . . . lets the Greek law of beauty direct his hand and his senses, he is on the road which will lead him with certainty to the imitation of nature,"[66] and a recent edition of his *Reflections* has pointed out that basic to his thought was the idea that "that which the Greeks did in regard to the nature that was their model, the moderns must do in regard to the models which the masterpieces of ancient Greece provide for them."[67] That Degas proceeded in precisely this way is emphasized by the number of unclear actions performed by his figures: *Dancer Rubbing Her Knee* (Fig. 76), *Dancer Looking at the Sole of Her Right Foot* (Fig. 99), and *Dancer at Rest* (Fig. 47), for example. These actions, although unambiguous sculpturally, relate of necessity neither to dancing nor to bathing, the two activities usually ascribed to the Degas sculpture and most often found in his drawings and pastels. They were presumably chosen for their particular qualities as three-dimensional configurations and not as identifications of particular occupations; they are clear reminiscenses of Classical poses seized on without regard to their immediate context. Degas used this rigorously academic method in a search for entirely nonacademic results and he was among the few artists of his time to bring off such an amalgamation successfully, one of the few modernists to turn to the Classical, rather than to the more recent, past for historical support. Any appreciation of the scope, nature, and quality of the synthesis he achieved must be based on a realization of how profound his attachment was to Classical sources and academic method.

[65] Virginia Williams, director of the Boston Ballet, has kindly confirmed this for me in conversation, as well as the fact that Degas' ballet poses are precisely observed.

[66] J.-J. Winckelmann, *Réflexions sur l'imitation des oeuvres grecques en peinture et en sculpture* (tr. Léon Mis, Paris 1954), p. 125.

[67] Ibid., pp. 15-16.

6. DEGAS AND THE ROMANTIC TRADITION

I₉ Degas derived his working habits and iconography from the Classical tradition, his style and spatial ideas were entirely rooted in the more experimental sculpture of his time. This fact is at once less demonstrable and infinitely more important, both for his sculpture itself and for its significance to the future, than Degas' academicism. It is more important because it is the basis of the sculpture's present and continuing relevance. It is less demonstrable because, in the absence of documentation relating Degas to Romantic and contemporary sculptors, it has largely to be extrapolated from the work itself, and community of ideas is less easily proven than iconographical borrowing. The nature and extent of Degas' contacts with other nineteenth-century sculptors is not certain but it is clear that he had wide acquaintance with their work. The evidence for that acquaintance is not merely in the effect it had on his own work, but in the obvious breadth of his general artistic knowledge. It is therefore helpful to investigate Degas' provable and probable knowledge of the sculptors and sculpture of his time to determine the type of work to which he was attracted and on which he drew to reinforce his own explorations.

David d'Angers is the major nineteenth-century sculptor who hovers in Degas' background, although there is no demonstrable direct connection between the two. One of Degas' early acquaintances in Florence, P.-J.-T. Blard, was a pupil of David's,[1] and Degas apparently later knew David's son, Robert David d'Angers, who was himself a sculptor.[2] François Halévy, whose family seems so intimately connected with Degas' early sculptural efforts, included David as the only sculptor in his biographical and critical essays, *Souvenirs et portraits*;[3] and, most convincing of all, Degas' early family friend and intimate acquaintance, Prince Soutzo, was instrumental in securing David's *Young Greek Girl* for the tomb of Marco Botzaris in Greece.[4] Of sculptors

[1] Reff, "More Letters" [B. 9], pp. 281, 282.

[2] Notebook 22 (Reff 1869-1873) has the notation "20 rue Petrelle . . . David d'Angers" (p. 104). Robert David d'Angers is listed in the Didot *Almanach* as having his studio at that address in 1871-1872.

[3] François Halévy, "David d'Angers," *Souvenirs et portraits (études sur les beaux-arts)* (Paris 1861), pp. 213-239.

[4] Gustave Planche, *Etudes sur l'école fran-

prominent later in the century, Degas knew Carpeaux when both were students in Italy[5] and he seems later to have had a particular fondness for the latter's portrait of the same Mademoiselle Fiocre he himself had painted in *La Source*. Apostrophizing Degas soon after his death, Daniel Halévy wrote, "My memory sees you, eyes closed like a Homer, holding between your hands a little terra-cotta by Carpeaux: it was a marvel, the bust of that Fiocre whom you had loved. . . ."[6] Degas may also have known Dalou and seems to have exhibited with him at the time when Dalou was in exile in England for having been a Communard.[7] In addition to Bartholomé, Degas knew the sculptor Adolphe Auguste Camus later in life,[8] and he admired the sculpture of Meissonier and Paul Dubois, although this admiration was based rather on the naturalistic accuracy of the work than on its quality.[9] The number and nature of these relationships, however, whatever the extent of Degas' knowledge of the work of the artists involved, bore no necessary relationship to his own work. As in his painting, Degas chose whatever was useful to him artistically without regard to attachments resulting from personal relationships. Thus, his close friendship with Bartholomé seems to have left no mark whatever on his sculpture, nor did the fact that he owned hundreds of Daumier prints leave any on his graphic style. Of far more artistic importance to his sculpture than the work of the artists so far mentioned was his general knowledge of Romantic sculpture,

çaise (Paris 1855), v. I, p. 272. A portrait photograph pasted onto page 105 of Degas notebook 1 (Reff 1859-1864) may be of Soutzo.

5 Reff, "More Letters" [B. 9], p. 282.

6 Daniel Halévy, "A Edgar Degas," *Le Divan*, September–October 1919, pp. 213-214.

7 Reff, "Some Letters" [B. 8], p. 89.

8 Fevre, *Mon Oncle* [B. 115], p. 98, in which Degas' niece quotes a letter from her uncle to her parents concerning a visit to Camus' house after his death. "J'ai retrouvé avec une certaine émotion," wrote Degas, "cette maison ou j'étais si souvent venu en ami. Les deux selles de sculpteur étaient près de la fenêtre du cabinet avec ses modèles en train."

9 Paul Valéry, *Degas, Dance, Dessin* (Paris 1938), p. 74. It is curious that of the three sculpted portraits of Degas one was made by Valéry, who seems to have been particularly in-terested in the Degas sculpture (for the other two, made in 1884 and about 1909 by Paul Paulin, see Léonce Bénédite, "Les Portraits du sculpteur Paul Paulin," *L'Art et les artistes*, May 1922, pp. 299-304). On the Meissonier sculpture, see M. O. Gréard, *Meissonier, ses souvenirs—ses entretiens* (Paris 1897), pp. 451-452, where eighteen pieces are listed (a classically derived *Dancing Muse* is illustrated on p. 228), and E. Duhousset, "Les Cires de Meissonier," *Magasin pittoresque*, 15 June 1893, pp. 194-196, which is largely concerned with Meissonier's dependence on the photographs of Muybridge. Degas also knew and discussed sculpture with Gérôme, whose own sculpture, frequently painted, was of the coldest neoclassical sort (Jeanniot, "Souvenirs" [B. 79], 15 October 1933, p. 171).

at least partly derived from the statuettes in the collection of his friends Rouart, which included the *Seated Grenadier* by Moine, Barre's figurine of Fanny Elssler performing a Spanish dance (Fig. 75), and Maindron's well-known *Bocage*.[10] Whether Degas knew Maindron, who encouraged the young Rodin,[11] is not known. He was certainly familiar with the Géricault *écorché* horse, which he drew twice, probably in the commercial plaster version popular in the nineteenth century (Fig. 17).[12] Later in life, he owned a series of fin de siècle dancing figures by François Carabin.[13] Most influential of all was the work of two contemporary artists he probably did not know, or may have known simply from the deferential standpoint of a younger artist vis-à-vis an older, Barye and Daumier.

Degas would have been thoroughly familiar with Barye's work not merely from the pieces in the Rouart collection[14] but from those he himself owned.[15] He would certainly have realized that Barye was not only unsurpassed in animal sculpture, the genre which first attracted Degas, but that he was the finest sculptor of the mid-nineteenth century and had dealt in precisely the sculptural problems Degas himself was to explore. He would almost certainly have seen the 1875 Barye retrospective at the Ecole des Beaux-Arts, and he had known of Barbedienne, the founder who edited and sold Barye's sculpture, as early as 1860.[16] Whether this fact indicates any direct contact between Degas and Barye is not certain. Barye's most important impact on Degas, that of his

[10] Luc-Benoist, *La Sculpture romantique* (Paris 1928?) pp. 175, 170, and 173, respectively. The Rouart collection included a great deal of sculpture which is now difficult to identify. Some idea of what it contained is given in Lemoisne, "Collection de M. Alexis Rouart," *Les Arts*, March 1908, pp. 24-27.

[11] Luc-Benoist, op. cit., pp. 56-57, 161.

[12] Notebook 1, pp. 93 (profile) and 94 (front view). The pose and musculature of the horse in these sketches make it practically certain that they are after the Géricault, as Reff has suggested ("Addenda on Degas's Copies," *Burlington Magazine*, June 1965, p. 320, repeated in "Further Thoughts on Degas's Copies," *Burlington Magazine*, September 1971, p. 537), although slight indications of a vertical support

under the belly make it not impossible that the original was an older, more monumental figure.

[13] Coquiot, *Degas* (Paris 1924), p. 39.

[14] Jacques-Emile Blanche wrote that, with Millet, Delacroix, and Daumier, Barye was Henri Rouart's favorite artist. See his "Notes sur la peinture moderne (à propos de la collection Rouart)," *Revue de Paris*, 1 January 1913, p. 47. This essay was later re-edited and published as the chapter "Degas" in *Propos de peintre: de David à Degas*, Paris 1927, pp. 245-308.

[15] Paul Lafond (*Degas* [B. 33], v. I, p. 118) mentions "quelques bronzes de Barye et de Bartholomé" among the contents of Degas' apartment.

[16] Barbedienne's name and address appear on page 43 of notebook 26 (Reff 1859-1860).

sculptural ideas, will be discussed later, but there is one possible instance of direct iconographical influence that should be noted here. In 1833 Barye had exhibited a figure of a *Bear Playing in Its Trough* (Fig. 94) at the Salon, and it came to be among the best known of his works during his lifetime.[17] Apart from its comic effect, the piece was sculpturally striking in that it represented a figure reclining inside a bath, very much in the manner of Degas' *The Tub* (Fig. 92), and it was an early experiment in the sculptural exploration of the relationship of inner and outer space that was to fascinate Rodin. Despite the fact that Degas' sculptural problem in *The Tub* was somewhat different, the similarity in pose suggests that Degas' knowledge of Barye's work may have encouraged him to adapt it to his own uses. Although Degas would probably have felt personally closer to less monumentalized animal sculpture such as he knew from his friendship with Cuvelier and Debrie, a style that seems essentially derived from that of Mène, he could not but have realized the important implications of Barye's sculptural solutions.

The major Romantic stylistic influence on Degas seems to have been the sculpture of Daumier, whose graphic work he knew well, loved, and collected, and whom he pronounced "as great as Delacroix."[18] The terms in which Degas saw the work of Daumier, a wholly modern artist, are both curious and telling of Degas' own mental processes.[19] "Daumier has a feeling for the antique," he is said to have said, "He understands it to the point that when he represents Nestor pushing Telemachus, it is expressed as at Tanagra."[20] Thus, although Degas was fully capable of seeing and understanding Daumier's modernism, he saw it through the antique. He seems to have been particularly

[17] Cf. Gabriel Laviron and Bruno Galbaccio, *Le Salon de 1833* (Paris 1833), p. 204.

[18] Jacques-Emile Blanche, *Les Arts plastiques* (Paris 1931), p. 36.

[19] Daumier himself seems to have been particularly drawn to the sculpture of Préault. According to Théophile Silvestre ("Préault," *Histoire des Artistes Vivants*, Paris 1856, p. 302) he owned a Préault relief entitled *Un jeune Comédien romain égorgé par deux esclaves*, and Luc-Benoist says that his studio walls were ornamented "seulement [avec] son bas-relief des *Emigrants* et sa lithographie non encadrée

d'après les *Parias* de Préault . . ." (op. cit., p. 143). Since no trace of the latter remains (cf. Loys Delteil *Honoré Daumier*, Paris 1925-1930, 10 v.), Benoist may have mistaken a copy of Célestin Nanteuil's lithograph after the *Parias*, published in *L'Artiste* in 1834 (v. VII, no. 14), for one of Daumier's own. For the Daumier sculpture, see Jeanne I. Wasserman, *Daumier Sculpture: A Critical and Comparative Study*, catalogue of an exhibition held at the Fogg Art Museum, Cambridge, 1 May–23 June 1969.

[20] Jeanniot, *Souvenirs* [B. 79], 15 October 1933, p. 171.

75

conscious of Daumier around 1879, and it is then that his interest in Daumier becomes wholly apparent in his sculpture.[21] The pose of the *Little Dancer* is profoundly reminiscent of that of the *Ratapoil* (Figs. 24, 25), although Daumier's sculpture is considerably more sophisticated, and the lambent line that delimits the nude version of Degas' figure recalls Daumier's drawn and lithographed, rather than his sculpted, line. Degas' awareness of the *Ratapoil* in 1879, the moment at which he began the *Little Dancer*, is further evidenced in the pastel double portrait of Ludovic Halévy and Albert Boulanger-Cavé (Lemoisne 526), in which Halévy is represented in precisely the pose of the Daumier statuette. It is also possible that the polychromy of the Daumier caricature busts, shown by Durand-Ruel in 1878, suggested to Degas the possibility of a viable contemporary use of color. However that may be, what the younger man took from the older stylistically is obvious from a comparison of Daumier's *Refugees* with the Degas relief (Figs. 38, 39).[22] The way in which the material is worked, the modelling of the figures, the use of heads as accents disposed across the surface, and the relationships of the figures to the background are almost identical in the two reliefs, as is the unity with which the sculptural material is treated, the facture being no different for flesh than for fabric, no different for foreground than for background. Nothing could make it clearer that the boldness, breadth, and rapidity with which Daumier worked his material was a major formative influence on Degas' sculptural style. It is especially interesting in view of Degas' comment on Daumier that the format of the *Refugees* and the processional nature of its subject are even more reminiscent of a classical sarcophagus relief than Degas' composition, although the latter, if it has a more freely varied composition, uses figures more purely Classical in pose.[23]

That Romantic sculpture was Degas' stylistic point of departure is obvious, finally, from the scale of his works, all of which can be classified as "statuettes";[24] from the

[21] In 1878, Duranty had written of Daumier suggesting a parallel with Barye (Edmond Duranty, "Daumier," *Gazette des beaux-arts*, May 1878, pp. 429-443, and June 1878, pp. 528-544) and about the same time, that of the Durand-Ruel retrospective, Degas copied Daumier's *Ventre legislatif* (notebook 23, p. 47: Reff 1878-1879).

[22] This connection has been suggested by Jean Selz, *Découverte* [B. 146], p. 174. The broader connections of Degas' sculptural style with Daumier's have been hinted at in Antonsson, "Nyförvärv" [B. 119], pp. 68-69.

[23] Luc-Benoist claims that Daumier owned a plaster cast of marching legionnaires from Trajan's Column (op. cit., p. 143). This may well have influenced his conception of the *Refugees*.

[24] Luc-Benoist has said that "La statuette fut . . . la technique preferée des novateurs" (*La Sculpture française*, Paris 1963, p. 155). In the Salon of 1834 Jules Klagmann announced this

material in which he worked, wax being the Romantic material par excellence; and from the increasing breadth of his facture. Beginning with Romantic sculptural ideas, exemplified largely in the work of Barye, and Romantic style, exemplified largely in the work of Daumier, Degas evolved a sculpture which was perhaps the most important realization of the potential suggested by the Salon of 1833.

Of the sculptors who emerged during the period of Degas' maturity, Medardo Rosso was probably the most innovative, and Rodin certainly the greatest. Degas' relationship with each of them is unfortunately a subject still open to speculation. Rosso first came to Paris in 1884 and worked briefly in Dalou's studio.[25] He may have encountered Degas at that time, since there is a story of his having shown Degas a photograph of his *Impression in an Omnibus*, executed in 1883-1884, which Degas took for a photograph of a painting. Be that as it may, Rosso returned to Paris in 1889 and was for a while confined to the hospital. During his convalescence he was taken in by Henri Rouart, and shortly thereafter was commissioned to execute a portrait of his benefactor, supposedly at Degas' suggestion.[26] Rouart owned a sufficient number of Rosso's works that Edmond Claris could write, "The celebrated collector Rouart is mad for the work of Rosso."[27] That fact, combined with the general attention Rosso's work drew in Paris and Degas' characteristic awareness of Italian artists working there, makes it certain that he knew Rosso's work well and probable that the two artists had met more than once.[28] Whatever the status of their personal relationship, it is clear that Degas, like Rodin, was significantly affected by Rosso's art. Comparison of his large portrait of Mademoiselle Salle with Rosso's *Large Laughing Woman* (Figs. 117-118), executed the year before, suggests that he was influenced not merely by the unusual type of the neckless head and by the "motif of the blurred . . . eye,"[29] but by the roughness of the

sculpturally by exhibiting small figures of Dante, Shakespeare, and Byron.

[25] Margaret Scolari Barr, *Medardo Rosso* (New York 1963), p. 25. Many of the following facts about Rosso are derived from Mrs. Barr's book.

[26] Ibid., p. 30. Rosso's *Bookmaker* of 1894 is said to be a portrait of Rouart's son-in-law Eugène Marin (ibid., p. 43).

[27] Edmond Claris, *De l'Impressionnisme en sculpture* (Paris 1902), p. 122.

[28] Louis Rouart remembered that Rosso frequented the Rouarts and met Degas there at least once (Barr, op. cit., p. 54).

[29] Ibid., p. 73, note 111. Degas would have been particularly conscious of this curious motif, which he had no objective reason to introduce into his portrait of Mademoiselle Salle, because of his own infirmity. Rodin, too, seems to have been affected by it, and it is particularly noticeable in the 1898 neckless head of Baudelaire. In this regard, it is interesting that it was the

facture, which represented a type of openness toward which Degas was moving at the time. The smaller Degas portrait brings to mind an aspect of Rosso's style that developed more fully some time later, as in the 1906-1907 *Ecce puer* (Figs. 115-116). Rosso's work may also have suggested to Degas the way toward a solution of certain problems that occupied him at the end of the century. Rosso's *Man in the Hospital*, executed in 1889 at precisely the moment Degas would first have been deeply conscious of his work, may well lie behind the series of seated bathers begun by Degas some years later (Figs. 137-138). Although Degas used the seated figure to different effect than Rosso, it was no doubt the Italian sculptor's example that encouraged him to experiment with the type. Rosso may well, thus, have been the principal influence on Degas' later sculptural style, and was the only sculptor contemporary to or younger than Degas who seems to have had any important effect on that style.

If Degas' relationship with Medardo Rosso was of more importance for his work, his relationship with Rodin tends to arouse more curiosity. That Degas knew Rodin's work is perfectly apparent, not only from Pissarro's remark that in 1887 he had found it "a little mannered,"[30] and from William Rothenstein's that he "greatly disliked" it,[31] but from a charcoal drawing of a model in a pose taken directly from Rodin's *Eve* (Figs. 142-143). The drawing suggests, indeed, that Degas was somewhat more positively interested in Rodin's work than Pissarro and Rothenstein indicate. Victor Frisch and Joseph Shipley say that Degas became closer to Rodin at the time of the Dreyfus case when they shared anti-Dreyfusard sentiments,[32] that they remained "cordial friends" until 1912,[33] and that they "often . . . talked of their mutual art."[34] There is, unhappily, no documentary evidence for this relationship, nor for Albert Elsen's statements that

Large Laughing Woman that Rosso traded to Rodin for a cast of the latter's *Walking Man* (Raffaele Carrieri, *Pittura, scultura d'avanguardia (1890-1950) in Italia*, Milan, 1950, p. 7).

[30] Undated letter (14 May 1887) from Camille Pissarro to his son quoted in Pissarro, *Lettres* [B. 13], p. 146.

[31] Rothenstein, *Men and Memories* (New York, n.d.), v. I, p. 106.

[32] Victor Frisch and Joseph T. Shipley, *Auguste Rodin* (New York 1939), p. 309. Although certain of the Degas *mots* credited to

conversations with Rodin by Frisch and Shipley have been claimed for their own conversations with Degas by Vollard and others, this book generally has a ring of authenticity. One suspects that when Degas got off a good comment he remembered it for re-use on later occasions.

[33] Ibid., p. 319. Frisch and Shipley also suggest that Degas was particularly fond of Rose Beuret.

[34] Ibid., p. 312.

78

Degas and Rodin were "good friends,"[35] and that "Degas was a frequent visitor to Meudon."[36] Nor is there any significant evidence in the sculpture that Degas was affected by Rodin's work. It would seem, rather, that Rodin fell under Degas' influence, and that he thought highly of the latter's sculpture. Blanche remembered that "Rodin declared himself astonished before his [Degas'] models of horses, of nudes . . . ,"[37] and Rilke is reported to have quoted Rodin saying, after an initial unfavorable impression of Degas' sculpture, "I was mistaken: Degas is a great sculptor. He is stronger than I!"[38] Whether this latter astonishing statement is true or not, it is suggestive that at the time Rodin is reported to have been closest to Degas, his sculpture not only became smaller in scale but began to deal frequently with dancing figures. While the effect of these figures is far different from those of Degas, the fact remains that toward the end of his life Rodin moved a great deal closer to the sculptural ideas that Degas had explored from the beginning, and, hence, closer to the Romantic tradition of which he has been seen by Luc-Benoist as the last expression.[39] It is, then, by no means unfair to suggest that Degas had a profound influence on Rodin's art by showing him how great a small-scale sculpture could be and how pure and abstract ideas of movement could became in a small object.

In addition to the sculptors he knew, Degas had a series of relationships with contemporary painters who also made sculpture, and with some who did not, that seem relevant to his own sculptural explorations. The earliest of these to develop, and in many ways the most significant, was that with Gustave Moreau.[40] Having been close to each other as students, Degas and Moreau maintained a friendly relationship all their lives, although Degas apparently had an increasingly low estimate of Moreau's art. Moreau's sculptural experiments, which look more like Degas' sculpture than any other such work of the nineteenth century, may well have had some effect on Degas'

[35] Albert Elsen, *Rodin* (New York 1963), p. 145.

[36] Ibid., p. 145.

[37] Blanche, "Degas" [B. 85].

[38] Pierre Borel, *Sculptures* [B. 114], p. 11. The complete quotation is: "Quand, pour la première fois, on lui [Rodin] avait parlé de ses statuettes, il avait dit à son secrétaire d'alors: Rainer-Maria Rilke: 'Mon opinion est depuis longtemps faite sur ces touche-à-tout.' Un jour que l'auteur de la *Porte de l'Enfer* avait vu une statuette de Degas, il avait fait amende honorable. Au même, il avait alors déclaré: 'je me suis trompé: Degas est un grand sculpteur. Il est plus fort que moi!'" I have been unable to find any trace of this anecdote in Rilke's book on Rodin or elsewhere.

[39] Luc-Benoist, *Sculpture romantique*, p. 161.

[40] On the Degas-Moreau relationship, see especially Phoebe Pool, "Degas and Moreau," *Burlington Magazine*, June 1963, pp. 251-256, and Reff, "More Letters" [B. 9].

initial decision to sculpt. Moreau's wax figures are of the same scale as those of Degas and are worked with somewhat the same sketchy rapidity.[41] Of the thirteen known figures by Moreau,[42] at least three exploit the curious incorporation of foreign elements that also interested Degas and is an extension of more orthodox polychromy. Moreau's group of the *Argonauts* is built up over a low green box, probably a candy box, while his *Salomé* is constructed over an articulated wooden lay figure and wrapped in a sort of linen shawl. The largest of the Moreau sculpture, a wax figure constructed astride a horse that is a commercial plaster cast of a work by Emile Loiseau, is also draped in cloth, and it and the *Salomé* may be, along with the *Little Dancer*, the only surviving pieces of nineteenth-century sculpture so clothed. There is also one important icono-graphical connection between the work of the two men. Moreau's sculptural study of a reclining figure in a basket after the *Moses* is the most meaningful of the modern sources for *The Tub* (Figs. 92-93). Although wholly different in quality and intent from Degas' figure, it is the most like it of any sculpture of the period, and the one Degas would have been most likely to have known intimately.

Degas' friendship with Gauguin also seems to have involved a good deal of sculptural influence, in this case passing mostly from the former to the latter. Gauguin, who later lived near Dalou,[43] began sculpting in marble in 1877 in a wholly academic vein.[44] By 1881, however, he was prepared to exhibit two wood sculptures in the same Impressionist exhibition in which Degas showed the *Little Dancer*. Christopher Gray has suggested that the subject of the first of these, *The Singer*, owes something to Degas' café scenes,[45] although the sculptural conception of the roundel almost certainly descends from Préault. The second piece, a small figure of a woman dressed in contemporary clothing called *The Little Parisian* inevitably suggests Degas' *Schoolgirl* made at about the same date (Figs. 35, 32).[46] Since Degas seems to have known Gauguin

[41] Moreau seems also to have been interested in Barye and to have owned examples of his work. Holten suggests the influence of Barye on Moreau in "Gustave Moreau sculpteur," *Revue des arts*, no. 4-5, 1959, pp. 209-210.

[42] Only twelve of these were known to Ragnar von Holten, who first published them (ibid.). The thirteenth and largest was discovered on the ground floor of the Musée Moreau when it was remodeled in 1968 or 1969, and is now in the room with the others. It may relate to the paint-

ing *La Parque et l'ange de la mort* (1890-1895). I am indebted to Julius Kaplan for the information concerning its discovery.

[43] Jean de Rotonchamp, *Paul Gauguin* (Paris 1906), p. 26. This was about 1885-1886.

[44] See chapter 1, note 18.

[45] Christopher Gray, *Sculpture and Ceramics of Paul Gauguin*, Baltimore 1963, p. 2.

[46] Reff ("Sculpture" [B. 159], p. 290) has pointed out the similarity of the Gauguin figure to those in the Degas *Portraits in Frieze for*

well during this period,[47] and since Gauguin was just beginning to find his sculptural way whereas Degas was already fairly well along in his, it seems not unlikely that such works of Gauguin's as the *Little Parisian* reflect his knowledge of what Degas was doing. Indeed, almost all of Gauguin's sculpture of this period reinforces that impression. The portrait of his son Clovis, exhibited at the seventh Impressionist exhibition in 1882, is executed in wood and painted wax, and the head, especially when seen in profile, clearly evokes that of the *Little Dancer* (Figs. 30, 28). Degas seems particularly to have liked the piece, for he made a sketch of it in one of his notebooks (Fig. 31), and it is not impossible that the unusual half-length format suggested the format of his own portrait of Hortense Valpinçon, executed two years later. It was also in 1882 that Gauguin carved a relief, at the same scale as Degas' relief of roughly the same time, that has come to be known as *The Toilet*, since the seated girl is generally thought to be brushing her hair (Fig. 41).[48] The work is, however, rather unusually executed in pear wood, and the girl is probably sitting under a pear tree,[49] so it is not unlikely that the indistinct object she holds in her left hand is a pear rather than a hairbrush, and that the association of a young girl and fruit was directly inspired by Degas' *Gathering Apples*. This connection is emphasized by the ambiguity of the girl's gesture in raising her hand to her mouth, and, if correct, lends further strength to the hypothesis that the original version of Degas' relief included a tree. Two years later, in 1884, Gauguin carved a wooden box inside of which a female figure reclines as if dead, the front and back decorated with reliefs of ballet figures "after the dancers of Degas."[50] Finally, among the earliest of Gauguin's ceramics is a vase decorated with a figure clearly after Degas.[51]

Decoration of an Apartment, which is closely related to the *Schoolgirl* (see p. 14).

[47] Gauguin's name and address occur on page 1 *bis* of notebook 5 (Reff 1879-1883), followed by directions for getting there.

[48] Gray, op. cit., p. 4. The work is signed, dated, and dedicated to Pissarro, who was later to note Degas' appreciation of Gauguin's work and, in 1886, the renewed closeness of their friendship after a brief period of estrangement (Pissarro, *Lettres* [B. 13], p. 111). It is curious that it was precisely in 1886 that Gauguin re-used the motif of the girl beneath a pear tree on

a ceramic jardinière (Merete Bodelsen, *Gauguin's Ceramics*, London 1964, pp. 30-31). Bodelsen also refers to the figure as a "girl brushing her hair" (ibid., p. 35).

[49] Felix Fénéon, "Les Impressionnistes en 1886," *Oeuvres* (Paris 1948), p. 76.

[50] Pola Gauguin, *Paul Gauguin mon père* (Paris 1938), p. 65. This is part of a longer passage (pp. 65-66) noting Gauguin's admiration for Degas' work. For the box, see Gray, op. cit., pp. 120-121.

[51] Gray, op. cit., p. 125; Bodelsen, op. cit., p. 17, where it is dated 1886-1887.

All of these congruences, as well as Gauguin's interest in polychromy in his sculpture, suggest how fertile was his association with Degas at the moment when both were deeply involved in sculpture, and how broad the range of Degas' contacts.

Renoir's admiration for Degas' sculpture was both extreme and frequently expressed.[52] He had apparently known the sculptural work of the man he called "the foremost sculptor"[53] from its inception, since Vollard has recorded his references to both the original relief and the *Little Dancer*.[54] He seems to have had an especially strong interest in what Degas was doing sculpturally after 1900, and two of his pictures of seated bathers wiping themselves, a peculiarly Degasian theme that Renoir took up around 1905, are particularly close to sculpture by Degas. One, the *Bather Wiping Her Right Leg* now in São Paolo, recalls the two versions of Degas' *Woman Washing Her Left Leg* (Figs. 132, 131), while the other, *After The Bath*, is almost identical in pose to *Seated Woman Wiping Her Left Armpit* (Figs. 136, 134). A standing *Bather Arranging Her Hair* in Washington recalls Degas' *Woman Arranging Her Hair* (Figs. 109, 107), although the theme is common enough to have occurred to Renoir without the aid of the Degas sculpture. If, indeed, these pictures can be seen as a reflection of poses Degas was exploring in sculpture, the fact that Renoir began sculpture seriously in 1907 may be at least partly attributable to his knowledge of and admiration for Degas' work. Like Gauguin, Renoir began with a portrait of his son that recalls the *Little Dancer* he so much admired (Figs. 29, 28). His style, however, was wholly different from that of Degas, perhaps owing something to Dalou with whom he shared an admiration for the eighteenth century, and certainly reflecting that of Maillol, particularly after 1913 when he was active making sculpture with the help of Richard Guino, one of Maillol's assistants.[55] Be that as it may, it is not unlikely that Renoir's knowledge of Degas' sculpture was an influential force in the development of his art, as it had been with Gauguin and Rodin.[56]

[52] See chapter 2, note 15.

[53] Ambroise Vollard, *La Vie et l'oeuvre de Pierre-Auguste Renoir* (Paris 1919), p. 88.

[54] Ibid.

[55] Selz, *Découverte* [B. 146], pp. 185, 188.

[56] The most curious and least concrete of the relationships of other artists' work to the Degas sculpture involves Zandomeneghi, the subject of one of the lost sculpted portraits. Both stylistically and iconographically, Zandomeneghi was in many ways a pasticheur of Degas, and he seems regularly to have evidenced knowledge of and interest in the sculpture. This knowledge is most apparent in a group of drawings of uncertain date. Since the drawings in question are clearly taken directly from the model, one must assume either that Zandomeneghi posed his models in positions taken from Degas or that he shared

models with Degas. One such drawing is so close to the pose of the *Dancer at Rest* it could be a study for it, and others are all but indistinguishable, save in quality, from Degas' studies for the *Little Dancer*. A drawing of a reclining nude could have been studied directly from *The Tub* (Figs. 96, 92), while a pastel of a woman drying her hair recalls the *Woman Arranging Her Hair*. A study of a woman stretching for a painting of the same subject dated 1886 could be drawn from the same model as the *Woman Stretching* (Figs. 130, 129). Since the latter seems stylistically to date from the very end of Degas' career it could not itself have been the source for the Zandomeneghi, but the pose was one Degas had explored as early as 1884 in the painting *Women Ironing* now in the Jeu de Paume, and it is tantalizing to think that the Zandomeneghi may reflect an earlier sculptural version of this theme now lost. Finally, a painting entitled *The Schoolgirl* is clearly dependent on Degas' sculpture of the same name. Whether other works by Zandomeneghi relate to lost Degas sculpture cannot for the moment be proven, and, indeed, one is perplexed what precisely to make of this curious iconographical relationship between Zandomeneghi's drawings and Degas' sculpture.

7. THE PERSONAL ROOTS OF DEGAS' SCULPTURAL STYLE

DEGAS' subjects and the ways in which he treated them reflect not only personal and contemporary artistic problems but aspects of his personality which relate, in turn, to matters that were of more general importance to his time. Born and raised in an upper middle class banking family, Degas tried throughout his life to maintain the life-style of the class to which he felt he belonged, and was particularly attracted to families of the same general standing, some of which had been friendly with his family for many years. In this respect it is telling that many of his friends—Gérôme, Boldini, etc.[1]—were chosen from among the more socially acceptable academic artists, although Degas had wit enough to let other considerations shape his art. Only Manet seems to have been sufficiently acceptable both socially and artistically to be both friend and mentor to him. Be that as it may, Degas' social preoccupation helped shape his choice of subjects throughout his life. The horses he painted and sculpted until mid-career were a convenient reconciliation of modernism and fashion. Racing had had aristocratic overtones as early as Géricault, overtones which were to carry through to the early work of Toulouse-Lautrec, and in Degas' own time the popularity of John Lewis Brown emphasized its identification with England. The anglophilia of which racing was part—"No sport is less French than horse racing," Pierre Cabanne has noted[2]—swept France during the first three-quarters of the nineteenth century as part of the belief in and search for a workable internationalism. With the disenchantment of these hopes after 1871, fashionable taste turned toward theater and the ballet, an eighteenth-century art that was considered to be particularly French, and the taste of a good many artists, Degas included, followed suit.[3] "Toward 1875," Madeleine Vincent has written, "there begins

[1] Jeanniot ("Souvenirs" [B. 79], 15 October 1933, p. 171) implies not only that Degas and Gérôme were at least good acquaintances but that they discussed sculpture together.

[2] Cabanne, Degas [B. 140], p. 27.

[3] On the resurgence of nationalism in France after 1870, see Jacques Chastenet, La République des républicains (Paris 1954), and Carlton J. H. Hayes, A Generation of Materialism (New York 1941).

84

in painting and sculpture an explosion of dance."[4] The return of bathers as a subject, not only in the work of Degas but in that of Manet, Dalou, Renoir, Cézanne and many others, was part of this same trend toward a prerevolutionary nationalism.[5] In following these trends, Degas clearly showed himself to be "not only a Frenchman, but a fin de siècle Parisian."[6] It is also clear, however, that his exaggerated consciousness of the social milieu in which he moved involved quite early a serious conflict between the aims of his art and those of his life. That conflict is most clearly illuminated by the family legend of his relationship with Princess Wolkonska.[7] Deeply in love with her, he was rejected because he was a painter and therefore socially unacceptable. This rejection can, in the absence of fuller documentation on Degas' emotional life, be used to stand for the complex of factors that engendered in him the desire for social acceptability and the distrust of women that later turned to snobbism and misogyny, both used as defenses against the world.[8] Such feelings are almost certainly at the bottom of his otherwise inexplicable break with the Halévys at the time of the Dreyfus affair, and cast considerable light on the emotions he must have experienced shortly after his return from the United States when his brother René failed in business and left his wife and family to marry another woman. One knows for certain of the latter incident only that it estranged Degas and his brother, to whom he refused to speak for some time, until quite late in both their lives. Degas' financial straits during the 1870s, in part caused by his brother's reverses, must have aggravated these responses considerably.

If Degas' choice of subject was influenced by personal and social considerations

[4] Madeleine Vincent, *La Danse dans la peinture française contemporaine (de Degas à Matisse)* (Lyon 1944), p. 9.

[5] Aspects of this popularity of bathers as a theme are discussed by Barbara Ehrlich White in "The *Bathers* of 1887 and Renoir's anti-Impressionism," *Art Bulletin*, March 1973, pp. 106-126.

[6] Théodore Duret, "Degas," *Art Journal*, 1894, p. 205.

[7] Mademoiselle Nepveu-Degas kindly told me of this. There may still be some love poetry in the family addressed to Princess Wolkonska, and there is certainly a drawing of her in the family's possession. Unfortunately, I have been unable to identify her with precision.

[8] Benedict Nicolson suggested as much in 1963 when he speculated that Degas "closed down on his *éducation sentimentale* after some bitter experience, and had allowed passion to wither" ("Degas as a Human Being," *Burlington Magazine*, June 1963, p. 239). Nicolson also raised the possibility of Degas' being a repressed homosexual. Since there is no direct evidence for this either in Degas' life or in his art, it seemed wise to avoid here the speculative and complex issues generated by such a theory.

85

deeply rooted in his character, his interest in movement seems just as profoundly attached to psychological factors. It has been pointed out more than once that the movement of horses and dancers is essentially the same and that, "Race horses are in the animal world what the *danseuses* are in the human, being trained for a special purpose, and full of movement and graceful energy."[9] For Degas in his sculpture "there is really no difference between the horses and the women. Just as this nude ballerina stretches out her leg, forward, backward, strong and sturdy, and as that other does so with her arms, so also can the legs, hindlegs and forelegs, of a horse be stretched. The tension is the same. Both are models of animal training."[10] This interest in ritualized and highly sensual animal movement has clear erotic overtones which Degas himself obliquely recognized in the sonnet in which he spoke of a horse, "tout nerveusement nu dans sa robe de soie."[11] Erotic associations with horses were not, of course, new to the nineteenth century, having been exploited by Géricault and Fuseli among others, but Degas' handling of them was far more subtle than that of any other artist of his time. Rather than using horses or dancers as openly erotic symbols, he detached them from all external associations whatever, an artistic transmutation which cannot conceal the fact that a deep and sensual attachment attracted him to the subjects in the first place, nor that the type of movement he found in them appealed to him on a very basic level indeed.

A second, equally important, and more openly expressed association that Degas had with movement is suggested in a letter to Henri Rouart in which he wrote, "It's the movement of things and people that distracts and even consoles, if one can be consoled when one is so unhappy. If the leaves of the trees didn't tremble, how unhappy the trees would be and we also."[12] This sense of movement as an antidote for unhappiness is carried to its extreme in Degas' solitary wanderings during the last five years of his life. "Obsessed by the idea that one does not die while walking," wrote Madeleine Zillhardt, "he took to wandering through Paris."[13] Thus movement, the visible sign of life, became

[9] Duret, op. cit., pp. 207-208.

[10] Hausenstein, "Anmerkungen" [B. 51], p. 116. Paul Valéry has also pointed out that, "nul animal ne tient de la première danseuse, de l'étoile du corps de ballet, comme un pur-sang en parfait équilibre, que la main de celui qui le monte semble tenir suspendu, et qui s'avance au petit pas en plein soleil" (Paul Valéry, *Degas, Danse, Dessin*, Paris 1938, pp. 69-70).

[11] *Sonnets* [B. 11], p. 26.

[12] *Lettres* [B. 7], p. 119, Letter XCI.

[13] Zillhardt, "Monsieur Degas" [B. 113], 16 September 1949, p. 5.

the antidote even for death and would, so long as it were maintained, keep one from dying. There is clearly here an emotional association of movement with fear—fear of death—and the double association of movement with fear and with desire suggests the underlying ambiguity that played such an important role in Degas' life and art—an ambiguity that almost certainly resulted from unresolved emotional conflicts involving his attitude toward women.

Although there is almost no documented information on Degas' emotional life, one character trait runs like a thread through his life: the simultaneous wish for love and domesticity, as expressed in the moments of great warmth to which all his close friends allude, and shrinking from close personal contact, as expressed by his increasing gruffness and his use of that gruffness to shield himself from the world. The existence of this trait gives a particular ring of credibility to an otherwise unprovable statement from an unusual source, Victor Frisch and Joseph Shipley. Speaking of Degas' supposed fear that a wife would be unable to understand his work, Frisch and Shipley wrote,

> something deeper underlay this attitude of Degas', a quality that also helps to explain, not only his sarcasm and his pride, but the women that are the incessant theme of his art.
>
> Degas—unlike Rodin—had the reputation of using his models only to paint. He had no weakness for women, it is said. On the contrary, he longed for them deeply; but, alas, yearned not merely to possess them, but to possess the initial courage to reach out for them. He was prey to an adolescent shyness, a fear of refusal, a preliminary embarrassment and shame, that kept him from moving along the amorous way. His tentative questing, with his models, would be checked, then turned to jesting; so that Degas grew to be known not as a lover but as a prankster, and all the practical jokes of the bohemian quarter were attributed to him.[14]

This adolescent timidity seems gradually to have become associated with adult fear of death, and by the 1880s strong emotions of fear and desire concentrated on women shaped Degas' choice of subjects, the way in which he saw those subjects, and his in-

[14] Victor Frisch and Joseph T. Shipley, *Auguste Rodin* (New York 1939), p. 316. Degas' longing may well have been for women as maternal figures rather than sexual partners, particularly as it seems to have been connected with both domestic tranquillity and the security of academicism. Benedict Nicolson has pointed out in relation to Degas that "timidity is no more than a convenient excuse for some deeper urge towards non-involvement" (op. cit., p. 240).

creasing perfectionism and inability to bring his works to a high state of finish. That Degas was at least peripherally conscious of his ambivalent attitude is evident from an unpublished poem written by him in 1890 which conflates a wedding and a funeral:

> Les six landaus n'arrivaient pas;
> Mais tout était prêt pour le mort.
> On eut voulu passer d'abord
> Et les landaus n'arrivaient pas!
> Au signe qu'un des pères fit,
> Le monde, ami de défunt, vit
> Les cochers bottés avancer
> La noce, qui boudait le seuil,
> Leste, avec ordre se placer
> Dans les six voitures de deuil.[15]

Degas' only comment on the poem is, "What a subject! Inexhaustible."[16]

Since the ambiguity in Degas' character seems to have sprung from erotic conflict and is in part associated with ideas of movement, it is no wonder that he was attracted to the dance, the more so as the late nineteenth century laid particular stress on the dancer as Fatal Woman, often in the guise of Salomé the temptress.[17] Moreau was particularly attracted to the theme in painting, and Wilde was only one of several who explored it in literature. Because of the dubious morals of the dancers at the Opéra, the backstage of which was a favorite rendezvous for fashionable men and young girls, this image became attached to them. In an extraordinary article entitled "La Danse," published in *L'Evénement* in 1887, Jean Lorrain made the connection clear by maintaining that, "throughout the centuries the Dancer has everywhere been the grace and the corruption of the antique world and of modern people."[18] In his extended and Baudelairean description of the modern dancer, he went on to assert that she represented the very conflicts which probably underlay Degas' character, associating Degas by name with the image he created:

[15] This poem is contained in the letter to Bartholomé dated 18 August [1890] which was published in part as letter CXXIII (*Lettres* [B. 7], p. 154). The manuscript is now in Houghton Library of Harvard University.

[16] Ibid.

[17] For the Romantic background of this image of woman, see the chapter, "La Belle Dame sans merci" in Mario Praz, *The Romantic Agony* (Cleveland 1965), pp. 189-286.

[18] Jean Lorrain, "La Danse," *L'Evénement*, 16 December 1887, p. 1.

Les lugubres marionnettes de l'Elysée remisées ou brisées, avec quelle joie nous revenons tous, grisés de lumière et de boulevardisme, vers les étincelantes pupazzi de la mode et de l'art. Or, séductrice et délirante entre tous ces fantouches, la poupée souveraine et absurdement femme, la goule irritante, délicate et fuyante entre toutes avec sa tête de Sidonie perverse, le ballonnement fou de ses jupes, sa taille invraisemblable et guepée et, mystère inquietant dans cette face poudrée, la fleur de sang frais des lèvres grasses de fard, c'est la Danseuse, la Danseuse moderne et même un peu macabre de pâleur exsangue et de maigreur, la Danseuse chère à Degaz. . . .[19]

Certain aspects of Degas' interest in Classical sculpture also touch on this theme of the threatening woman, which is ultimately that of the *liebestod*. Duranty had stressed the funerary function of Tanagra figures, pointing out that "this multitude of statues and statuettes was almost entirely devoted to celebrating death";[20] and Louis Ménard, writing on the iconography of Eros, whose Classical image a good deal of Degas' early sculpture resembled, said that "in penetrating more deeply into the theological conception of this God, I think I have found the true origin of the complex symbol of love, the bond which connects it to the idea of death. . . ."[21] Even Degas' sculptural material could be taken as a symbol of instability, if not of outright ambiguity, and in a passage that recalls the Cupid-like *Arabesque over the Right Leg* (Fig. 18), Spire Blondel wrote of Classical sculpture in wax that, "they also copied the statues of the Gods in this manner; but it is particularly to Love . . . that they erected such images, as if, by a malicious allusion to the instability of the passions deified in him, they wanted the fragile effigy to become thereby more appropriate for a fragile God."[22]

The conflicting pressures in Degas' personality seem to have had the greatest effect on his sculpture at the moment he first began modelling the human figure in the late 1870s and early 1880s. Indeed, the fact that he turned to sculpture at all may partially evidence those pressures, externalized in the trials of life in Paris in the early 1870s, the death of his father, his financial difficulties, and the loss of René's family, which he must have looked on as partially his own. Small wonder he spoke of sculpture as a

[19] Ibid.

[20] Edmond Duranty, "Les Statuettes de Tanagra," *La Vie moderne*, 17 April 1879, p. 31.

[21] Louis Ménard, "Eros, étude sur la symbolique du désir," *Gazette des beaux-arts*, October 1872, p. 266. In 1878 Ménard published *La*

Mythologie dans l'art ancien et moderne, based on the *Gazette des beaux-arts* articles of which the "Eros" is one.

[22] Spire Blondel, "Les Modeleurs en cire," *Gazette des beaux-arts*, May 1882, p. 494.

medium in which to express profound suffering. It was during these years that his models are obviously adolescents and not the adult women of indeterminate age represented in the later sculpture; Degas' psychological relationship to these models is therefore neither clearly that of lover nor that of father. It was also at this time, and throughout the 1880s, that he produced a series of pastels of family groups, notably the Rouarts, and that his notebooks are filled with sketches of children, some playing, some accompanied by nurses, and some at their mothers' breasts. He even considered painting two panels on the subject of birth.[23] This interest in domesticity, as well as the underlying conflict that both attracted Degas to it and kept him from it, is reflected in his relief, a work unique in format and subject and perhaps the most psychologically revealing of his entire oeuvre (Figs. 38, 44). It is significant that Degas chose the general composition and subject of a Classical sarcophagus relief, not simply because of the ancient association of love and death but in light of the associations imputed to such reliefs by Louis Ménard in his essay on Eros: "Whenever one sees the troops of winged children vying for victory in gymnastic contests or chariot races that figure so often on sarcophagi, one can assume an intention to represent life as a perpetual struggle of the desires of the soul which aspires toward an unknown happiness."[24]

This struggle of the desires, of a soul aspiring toward an unknown or distant happiness, must have been intensely real for Degas around 1880, the more so as it emphasized the difficulties of his relationships with women. The latter is even more clearly pointed to by the unusual subject of the relief. Certainly the bucolic overtones of children gathering apples were of little interest to a man who was said to have disliked rural life, and who was so clearly a Parisian. Rather, it combined aspects of domestic tranquillity with a deeper psychological significance, the apple being not merely the simultaneously attractive and sinister instrument of the Temptation but, as Meyer Schapiro has pointed out in relation to Cézanne, having ancient significance as a love gift.[25] In suggesting

[23] The sketches are enumerated in Boggs, "Notebooks" [B. 5], July 1958, p. 246, which also includes a written description of the projected "2 panneaux sur naissance" on p. 11 of notebook 2 (Reff 1880-1884).

[24] Louis Ménard, *Gazette des beaux-arts*, November 1872, p. 428.

[25] Meyer Schapiro, "The Apples of Cézanne," *Art News Annual*, no. 34 (1968), pp. 34-53.

Schapiro is partly concerned in this article with reinterpreting a painting by Cézanne generally called *The Judgment of Paris*, for which he suggests the title *The Amorous Shepherd*. It was executed in 1883-1885, at precisely the time Degas was probably engaged on his relief. The Judgment of Paris is, of course, the most widely known association of apples and victorious love.

90

that the choice of apples represents a "displaced erotic interest"[26] for Cézanne, an artist almost as timid as Degas in his relationships with women, Schapiro points out that "the classic association of the apple and love has been fixed for later art, including Cézanne's, through the paraphrase by Philostratus, a Greek writer of about 200 A.D., of a painting of Cupids gathering apples in a garden of Venus. The Cupids have laid on the grass their mantles of countless colors. Some gather apples in baskets—apples golden, yellow and red; others dance, wrestle, leap, run, hunt a hare, play ball with the fruit and practice archery, aiming at each other. In the distance is a shrine or rock sacred to the goddess of love. The Cupids bring her the first-fruits of the apple trees."[27]

The threat represented by such gamboling with apples was suggested by Aristophanes, as Oscar Rayet noted in writing of the ancient art exhibited in Paris in 1878: "In a passage in *The Clouds*, Aristophanes advises a young man 'never to go to the house of a dancer for fear that, while he pauses to stare at her, mouth gaping, the courtisan, in throwing him an apple, will cause him to lose his good reputation.' On a vase in the Naples museum love throws a ball at a young girl, and the scene is completed by the legend: 'The ball has been thrown to me.' "[28]

Leaving aside the probability that the classically-educated and literate Degas knew the work of both Philostratus and Aristophanes,[29] not to mention the Neapolitan vase, one is struck with the similarity of his position to that of the young man at once attracted to the beautiful dancer and afraid of association with her. If the suggested reconstruction of the original relief is correct, one can easily see in the boy in the tree, the most studied of all the figures, a projection of Degas himself offering apples to the

[26] Ibid., p. 37.

[27] Ibid., p. 37.

[28] Oscar Rayet, "L'Art grec au Trocadero," *Gazette des beaux-arts*, 1 September 1878, p. 356 (reprinted in *L'Art ancien à l'Exposition de 1878*, Paris 1879, pp. 89-90). Contemporary writers were also at pains to point out the apple as an attribute of Aphrodite (Louis Ménard, "Aphrodite," *Gazette des beaux-arts*, October 1873, pp. 362-363, where mention is made of the hand with an apple found with the Venus de Milo), and its erotic associations were sufficiently well known to the nineteenth century, particularly in relation to Greek terra-cottas,

that Cartault could write of a Myrina figurine in 1882 that "il est inutile d'insister sur la signification érotique de la pomme . . ." (A. Cartault, "Jeune femme tenant une pomme," *Collection Camille Lecuyer: terres cuites antiques*, Paris 1882, v. I, unpaginated). The erotic associations of fruit were also stressed by Zola in *Le Ventre de Paris*, published in 1873 (Schapiro, op. cit., p. 37).

[29] For a suggestion of the extent of Degas' literary culture, see Theodore Reff, "Degas and the Literature of his Time," *Burlington Magazine*, September 1970, pp. 575-589; October 1970, pp. 674-688.

waiting girls below and assisted by a small child as surrogate for Eros. That one of the girls turns toward the boy and the other two away, brings to mind a Judgment of Paris although, of course, the specific allusion is unnecessary in this scene of fructitude and happiness which so fully expresses the unrealizable desire of the aging artist.[30] The theme continued to haunt Degas and in later creating a figure which recalls one of the best-known interpretations of a legend associating apples and love, he placed in its hand an object which may well be an apple (Fig. 80).[31]

The deep ambiguities and opposing forces in Degas' character evidenced in his desire for the security of a married life which would oppose the uncertain claims of his art and underlain by a simultaneous desire for and fear of women and consciousness of death were thus acted out in his art and reconciled there. By externalizing them in sculpture and pastel he was able to find objective equivalents for his emotions and seek synthetic solutions for their conflicts. Constantly attracted to the security of an established and masterable academic style, he had to recognize the superior claims of a modernism that led on to unknown ends. Thus the simultaneous Classicism and modernism of his sculpture reflects the deepest currents of his personality, and the wholly successful synthesis he achieved, their reconciliation.[32]

[30] Renoir, whose comments are one of the two documented sources for the Degas relief, later chose to translate a painting of the Judgment of Paris into one of his few essays at relief.

[31] The legend is that of Atalanta and Hippomenes. See pp. 67-68. In this regard it is interesting that Atalanta was also a Fatal Woman ("I will be the prize of him who shall conquer me in the race; but death must be the penalty of all who try and fail," *Bulfinch's Mythology*, New York, n.d., p. 116) and was defeated only through Hippomenes' supplication to Venus.

[32] Degas' sculpture may also represent a more overt analogue to his emotional progress. Shy of the female anatomy he may well—literally—have come to grips with it in his sculpture. It is noteworthy that he began with childlike and adolescent figures and that it was the pubic area of the *Little Dancer* that was compositionally unresolved. Gradually his subjects became adult women, and toward the end of his career there appears a figure that suggests pregnancy (Fig. 127). His models, thus, almost literally grew up, and Degas with them. Felix Deutsch has cast light on the functioning of such externalizing mechanisms in the artist in his "Creative Passion of the Artist and its Synesthetic Aspects" (*International Journal of Psychoanalysis*, 1959 [v. XL], pp. 1-14). Citing a patient who could "free herself from the submission to tabooed objects [by] modelling them and thus eliminating them magically," he quotes Ernst Kris as noting that "magic control through artistic creation is one of the frequent unconscious determinants of production in the arts," referring also to sculptors' "urge to recreate living forms as if resolving their own unconscious conflicts in this manner." I am indebted to Ernest Kahn for bringing this article to my attention.

The struggle within Degas which found expression in his work also acted itself out on a larger stage. In his eloquent and extended excursus on the struggle of the ancient and the modern, Jules Claretie pointed out that "it is as if there were two characters to an epoch: the apparent spirit (I mean the triumphant spirit), destructive and hateful, and the other which is, on the contrary, like the sacred fire which a generation tenaciously maintains and which nothing can extinguish. It is at that flame that one must warm oneself. It is with that living spirit that one must be inspired."[33] Not only is Claretie's statement probably the first recognition of the modern paradox that what is generally taken to be the most important art may only be so taken because it is readily recognizable, but it is part of an impassioned plea for modernism and spontaneous vitality. Of "the moderns," he says "life is on their side."[34] In revealing that life, the best of the "moderns" realized that much else also had to be uncovered. Throughout the nineteenth century there was a constant avant-garde effort to bring into consciousness and acceptance emotions that were hidden by contemporary moralities. Love, death, violence, and their connections were all insisted upon by avant-garde artists, with Baudelaire at their head. The struggle for an open, accepted, and acceptable eroticism was waged by critics as well, and as early as the 1830s Charles Lenormant had made the bold assertion that "the beautiful, in fact, is the ally and often the guide of Love. What we mean here by love is exactly the carnal appetite. It affects the soul like all the other needs of the body, but more powerfully because it encounters there a quality which is in the spiritual order what the carnal appetite is in the material order."[35] This idea was echoed in 1844 by Thoré, who pointed out that "there is a sentiment which underlies all our modern arts. . . . It is love."[36] Eventually this recognition helped credit the artistic claims of the eighteenth century and its frank eroticism, which had been, and continued to be, denied by an academicism appealing to moral propriety.[37] Thus the way in which Degas' personal conflicts found expression in his work was in many important respects a paradigm of the larger search for a modernist art.

[33] Jules Claretie, "Préface," *Peintres et sculpteurs contemporains* (Paris 1882), p. vi.

[34] Ibid., p. ii.

[35] Charles Lenormant, "Du Beau," *Beaux-arts et voyages* (Paris 1861), v. I, p. 13.

[36] Théophile Thoré, *Salons de T. Thoré: 1844, 1845, 1846, 1847, 1848* (Paris 1868), p. 83.

[37] See p. 57. The Academy's demands for decorum resulted, in sculpture, in a cold and hidden eroticism that now seems little more than pornographic.

8. THE DEVELOPMENT OF DEGAS' SCULPTURAL STYLE

FROM the beginning Degas sensed and grappled with the problems raised by the desire of experimental sculptors to make pieces of sculpture that were not statues, a sculpture sufficiently freed from traditional human associations that it could explore new possibilities in its own terms.[1] The first and most difficult of the problems faced by these sculptors was the relationship of the piece of sculpture to the ground, since it was clear that only with the greatest difficulty could any vertical, standing object overcome human analogies and consequent limitations of pose. The problem was complicated by the traditional pedestal which, somewhat in the manner of a picture's frame, simultaneously monumentalized sculpture and removed it from direct association with the life around it.[2] The importance of the pedestal to conventional sculpture as well as its relationship to the second of the major nineteenth-century sculptural problems is indicated in Eugène Guillaume's comment, "Do not forget that the image is completed by a pedestal which contributes to its expression, but also limits its movement."[3] The convincing representation of movement was of importance to Romantic sculptors not merely because it could give vitality to sculpture, but because a figure in movement tended automatically to overcome the problem of the base by suppressing the vertical disposition of weight and thus significantly altering the relationship of the figure to the ground. Finally, the exploration of movement underlay the most important of the problems facing experimental sculptors, that of developing a spatial sculpture.[4]

[1] This was the basic problem of sculptural modernism. Charles Blanc, defending the making of statues, was careful to point out the word's derivation from the Latin verb *sto*—to stand (*Grammaire des arts du dessin*, Paris 1867, p. 364).

[2] Insofar as a pedestal stands surrogate for the ground, the problem of sculpture's relationship to it is the same as that of its relationship to the ground.

[3] Eugène Guillaume, "L'Art et la nature: Salon de 1879," *Etudes d'art antique et moderne* (Paris 1888), p. 160.

[4] W. R. Valentiner has discussed the role of movement in a spatially involved sculpture and the limitations imposed by the human body as follows: "If the volume [of a piece of sculpture] is dissolved, we feel comfortable only if the empty space thus created can be easily filled in by imagination and, embraced by the remaining

94

It is clear from the fact that painting moved steadily toward effects of increasing two-dimensionality in which the use of color was of great structural importance that the development of the arts during the nineteenth century was in part a purification involving the stripping away of all effects not proper to each art itself. Since sculpture was by nature a three-dimensional art, it became necessary to define what aspects of three-dimensionality were unique to it and to explore those aspects, rather than merely to strip away an accumulated illusionism. The latter was also necessary in dealing with the planarity of neoclassical sculpture, but the problem of sculptural illusionism was more one willed and imposed by the nineteenth century itself than one accumulated over centuries. Indeed, it was the ongoing historical tradition of sculptural development which suggested a solution in the form of sculpture in which space played an active part. Exactly how this was to be accomplished—the physical terms in which it was to be expressed—was the major avant-garde sculptural problem of the century. Because of these facts, a principal concern of experimental sculpture was to reestablish productive links with the immediate past—the eighteenth century—rather than to appeal to the earlier traditions, such as that of the seventeenth century, which had proved so fruitful for painting. It was only toward the end of the nineteenth century that sculpture, largely in the work of Degas and Rodin, began to show sustained signs of developing a new grammar. In doing so, it focused attention on the three leitmotifs of the search

solid part, forms the supplementary section to a well-rounded whole. Sculptures with partly open spaces can be compared to the human body with partly outstretched legs or arms; they may be stretched out to a certain distance, providing empty spaces in between, but we always feel that these spaces form part of a whole and that they do not overstep the limits set by the body's circumference. However . . . there exists a type of dissolved sculpture which satisfies our imagination, even if it goes beyond the limits set by the idea of a well-balanced whole, that is, if the sculpture expresses rapid movement. If man or animal is running, or if an inorganic element like water or a mechanical object like an engine or a plane is in rapid movement, their volume seems to dissolve completely. But it only seems so; in reality, the solid mass of which the moving object exists does not change. Thus, if this dissolving created by strong motion is expressed in sculpture, the outlines of the sculpture may well be broken through in one or in several directions, entirely changing the shape of the object, but the composition will not appear convincing if the sculpture has not at the same time the solidity and the connection with the earth which the human or any other body known to our experience, actually has" (*Origins of Modern Sculpture*, New York 1946, pp. 6-7). Movement can also be seen as one of the characteristics proper to sculpture since it is implied by the fact that one must walk around a three-dimensional object to experience it fully and by the alterations produced in such objects by changing effects of light.

for that grammar: the relationship of sculpture to the ground, the development of a movemented sculpture, and the active involvement of object and space. These motifs, announced by the Salon of 1833 at the moment neoclassical sculpture had clearly arrived at a self-perpetuating academicism, are inextricably woven through the work of experimental sculptors even into the middle of this century.

It was to be expected that early solutions to the problem of the relationship of sculpture to the ground on which it stood would be found in a genre frowned on by academicism. The reclining human figure opened new possibilities for eliminating standing attitudes and for extending sculpture along the ground in such a way that unexpected combinations of elements were possible, as well as for doing away with conventional pedestals. Although reclining figures enjoyed a long tradition in funerary sculpture, they were, perforce, static and were considered ignoble by the theorists. "What is the symbolism of the reclining statue?" asked Henry Jouin, "Defeat, sleep, or death remain graven in the horizontal lines of a reclining figure. . . . Such a pose has something of the excessive and the submissive. All liberty disappears in a fallen man. He has been defeated."[5] Both Rude and Duseigneur tried, nevertheless, to activate reclining poses, the former in his remarkable *Napoleon Awakening to Immortality*,[6] the latter in his *Roland furieux*. Although Duseigneur's *Roland* is successful sculpturally, it suggests that academic skepticism was partially justified, for the violently active reclining figure tends to be naturalistically unconvincing. It was Barye who found a way out of this predicament by turning to the sculpture of animals. In dealing with living beings that move naturally along a horizontal plane, he was able to overcome human allusions without sacrificing the vitality of movement. Although much of his sculpture is non-spatial and represents animals in direct contact with the ground or with each other, Barye was also capable of highly complex spatial development, as in his *Theseus and the Minotaur*, and could be a master at calculating the interstices of his compositions so that they functioned three-dimensionally with the masses to create a single sculptural object. A great deal of the most vital sculpture of the century followed his lead in taking animals for its theme, and Frémiet's huge compositions of such subjects as orangutans and African natives were among the most advanced explorations of an open sculpture

[5] Henry Jouin, "La Sculpture au Salon de 1876" (Paris 1877), p. 30.

[6] This figure of Napoleon lying on the rocks of St. Helena, his entire body cloaked and only his face exposed, is the most daring nineteenth-century statement of what may be called bulk sculpture before Rodin's *Balzac*.

96

to be made. Rodin himself tacitly recognized the sculptural advantages of animal movement by making many of his human figures, such as the *Ugolino*, behave like animals.

By taking horses as one of his principal sculptural subjects, Degas was thus not simply continuing a preoccupation of his work in other media nor responding to cultural and personal pressures, but was placing himself squarely in a position to explore problems of first importance to those seeking a new sculptural grammar. If his early horses were statically posed and academically conceived in that one senses their blockiness and the importance of their profiles, they were naturalistically observed and hence modern in intent. Having noted their similarities to the horses of Athens and Venice, Paul Gsell goes on to remark that "by the elegance of their slender proportions, by the stiltlike elongation of their legs, they lastingly realize the ultramodern type of the race horse."[7] It is an observation borne out by comparison of the horses with those of Cuvelier (Fig. 3) and Mène (Fig. 14) which share their interest in exact observation, in full and almost geometrical representation of the underlying bony structure, and in careful rendering of such details as the hair of the mane and tail. When Degas' early horses move they do so parallel to the planes of their bodies and at a fully-grounded and moderate pace (Fig. 13). Even the *Horse at Trough* (Fig. 9), the lowered head and tail of which increase the complexity of the spatial relationships, is wholly restrained in its movement. It also exemplifies the smooth and careful finish that Degas sought at the time.[8] Thus, while developing his naturalistic observation, Degas refrained in his first horse sculpture from exploring poses that were too actively movemented. The same is true of one of his first attempts at the human figure, *Dancer at Rest* (Fig. 21). The frontality of the pose, emphasized by the sideways winglike extension of the arms, the squarely planted feet, and the uprightness of the body reveals a wholly conventional underlying conception, although the informality, almost instantaneity, of the stance and the naturalism with which the figure is observed show interests that would lead to quite other things. What those were is more fully suggested by *Arabesque over the Right Leg* (Fig. 18), despite the importance of its profile. By raising the figure on one leg, Degas has chosen one of his favorite devices for freeing his sculpture from the ground, and by turning the raised foot inward has made a tentative move toward the circular patterns tying solid and void together which he later developed so highly. The

[7] Gsell, "Statuaire" [B. 28], p. 378.
[8] The pitted surfaces of the *Mustang* (Fig. 2) and *Horse Walking* (Fig. 7) probably indicate the ravages of time rather than Degas' intent.

equilibrium of the pose is also a first step toward the nicety of balance that was of crucial importance to his expression of sculptural movement.[9]

The *Little Dancer* (Figs. 23, 26) represents the last step in Degas' initial explorations as a sculptor and the beginning of more advanced experiments in movement and space. In it, Degas has overcome the planarity of *Dancer at Rest* (Fig. 21), to which the pose of the *Little Dancer* is related, by clasping the arms behind the back, drawing back the head and shoulders and creating a pull counter to the forward thrust of the torso and right leg. More important, the voids that penetrate the figure—between the legs, between the arms, and between the arms and the torso—provide a continuous flow of space through and around the piece, creating a constant opening and closing effect as the observer walks around it. Such all-round experience of the *Little Dancer* is encouraged by the model's position. The limbs are so arranged that the figure has no dominant viewpoint, each view being incomplete and leading on to another. From directly in front one sees the front of the torso and head, but a profile of the right leg and foot and a three-quarter view of the left leg. From the right side, one sees the figure in profile, but the right leg in front view, together with simultaneous views of the outside of the right arm and the inside of the left, and so on. Degas has, thus, started to break down the traditional hierarchy of views in favor of a continuous three-dimensional experience, and suggestions of planarity, as in the early horses, have completely disappeared.

In choosing a fourteen-year-old model, Degas was attacking, perhaps consciously, what had repeatedly been singled out as a difficult sculptural problem. As early as 1822 Thiers had suggested that adolescent forms, being inherently angular and nonsculptural, were difficult to render in three dimensions.[10] A decade later Gustave Planche, speaking of David d'Anger's *Young Greek Girl* for the Botzaris tomb, was considerably more specific. "In the transition from childhood to adolescence the female body rarely shows harmonious lines," he wrote. "The woman who will be beautiful at sixteen is often ungraceful at fourteen. To translate a woman of fourteen into marble one must have consummate skill, and above all great interpretive boldness."[11] It is tempting to think that

[9] Jeanniot recalls Degas complaining of his sculptural difficulties, "l'équilibre surtout est si difficile à atteindre" (Jeanniot, "Souvenirs" [B. 79], 1 November 1933, p. 300).

[10] Adolphe Thiers, *Salon de 1822* (Paris 1822), pp. 147-148.

[11] Gustave Planche, *Portraits d'artistes* (Paris 1853), v. II, p. 65. Charles Blanc also pointed out, from the point of view of an academic purist, that "Dans la sculpture antique des belles époques, on ne trouve jamais des adolescents véritables . . ." ("Salon de 1868: sculpture," *Annuaire de la Gazette des beaux-arts*, 1869, p. L).

in taking up this challenge Degas may have had precisely this statement by Planche, relative to the sculpture his friend Soutzo had commissioned, in mind. Be that as it may, the problems of the adolescent female form occupied Degas so long that he was unprepared to show the nude *Little Dancer* in 1880, and they probably forced his decision to clothe the figure for its exhibition the following year. Seen in profile, the earlier version is almost wholly successful except for the awkward moment at which the torso joins the legs (Fig. 24). The flatness of the pubic area below the swelling stomach is a moment of sculptural weakness for which there is no anatomically convincing solution. By clothing his figure, Degas covered up this clumsy transition and what he lost by the interference of the skirt with the spatial play of the arms he more than gained in the added harmony and strength of the entire piece. It is especially worth noting that the costume used by Degas—one, it must be admitted, that had been his constant preoccupation in painting for several years—fits the body in such a way as to change almost nothing sculpturally except the area where the legs join the body. It is also, in relation to Degas' interests and training, an interesting compromise. While academicism allowed nothing but Classical drapery and preferred the nude, Romantic sculpture had insisted on contemporary dress. By using a ritualized costume, unspecific in time, Degas theoretically answered the needs of both schools. In fact, of course, the costume was seen as aggressively modern, and so praised by avant-garde critics and damned by conservative ones.[12]

The effect of contrary thrusts of forces embodied in the *Little Dancer* is also apparent in the small figure of the *Draught Horse* (Fig. 59) and in *Horse Galloping* (Fig. 60) and *Horse with Head Lowered* (Fig. 63). The *Draught Horse* strains forward against a weight pulling it backward, and although the action remains planar and parallel to the horizontal axis of the animal's body, the disequilibrium of the pose suggests new sculptural possibilities. The action of *Horse Galloping* is also planar, but more sophisticated in that it is simultaneously forward and rising, one achieved by a trotting horse between the moment when its legs are most extended and that when they are completely drawn up under it. The sculptural effect of this pose, almost certainly revealed to Degas by Muybridge's photographs (Fig. 61), is of a suspended rocking motion, and its spatial possibilities are more fully realized in *Horse Trotting* (Fig. 62), which has

[12] A similar attempt at polychromy had been made during the 1860s by Frémiet, who created a series of minutely detailed statuettes of Second Empire soldiers flocked in imitation of contemporary military costume (Phillipe Faure-Frémiet, *Frémiet*, Paris 1934, pp. 49-55).

all four feet off the ground. A further complexity is introduced in *Horse with Head Lowered*, in which the head is drawn to the side in a balking gesture.[13] That gesture, combined with the lowered head and tail first seen in the *Horse at Trough* (Fig. 9) and the fact that two of the legs are drawn back, creates a sculptural space of great vitality, especially around the forelegs, and is an attempt to impart to the horse's body a type of twisting motion that Degas was to find fully feasible only with the human figure.

Horse Clearing an Obstacle (Fig. 66) is the most spatially sophisticated of all Degas' horses. Also related to a pose seen in Muybridge's photographs (Fig. 68), it combines forward, backward, rising, and twisting motions in the closest approximation of a centripetal spiralling movement possible with a four-legged animal. The turning of the head, the spreading of the rear legs, and the fact that from the side one sees both forelegs (they are not parallel) all discourage a planar reading of the piece by de-emphasizing its profile. The fact that the horse rises on its hind legs has allowed Degas to bring the front and hind legs into greater proximity than in any other of his horses, thereby permitting him to make infinitely finer adjustments of the sculptural spaces. Those spaces, most striking when the front legs are seen through the spread rear legs, are even more continuous in the way they open and close and more tightly woven through the figure than those of the *Little Dancer*. They are further exploited in *Rearing Horse* and *Prancing Horse*, but by the time in the late 1880s when he had developed the motions of his horses to this complexity Degas had found that dancing figures offered more fertile possibilities for spatial development.

While Muybridge's photographs were certainly of importance in suggesting poses of rapid motion not normally observed and representing moments of transition between more generally known positions, Degas' use of them should not be exaggerated. As first published, the photographs would not have been of much use in the development of sculpturally convincing poses of movement. They appeared as little more than sil-houettes and, while demonstrating proper relationships among the animals' legs, would have served as barely more than suggestions for the creation of a sculptural space. Degas could hardly, for example, have derived the spread of the rear legs of *Horse Clearing an Obstacle* from such photographs. Moreover, as Rodin pointed out, stop-motion photo-graphs are less convincing artistic representations of action than such naturalistically

[13] A monumentalized version of this pose was used by Barye in his *Ape Riding a Gnu. Horse Galloping* (Rewald XVII) combines the twisted head with the pose of *Horse Trotting* (Rewald XI).

inaccurate poses as the flying gallop, since all parts of the moving body are stopped at the same instant, giving an effect of immobility.[14] Only with a certain amount of adjustment and the adaptation of positions from previous and succeeding moments of action can a real illusion of movement be created.[15] The situation is particularly complicated by the fact that for Degas the desired illusion was not that of naturalistic equine motion, which might be achieved by a flying mane and other such devices, but true sculptural movement, the effect of unstable equilibrium achieved by such careful interaction of solid and void that the illusion of movement is created as one walks around the object or as it is rotated in front of one's eyes. Such movement is always movement around a center, and it has an exact analogy not in motion photographs seen singly, but in their reconstitution in a zootrope. By rotating a roll of consecutive motion photographs in such an instrument the original movement is cinematographically reconstituted, with one important unique characteristic. While the figure seems to move it does not give the appearance of progressing from one place to another. In zootrope rolls this is partly a function of the fact that the images revolve and partly of the fact that while the figures move the background changes little.[16] This effect of movement without progression, which Muybridge was able to project on a screen, was precisely that achieved by Degas in his sculpture and is, in fact, the quintessence of sculptural movement. The movement of Degas' horses, and, indeed, of all his sculptural figures, is not a self-willed movement but one imparted by the sculptor and accomplished by the spectator in going around the figure. It is a movement which can always be delimited by circumscribing a cylinder around the object in question, hence, always a movement that returns on itself. This fact results in the charging of the sculptural voids, which seem to be spaces through which the object has just moved or may be about to move. Degas' sculptural genius lay partly in being able to suggest in a three-dimensional solid object the synthetic recon-

[14] Auguste Rodin, *L'Art* (*entretiens réunis par Paul Gsell*) (Paris 1953), p. 108. Gsell is reported also to have gathered a series of conversations with Degas, which the latter forbade him to publish (François Fosca, *Degas*, Paris 1921, p. 63). These must certainly have touched on, if not been wholly concerned with, sculpture.

[15] Lillian Browse has pointed out that Degas' "interest did not lie in arrested movement—the frozen gesture of a film suddenly stopped—but

in the continuous progression of a form passing from one attitude to another, so that no explanation is needed as to what has gone before, nor suggestion as to what will follow" (*Degas Dancers*, London 1949, p. 44).

[16] The relative lack of change in relationship between the figure and the background is particularly true of Muybridge's pictures, which were taken against a continuous unified background.

101

stitution of movement achieved in Muybridge's zootrope,[17] and in transforming that reconstituted movement from movement of the represented object to movement resulting from interaction of the sculptural object and its surrounding space.

At the same time Degas was exploring increasingly complex animal movement, he was also exploring that of dancing figures. Although horses offered him the advantage of extenuating the relationship of the piece of sculpture to its base, they were ultimately less satisfactory than dancing figures as a means of developing the rising motion by which a figure seems to lift off its base that so interested him. Furthermore, the number of possible relationships among a horse's limbs were fewer than those among the limbs of a human model, which could be more freely distorted and more easily arranged in windmill-like patterns. In the latest and most complex of the horses, those in balking poses, Degas went as far as possible toward spatial involvement created by the play of the limbs, but the two figures of horses with all four feet off the ground already announce his interest in floating figures. *Arabesque over the Right Leg* (Fig. 46) is a more extreme exploration in this direction by being, in effect, a hanging figure, suspended from the armature constructed around it. If the wooden base were removed from beneath the single foot that touches it, the figure would be structurally unchanged—it would hang or float freely. This effect, explored again and again by Degas in variations of this pose, was as close as he came to complete freedom from the base, although certain of his other pieces project a more convincing illusion of floating as a result of the calculation of their spatial relationships. The first step in this direction was taken in the positioning of the legs of the *Little Dancer*, a pose developed further in *Dancer at Rest* (Fig. 47), in which the extreme outward turning of the feet creates a circular pattern around the lower part of the body. By extending the arms outward from the body and/or curving them around the body, as in *The Bow* (Fig. 48), Degas began to bring the upper bodies of his figures into active collaboration with this configuration, and by the time he created the *Spanish Dance* (Fig. 69) it was fully developed. In the *Spanish Dance* allusions to standing are suppressed by the motion of the right leg away from the body, and the space thus created, coupled with the inward turn of the foot, begins a spiral configuration that rises through the hip-shot torso, around the curving left arm and

[17] Toward the end of the nineteenth century E.-J. Marey substituted plaster models of a bird in flight for photographs of the same subject in a zootrope, and thus reconstituted motion in three dimensions. A modern version of this mechanism was until recently on exhibition in the lobby of the Cinemathèque française at the Palais de Chaillot.

turned head, and up through the raised right arm, whence it is returned to the body by the relationship of the hand to the head. This curving pattern of the arms at once suggests motion away from the body and returns motion to it, and the way in which the voids thus embraced interweave through and around the solid forms is a sculptural statement of a sophistication unrivalled in the nineteenth century.[18] The curving and spiralling of the forms completely does away with any sense of frontality, and the figure is wholly satisfactory from any angle, demonstrating perfectly Bazin's assertion that "Degas' statue . . . has neither front nor profile; it is alive in all directions and from whatever angle one perceives it it remains an active configuration."[19] A measure of its achievement can be had by comparing the figure to one of a nearly identical subject almost certainly known to Degas, Barre's *Fanny Elssler* (Fig. 75). The comparison demonstrates how Degas has, in the words of Thiébault-Sisson, gone "further than sculpture."[20]

Two other aspects of Degas' sculptural accomplishment are exemplified in the *Spanish Dance*. First, its expression is achieved entirely through the body and the face has almost no importance. This characteristic may well derive from Degas' attachment to neoclassicism, which considered the head and facial expression in sculpture relatively unimportant[21] while less orthodox critics pointed out their modern importance. What it allowed Degas to do was to externalize the gestures of his figures sufficiently—to remove them far enough from identification with personality and ideas of effort—that the sculptural configuration itself became all important. Paul Valéry pointed out how

[18] How much the fact of Degas' interest in dancers contributed to his development of a spatial sculpture is suggested by an observation of Adolphe Appia: "Volume without weight seems about to escape into the breeze, like a balloon; its stability is illusory; it is a portion of space momentarily enclosed, nothing more. Volume is like an inflated rubber doll, and for this reason the ballet dancer resembles a captive balloon, brought back at regular intervals to its moorings. To receive its portion of life from the living body, space must oppose this body; space that embraces our body only further augments its own inertness. But opposition to the body gives life to the inanimate forms of space" (*Adolphe Appia's "The Work of Living Art,"*

tr. H. D. Albright, Coral Gables 1960, p. 27). It might be pointed out that Degas' figures are not really volumes, since they give no sensation of being inhabited or inflated. They are masses or, more simply, solids.

[19] Bazin, "Sculpteur" [B. 72], p. 301.

[20] Thiébault-Sisson, "Sculpteur" [B. 34].

[21] Janneau quotes Taine to the effect that, "Dans la statue grecque . . . la tête n'excite pas plus d'intérêt que les membres ou le tronc; sa physionomie n'est point pensive, mais calme, presque terne; on n'y voit aucune habitude, aucune aspiration, aucune ambition qui dépasse la vie corporelle et présente" (Janneau, "Sculptures" [B. 37], p. 353).

103

Degas was able to "make one think that the entire mechanical system of a living being can *grimace* like a face."[22] This capacity constitutes the very core of his sculptural achievement.

Secondly, the *Spanish Dance* illustrates the degree of artistic license Degas allowed himself in his sculpture. Although he constantly checked his poses against nature, in the form either of models or of instantaneous photographs, Degas found such license necessary to achieve the sculptural effects he sought. One has only to imagine the Spanish dancer standing upright on both legs to see how great a degree of distortion was required by this particular sculptural configuration. It is a measure of Degas' genius that his distortion is never felt, and that he so modulated between reality and artistic effect that his figures are completely convincing.

Distortion is evident in almost all the poses of figures balancing on one foot (Figs. 90, 91). These poses, as Degas represented them, could have been held by a model only instantaneously in passing from one more stable position to another, but they were crucial to the spatial demands of his sculpture. In presenting such positions of disequilibrium as if they were humanly possible, Degas the perfectionist probably tried to make them possible by having his models "stand still in quite arbitrary poses which were in reality arrested movements between two normal postures." Julius Meier-Graefe, who asserted this, also pointed out that it was the reason "Degas' pictures and sculpture suggest motion, without depicting it—they are the balance points *between* two movements."[23] The necessity of such distortion for artistic effect was affirmed by Paul Richer in discussing running figures. "The more these figures are false from the scientific point of view," he wrote, "that is, the more the center of gravity shifts in front of the foot which touches the ground, the more intensely they seem to render the action they are intended to represent. . . . The figures which best seem to express the idea of racing are precisely those which deviate most from real truth, from scientific truth."[24] Degas himself had noticed this in relation to Greek sculpture, and asked Georges Jeanniot of the Venus de Milo, "Have you seen . . . how she goes beyond the perpendicular? She is in a position she could not hold if she were alive. By this detail, a fault to people who

[22] Paul Valéry, *Degas, Danse, Dessin* (Paris 1938), p. 96. Paul-André Lemoisne had previously noted how "Degas pense que le mouvement et l'attitude priment l'expression des physionomies" ("Statuettes" [B. 31], p. 113).

[23] Julius Meier-Graefe, *Degas* (tr. J. Holroyd-Reese, London 1923), p. 44.

[24] Paul Richer, "De la figuration artistique de la course," *Revue de l'art ancien et moderne*, 10 June 1897, p. 222. This article does for the analysis of human running movement what Duhousset did for comparable equine movement.

know nothing of art, the Greek sculptor has given his figure a splendid movement, while preserving in it the calm which distinguishes masterpieces."[25] To realize his poses of disequilibrium, Degas' subjects had to be dancers, for only with them could he find a rapid succession of balanced movements sufficiently ritualized that he could observe them repeatedly. His observation was so intense that he was eventually able to suggest successive motion in a static solid object. Many years before, David d'Angers had speculated on just such a possibility:

> When the inimitable Fanny Elssler danced in the theatre and her poses excited general enthusiasm, if she had remained in the same attitude for several minutes her most ardent admirers would have been obliged to cry "Enough!" . . . The dance is an art in which the principal effect resides in the extreme rapidity with which the dancer changes attitudes. The more movements are brief and graceful, the more numerous they are, the more also the dance provokes our enthusiasm. Are multiple movements reconcilable with sculpture? Can we even suggest the idea?[26]

Such multiple movements were often presented by Degas as successive poses in his paintings and pastels, particularly those in friezelike formats. In sculpting them, it is as if he were able to consolidate all the painted positions into one object. He was, apparently, also able to recreate from that object the multitude of successive poses that had given rise to it. Walter Sickert records that Degas once projected *Grand Arabesque* (Fig. 90) against a sheet by the light of a candle, rotating it slowly as he did so.[27] The

[25] Jeanniot, "Souvenirs" [B. 79], 15 October 1933, p. 158. Max Emmanuel suggested that "les statuaires de tous les pays helléniques se sont épris du *mouvement*: ils ont excellé à le fixer dans son instabilité même," and noted how those sculptors preferred "formes compliquées, synthétiques" ("La Danse grecque antique," *Gazette des beaux-arts*, April 1896, pp. 304-305). Muybridge also interested himself in "Grecian Dancing Girls," of whom he made some zootrope rolls (Eadweard Muybridge, *Descriptive Zoopraxography, or the Science of Animal Locomotion Made Popular*, Philadelphia 1893, p. 23).

[26] Henry Jouin, *David d'Angers, sa vie, son oeuvre, ses écrits et ses contemporains* (Paris 1878), v. II, p. 81.

[27] Sickert, "Sculptor" [B. 45], p. 180. Sickert had mentioned the incident without identifying the sculpture involved in "Degas" [B. 26], p. 185. Through the kindness of the Metropolitan Museum, and with Clare Vincent of its staff, I was able to repeat this astonishing experience. Among the least expected of its effects is that the projected figure is life-size, giving an impression of startling vitality. How Degas conceived the idea of projecting his sculpture is uncertain, but it may bear some relationship to the shadow theatres that were so popular at the end of the century. William Rubin has noted

effect of such projection is that of uninterrupted movement, what Rodin called in a similar context the "progressive unfolding of gesture."[28] It is, indeed, as if a dancer were behind the screen executing movements recorded by her cast shadow.

The development of Degas' planing pose reflects the entire development of his sculpture. In the beginning (*Arabesque over the Right Leg*, Figs. 18, 46) it was a pose in which the body was at right angles to the supporting leg, the limbs disposed parallel and close to the body. In *Grand Arabesque* (Fig. 90), the three upraised limbs are all flung out, increasing and perfecting the spatial complexity, while in subsequent versions of the figure (Fig. 91) the body and straight outstretched arm incline steeply downward, returning the motion to the ground. In all versions, the suggestion of spatial rotation is encouraged by the inward turn of the foot.

In bringing the motion of one of his favorite poses back to the ground Degas tacitly recognized that his efforts at levitation had reached their limit. In *Fourth Position Front* (Fig. 89) and other versions of the same pose, the upward spiralling of the *Spanish Dance* and the equilibrated balance of the planing figures, with only one point of contact with the ground, reached their peak in a position that seems continually and effortlessly to rise and turn from the base upward to the curved arm that returns the

Degas' love of the *pantomime anglaise* and suggested that the anatomical disjunctions of certain shadow plays may owe something to a new attitude toward the body fostered in art such as that of Degas, with its abrupt croppings, etc. (William Rubin, "Shadows, Pantomimes and the Art of the 'Fin de Siècle,'" *Magazine of Art*, March 1953, pp. 119, 121-122). Degas' apartment and studio at 37 rue Victor Massé was almost directly across the street from the Chat Noir, the most popular of the shadow theatres, and he knew both Gyp, who was on its Comité de Lecture, and Henri Rivière, its creator (Lucien Corpechot mentions frequent visits by Degas to Gyp's home in Neuilly in "Gyp," *Souvenirs d'un journaliste*, Paris 1937, v. III, p. 85. Lemoisne refers to Degas' "ami, le delicat artiste qu'est Henri Rivière," in "Statuettes" [B. 31], p. 115).

[28] Rodin, *Entretiens*, p. 108. The idea of suc-

cessive moments in time suggested by juxtaposed different views of the same pose, exploited by Degas in his drawing, was used by Rodin in the *Three Shades* at the top of the *Gates of Hell*. This group consists of three casts of one piece of sculpture arranged together at different angles. Rodin never arrived at the effect of synthesis of successive different movements suggested by the Degas sculpture. The cinematic quality of that synthesis, openly acknowledged in the experiment with Sickert, is noted by Bazin who says in speaking of the ballet sculpture, "dans cette admirable procession de ballerines on a, plus encore que dans l'oeuvre peinte, l'impression d'un déroulement cinématique" (Bazin, "Sculpteur" [B. 72], p. 301). It is also dwelt on by him in "Degas et l'objectif," *L'Amour de l'art*, July 1931, p. 303, and by Raymond Lécuyer, author of one of the first important histories of photography, in his "Degas" [B. 77], p. 40.

motion on itself. Without actually suspending his figures, Degas could go no further toward lifting them off their bases. He began, thus, to make figures that brought their motion back to the ground both by the implications of their gestures and by actual physical contact. *Dancer Rubbing Her Knee* (Fig. 76) is such a pose, as are the variations of the *Dancer Looking at the Sole of Her Right Foot* (Figs. 99, 125). In this pose Degas had some of the best of both worlds by the centrifugal implications of the outstretched arm and the centripetal ones of the downturned head and the hand grasping the foot. Referring to this latter masterful pose, Roger Fry wrote that the "silhouette is always exquisitely flowing and harmonious, and at each point full of surprises, of apparent discords which are subtly resolved,"[29] and Lincoln Johnson called attention to "its marvellous, spiralling pulsation of contracting and expanding volumes, constantly evolving, coherent rhythms not only in the solids but in the spaces between."[30]

At the moment in the late 1880s when Degas had perfected his rising configurations and begun experimenting with poses that returned on themselves he created a unique work which is among the most original not only of his own pieces but of all nineteenth-century sculpture. In *The Tub* (Fig. 92), instead of looking for a way to return a complex upright sculptural configuration to the ground, Degas simply developed that configuration along the ground to begin with. His interest in bathing figures offered him one of the few reclining human poses that is actively convincing, combining the advantages of the horizontal movement of animals with those of the spatial elaboration possible with the human figure.[31] Most innovative of all, *The Tub* is one of the few pieces of nineteenth-century sculpture—perhaps, indeed, the only piece—intended to be seen from directly above. Many reclining figures, such as Clésinger's *Woman Bitten by a Snake*, are seen diagonally from above—most funerary *gisants* are of this type—but *The Tub* is intended to be looked down on directly from above or, better, to be seen from above as well as from the sides and diagonally. At one stroke, Degas eliminated the problem of the base by simply identifying base and ground, making the ground serve as background to the sculpture. By compressing the body into a circular shape

[29] Fry, "Sculpture" [B. 46], p. 631.
[30] Johnson, *Four Painters* [B. 145], p. 24.
[31] In addition to more deeply rooted psychological causes, Degas' interest in horses, ballet dancers, and bathers reflected the changing demands of his art for more complex poses, and the bathing figure appeared in his sculpture pre-

cisely because he needed it to solve the problems discussed here. The most sculpturally promising of the few viable poses of reclining action, that of a couple making love, was largely barred to the nineteenth century because of the subject, although Géricault was aware of its potential and used it successfully.

and bringing the limbs into as close proximity as is physically possible, he also created an elaborate and masterful interpenetration of solid and void. Further, by not using a standing figure, he was able to suppress the planes so dear to academic relief-conceived sculpture. In this regard it is interesting that the same year he finished *The Tub* Degas wrote to Bartholomé, "Apart from bas-relief itself, isn't sculpture the one art to give an idea of forms while cheating all the same on relief? It's relief that spoils everything, that cheats the most, and it's in that that they believe," adding significantly, "That will lead me far."[32] These three sentences contain the very essence of his sculptural creed.

During the period between the *Little Dancer* and *The Tub* Degas' facture developed from carefully controlled and relatively highly-finished surfaces toward greater roughness, although he did not abandon his interest in careful delineation of anatomical forms. Unevennesses left by the application of pieces of wax were no longer smoothed away, and figures were built up with broader applications of material. What remained of careful finish was, however, about to disappear, probably under the influence of Medardo Rosso, and if the *Little Dancer* represents the break between Degas' early and his developed sculptural style, *The Tub* represents that between his developed and his broad late styles. New methods of facture are perhaps most apparent in the three portrait heads (Figs. 115, 117, 121), in which the features of the face are elided and the rough dabs of clay and marks of the tools are obvious. These heads represent something of an interlude in Degas' sculptural oeuvre in that they are bulk objects of quite different sculptural intent than the figures, but even in them he has managed to treat an old form in a new way. By sculpting merely a head, without even a neck to modulate it to its necessary support, Degas has allied his *Mademoiselle Salle* squarely with the more forward-looking sculpture of his time. In the very year it was made, Edmond Pottier referred to truncated portrait heads in connection with the Rodin portrait of Puvis de Chavannes.[33] When Degas did include more than just the head, as in the putative portrait of Rose Caron, he just as uncanonically used not only the shoulders but a

[32] *Lettres* [B. 7], pp. 138-139. The letter is dated 14 August 1889 by Guérin, almost exactly two months after Degas had written Bartholomé of working on the socle for *The Tub*. Degas' words recall those of Baudelaire, written in 1859, that "le bas-relief est déjà un mensonge, c'est-à-dire un pas fait vers un art plus civilisé [paint-ing], s'éloignant d'autant de l'idée pure de sculpture" (*Curiosités esthétiques, l'art romantique et autres oeuvres critiques*, Paris 1962, p. 384).

[33] Edmond Pottier, "Les Salons de 1892: la sculpture," *Gazette des beaux-arts*, July 1892, p. 22.

hand and wrist to accommodate the head shape gracefully to the flat surface on which it rested.

Although he continued to develop old themes and explore new variations, Degas' great final accomplishment was the series of seated bathers. If the active possibilities of a fully reclining figure were limited, those of a seated figure were vast and Degas realized that such figures combined the advantages of horizontal movement with those of representation of the human form.[34] Moreover, the necessary chair or seat became an extension of the ground, so that by using a common facture for both figure and chair they were welded together and grafted to the ground. Levitated figures overcome the base by rising from the ground; seated figures could overcome it by becoming part of the ground, into which they could be made to sink or from which they could seem to rise. While Degas never pushed his explorations of seated figures this far, he did marry them to the ground through the use of the chair, and he was able to do it without sacrificing his interest in sculptural space. In *Seated Woman Wiping Her Left Side* (Fig. 133), a pose which was taken up again in *Seated Woman Wiping Her Left Hip* (Fig. 137), the twisting motion of the figure, the raised elbow, and the spread feet all help create a continuous flow of space around the sculpture. In *Seated Woman Wiping Her Left Armpit* (Fig. 134), the raised arm is responded to by the hanging sleeve of the bathrobe over the back of the chair,[35] and in *Seated Woman Wiping Her Neck* (Fig. 141) the towel helps shape the spaces. *The Masseuse* (Fig. 139), Degas' only surviving free-standing group, is the finest of the series.[36] The elaboration of its re-entrant space, made possible by the use of two figures and the extenuation of the chair shape by the use of a chaise longue, make it far and away the most sculpturally satisfying of the series. For all the sculptural possibilities they opened up, the seated figures imposed two restrictions which Degas never resolved wholly successfully, and of which the *Masseuse* was largely free. The first of these was the overbearing bulk of the chair, the second the reintroduction of frontality. Much as Degas counteracted these disadvantages by twisting the limbs of his figures and by such devices as the bathrobe which partially transforms a

[34] Seated figures had been fairly common in French sculpture since the revival of interest in the eighteenth century in the 1870s. Dalou especially used them, but in his work and that of others such poses were generally exploited for their anecdotal rather than their sculptural value. At the same time Degas was sculpting seated and reclining figures, Bourdelle and Matisse also made experiments in the genre.

[35] One wonders if this sleeve reflects a knowledge of the Rodin *Balzac*.

[36] Degas had explored this subject in drawing years before (Fig. 140).

chairback, he never wholly eliminated them, and he seems only to have begun to find a solution to the new and difficult problems they presented in the *Masseuse* just before he gave up working altogether. During these last years of sculptural production Degas' facture became ever broader, the wax applied in thick ropes or large globs. This added even further to the effect of bulk characteristic of these pieces, which remain the most difficult to grasp of all his sculptural oeuvre.

Thus, through a long career, Degas created a sculpture which, although it in large part depended on the human form, was mostly free from the conventions said to be inherent in the three-dimensional representation of the human figure. It freed itself from the pedestal to explore wholly new relationships to the ground, developing a meaningful vocabulary of movement so that space could be a functioning part of the sculptural object. It was worked rapidly in wax on a small scale, although the results, "in spite of their slightness . . . produce the sensation of a great art, an art of depth and strength."[37] It led Degas to an almost belligerent naturalism, for "the passion for the not-seen obliged him to investigate the most unusual poses. To attitudes that were simply beautiful he preferred constrained movements, a certain twisting of the limbs. Encouraged by the disjointedness of dancers he wore his models out with the most painful poses."[38] It was, finally, a sculpture of a complete and triumphant modernism.

> Degas found the means to express the malady of our contemporaries, I mean movement. . . . Before him only the Chinese had found the secret of movement. That is Degas' greatness: movement in a French style.[39]

[37] Thiébault-Sisson, "Sculpteur" [B. 34].
[38] Fosca, *Degas* [B. 36], p. 45.

[39] Renoir quoted in Jean Renoir, *Renoir* (Paris 1962), p. 69.

110

9. DEGAS AND THE SEARCH FOR A MODERNIST SCULPTURE

IF DEGAS' sculpture was rooted in the past and reflected major contemporary concerns, its continuing importance is based not only on its inherent quality but on the number of subsequently important problems with which it first came to grips and the advanced ideas and devices it first explored. Even in the most conservative of his efforts, the three portrait heads, Degas considered ways of adapting sculpture to its base which were to become important to later sculptors. Perhaps unsatisfied with the abruptness of the neckless head, Degas tilted the head in his putative portrait of Rose Caron to disrupt its normal balance in favor of a sculpturally more interesting pose, and used the hand to modulate between head and base (Fig. 121). The easy curving relationship thus created was one exploited twenty years later by Brancusi in his *Muse* (Fig. 122) and in the various versions of his portrait of Mademoiselle Pogany. More important, Degas' efforts to make his figures rise until they had to be suspended physically, which Paul Valéry compared to a horse in perfect equilibrium appearing to hang from its jockey by the reins,[1] advanced a sculptural idea that was not to be explored in depth until the work of Alexander Calder. Actual suspension and actual movement are the obvious next steps from figures such as the *Spanish Dance* (Fig. 69). Given the revolutionary quality of Degas' sculptural thinking one hesitates to suggest that he failed to take these steps because they were too daring. Rather, he may have realized that actual movement had serious artistic limitations and that the most meaningful efforts to create a sculpture of movement had to be made with static objects and by allusion. Finally, Degas' polychromy evolved in such a way as to be startlingly modern in its implications. The freedom with which he incorporated what were essentially *objets trouvés* into his sculpture suggests similar, if somewhat freer, usages by the Cubists and Futurists, and brings to mind the injunction of Boccioni's *Technical Manifesto of Futurist Sculpture* that modernist sculpture must "destroy the wholly literary and traditional nobility of marble and bronze. Deny the exclusivity of one material for the entire construction of a sculp-

[1] See chapter 8, note 9.

111

tural ensemble. Affirm that even twenty different materials can contribute in a single work toward the end of plastic emotion. Let us enumerate some: glass, wood, cardboard, iron, cement, hair, leather, fabric, mirrors, electric light, etc. etc."[2]

The additive process by which Degas incorporated such matter into his sculpture tended to make his working method one of assembling sculpture rather than modelling it in the normal sense. Although such ideas are not unique to Degas in the nineteenth century—Barye is said to have rearranged his figures freely in relationship to each other and to their bases, and Rodin created groupings of assorted detached anatomical parts—they have greater significance in relation to his work than in relation to that of any other sculptor of his time. This is because his figures are, in a very real sense, constructed—assembled in relation to external and mechanical considerations that have little to do with naturalistic necessity, although convincing naturalistic appearance is never sacrificed. As Ragnar Hoppe has observed, "Degas was a constructor and a forerunner of the radical artists of our day in the sense that he was one of the first who consciously dared to deform—in order to be more realistic and expressive."[3] Degas' deformations consist largely in his calculating the unstable equilibrium of his figures so that solid and void play an equal role in the sculptural configuration. Because of this fact, the gesture of the figure is externalized in such a way that its human identity and the expressive significance of its actions are suppressed. This tendency for the body to become uninhabited has a long and respectable history, as David d'Angers recognized in observing that, "since Raphael and Michelangelo, artists have elaborated draperies and movements, they have put life on the outside."[4] J. Laude has noted one of its nineteenth-century manifestations in works by artists interested in the circus, a source of ritualized and equilibrated movement exploited by Degas only in his *Miss LaLa at the Cirque Fernando*. "We perceive there," Laude wrote, "the traces of a new curiosity for the body captured in fresh attitudes. The body is no longer the receptacle of the soul, whose inclinations and special psychology it expresses, but tends to become a tool perfectly adapted to its functions: the extreme point of this conception is found in the work of

[2] Umberto Boccioni, *Manifesto tecnico della scultura futurista* (Milan 1912). Italian interest in assemblages of materials may owe something to Medardo Rosso, who incorporated pipes, miniature electrified lamp posts, etc., into his early sculpture (Margaret Scolari Barr, *Medardo Rosso*, New York 1963 passim). This was before he and Degas had had any contact.

[3] Hoppe, *Degas* [B. 44], p. 81 (translation by Kaaren Grimstad).

[4] *Les Carnets de David d'Angers* (Paris 1958), v. I, p. 255.

Léger, in which the body becomes the equivalent of a machine."[5] It might be added that, while Léger made the equivalence of the human body and the machine more obvious, Degas realized a more complete and meaningful synthesis of human and mechanical action in his sculpture.[6] Léger's equivalence depended on combining the identities of man and machine, Degas' synthesis on suppressing identity altogether and appealing to fundamental physical laws. All of this is simply to say that Degas' sculpture is highly abstract—more abstract than any other until well into the twentieth century.[7]

Just how far Degas went toward abstraction can be gauged by comparing his sculpture with that of Rodin. The comparison is all the more instructive in that it shows to what lengths Degas was able to pursue his synthesis of classical form, academic method, and contemporary style, bringing out of their coalition an art wholly new in its implications. Conversely, one sees how Rodin's conventional sculptural training may have blinded him to the possibilities explored by Degas until the very end of his life when he probably turned to them partly under Degas' influence. Among the most striking of the comparisons of specific works by Rodin and Degas is that between a small Rodin plaster donated by the artist to the Metropolitan Museum in 1912 (Fig. 128) and Degas' *Pregnant Woman* (Fig. 127), which is identical in pose and probably close in date. The protective gesture of Rodin's figure is of singular importance to the effect of the work and is emphasized by the importance of the single visible hand which attempts to hide the aged body, otherwise revealed in the working of the fleshy arms and in the sagging breasts. The emotions aroused by the piece are inseparable from one's empathetic response to the figure as a human being, almost as an individual, despite the fact that there is no head. It is clearly related to the *She Who Was Once the Helmet Maker's Beautiful Wife*, the title of which makes clear the point Rodin wished to convey. The sculptural spaces around the legs are suppressed by the mass of plaster into which they melt, and those around the arms are minimized by placing the elbows close to the body. Both devices concentrate the effect of the piece in the body itself. That Rodin could bring off such a powerful poetic—not to say literary—effect at this late date is a mea-

[5] J. Laude, "Le Monde du cirque et ses jeux dans la peinture," *Revue d'esthétique*, October-December 1953, p. 432.

[6] Gauguin wrote that "les danseuses de Degas ne sont pas de femmes. Ce sont des machines en mouvement avec de gracieuses lignes pro-

digieuses d'équilibre" (*Avant et Après*, Paris 1923, p. 117).

[7] As early as 1903 Camille Mauclair had declared that "l'art de M. Degas est abstrait" ("Edgar Degas," *La Revue de l'art ancien et moderne*, November 1903, p. 382).

113

sure of his genius. The Degas figure, on the other hand, has no age, no individuality, no occupation. It has generally been referred to as being pregnant, but this is by no means clear, the distension of the stomach being ambiguous in nature and no greater than that of the Rodin. The hands are all but obliterated, the elbows thrust out in a gesture meaningless expressively but crucial sculpturally, the legs spread apart and thrusting in opposite directions, the mass of the stomach used as a counterpoise to that of the buttocks. Although the figure is by no means among Degas' most successful, it is clearly much more abstract than that of Rodin and much less engaging of recognizable emotions.

The Tub (Fig. 92) is no less revealing in comparison with works by Rodin. Women in basins were a theme explored more than once by the younger master, almost always for the associations possible between ideas of femaleness and those of a spring—that is, for basically sexual associations—and often to explore the sculptural problem of inside and outside.[8] For Degas there was no inside, his figure being wholly exposed to view and the vessel in which it reclines merely a realistic excuse for its existence. When The Tub is seen next to one of the plaster studies for the Gates of Hell in a not dissimilar position (Fig. 95), the differences are at once apparent. In the Rodin study, the drawn-up legs, the arms, one flung out, one thrown over the body, and the head thrown back with its mouth open are all expressive distortions intended to dramatize the emotions felt by the figure and its relationship to the situation in which it finds itself. The Degas figure, on the other hand, has no emotions, its prosaic gesture being merely an excuse for an elaborate sculptural configuration. Its distortions are those necessitated by that configuration itself and not by any contextual situation with which the figure can be associated.

Finally, it is instructive to compare the use made by Degas and Rodin of figures in almost identical poses with respect to movement. The conceptual differences between Dancer Looking at the Sole of Her Right Foot (Fig. 99) and another of the Rodin studies for the Gates (Fig. 101) are so great that one fails at first to realize the similarity of the pose. The Rodin is clearly a fleeing figure, every element of its body used to convey the idea of running, the sculptural movement of space around it sacrificed to the governing idea of flight. The Degas, on the contrary, exploits the same position for entirely spatial purposes, the figure's movement being of no importance, while move-

[8] Gustave Kahn mentioned the Rodin women in basins in connection with Degas in his column "Art," Mercure de France, 1 August 1931, p. 711.

ment of space around it is crucial. This is most apparent in the major difference between the two, the position of the arms. The arms of the Rodin are again kept close to the body, the one seeming to emphasize flight by in effect streamlining the figure, the other apparently shielding the face in a gesture of shame or fright. The arms of the Degas are placed solely so as to balance the three-dimensional configuration, to return that configuration upon itself, and to encourage an all-round experience of the piece.

Rodin's constant preference for expressive distortion is evident even in his late small studies of dancing figures, making the calculated balance of a Degas seem effortless by comparison. "In Rodin, in addition to the curiosity of the anatomist, there is the wish to express passion, sensuality, or pain. In Degas, none of that; he seeks simply new combinations of that assemblage, the human body."[9] Although Rodin was the more monumental artist, Degas was the more advanced in his spatial thinking. When Rodin's sculpture opened up, it tended to do so as a series of disjunctive masses, rather than in relation to intervening spaces. His most complex spatial conception, the *Burghers of Calais*, was conceived as a series of individual figures the juxtapositions of which were calculated later, and hence its spaces are not sculpturally highly charged. This procedure is the opposite of that of Degas, who, "instead of breaking up form, which sometimes in Rodin animates a disordered internal movement . . . condenses it without, however, rendering it rigid, transforming it into radial lines of force which plow through space."[10] In the words of Hilton Kramer, "Placed in juxtaposition with Rodin's, the work of Degas seems to assert a prior claim to the title of the first modernist sculpture."[11] Thiébault-Sisson had suggested as much thirty-six years earlier in seeing in the Degas sculpture, "a fresh art form in which the rigorous establishment of volumes is joined to the loftiest and most austere observation and to an acute sense of modernism."[12]

The nature and extent of Degas' sculptural modernism can perhaps best be gauged in relation to ideas of time. Western art since the Renaissance has traditionally concerned itself with fixing a moment in time or creating a moment outside of time, what Gombrich, following James Harris, has called the *punctum temporis*.[13] In painting this was accomplished by perspective, chiaroscuro, and other devices which tended to

[9] Fosca, *Degas* [B. 36], p. 45.
[10] Brest, "Peintres Sculpteurs" [B. 124], p. 283.
[11] Hilton Kramer, "Month in Review," *Arts*, September 1957, p. 51.

[12] Thiébault-Sisson, "Sculpteur" [B. 34].
[13] E. H. Gombrich, "Moment and Movement in Art," *Journal of the Warburg and Courtauld Institutes*, v. 27 (1964), p. 294.

delimit space absolutely and hence suggest the fixation of time. In sculpture similar pictorializing devices accomplished approximately the same thing, the end being to allow the object to be seized instantaneously by the viewer. Sculpture, however, being possessed of more than two physical dimensions and usually having to be seen from more than one point of view to be comprehended, lent itself more readily to distension of the moment and extended temporal experience, and Bernini and his followers played on these possibilities by creating figures that tended to explode into the space surrounding them. By the end of the eighteenth century this tendency culminated in groups of figures responding to one another across substantial distances and in the structural dissolutions of the *rocaille*. Such use of undelimited space as a sculptural element woven around increasingly movemented figures attacked the *punctum temporis* not only by suggesting movement itself, and hence temporal succession, but by extenuating the viewer's experience of the object or objects involved. Among the major problems for modernist sculpture was to return to this eighteenth-century sculptural tradition, obscured by Napoleonic neoclassicism, and build a meaningful development on its foundation, as well as to find ways in which temporal continuity could be suggested in a single solid object. In the nineteenth century only Degas, led on by his interest in movement and his powerful ability to synthesize, developed a sustained sculptural expression based on temporal simultaneity. Thinking "no longer in fixed terms of space but in flexible terms of duration,"[14] he turned to the dance and to "the dancers who play with . . . space . . . but always reconcile it with time, which constitutes the great mystery of their art."[15] It was a solution familiar to Indian art, with its nonwestern temporal conceptions, for the dancing Siva figures certainly known to Degas "are far from showing one phase of the dance or one moment only of time. Dance in them is a state and suggests the totality of the flux of time."[16] They do this in precisely the way developed by Degas, by making "space and figure . . . of the same substance,"[17] and by suggesting unfolding, growing configurations. "This growing in space . . . manifests the duration of time."[18] By wholly externalizing his sculpture, by treating his material as one sculptural sub-

[14] René Huyghe, "Degas ou l'art entre le réel et la fiction," *Revue des deux mondes*, 15 June 1955, p. 598.

[15] Madeleine Vincent, *La Danse dans la peinture française contemporaine* (*de Degas à Matisse*) (Lyon 1944), p. 27.

[16] Heinrich Zimmer, "Some Aspects of Time in Indian Art," *Journal of the Indian Society of Asiatic Art*, June 1933, p. 38. I am indebted to the late Benjamin Rowland for suggesting this article to me.

[17] Ibid., p. 43.

[18] Ibid., p. 46.

stance, by thinking in terms of continuous transition so that one may "enter" his sculpture at any point, and by developing configurations in which void was an equal partner with solid, Degas not only distended actual temporal experience of his works, but managed to convey the impression of the passage of time within the object itself, to compress, as it were, many successive moments into one solid object.[19] In this sense he ranks as a pioneer alongside Cézanne, who achieved a similar effect pictorially in paintings that seem to have coalesced simultaneously at all points of the canvas—hence the completely satisfying quality of his "unfinished" pictures—and Joyce, who worked on several parts of *Ulysses* at once, with the result that it can be meaningfully entered at almost any point.[20]

When one contemplates the work of Degas today in the light of the subsequent development of sculpture, which is marked by a clear tendency to exchange forms acting as filled volumes for other forms acting indisputably as structural indications of space, one understands that it is with him that the plastic language of our time begins to take form.[21]

[19] Rodin, although concerned with temporal phenomena, always dealt in terms of the succession of isolated movements, as his comments to Paul Gsell on the three successive moments represented in the Rude *Maréchal Ney* indicate (Auguste Rodin, *L'Art, entretiens réunis par Paul Gsell*, Paris 1953, pp. 99-100, 103-104). Pierre du Colombier has drawn a parallel between the Ney and Degas' sculpture ("Rythmes," *Sculpture et danse*, Paris 1942, p. 6). The idea of time in relation to space and to movement is discussed by E.-J. Marey, *La Photographie du mouvement* (Paris 1892).

[20] Arnold Hauser has pointed out the simultaneity characteristic of *Ulysses* in "The Conceptions of Time in Modern Art and Science," *Partisan Review*, Summer 1956, p. 333.

[21] Brest, "Peintres Sculpteurs" [B. 124], p. 284.

APPENDIX

Critical Reaction to the Exhibition of
the Little Dancer in 1881

JULES CLARETIE, *La Vie à Paris: 1881* (Paris, n.d.), pp. 150-151.

(This material originally appeared under the same title in *Le Temps* for 5 April 1881, p. 3, with the exception of the first paragraph, which then read as follows: "M. Degas, qui a de l'esprit infiniment et infiniment de talent aussi,—un vrai talent et un talent vrai,—devait exposer une danseuse modelée en cire. On ne voit jusqu'à présent que la cage de verre destinée à recevoir et à protéger la statuette, qu'on dit charmante. M. Degas a envoyé des dessins curieux, mais on l'attend à sa sculpture. Il est bien assez narquois pour ne pas l'envoyer.")

M. Degas, qui a de l'esprit infiniment et infiniment de talent aussi,—un vrai talent et un talent vrai,—a exposé, à coté de dessins curieux, de profils d'assassins, d'études saisissantes de gibiers de cours d'assises, une danseuse en cire d'un naturalisme étrangement attirant, troublant, singulier et qui rappelle, avec une note moderne très parisienne et très aiguisée, le réalisme des sculptures polychromes espagnoles. Le museau vicieux de cette fillette à peine pubère, fleurette de ruisseau, est inoubliable.

Car—voilà l'originalité de cette Exposition des Indépendants—ils commencent à affirmer leur indépendance sous la forme sculptée. Ce n'était pas assez de la couleur. Il leur faut la cire, ou le plâtre ou le bronze. Nous allons avoir, bone Deus! des sculpteurs *impressionnistes*! Je ne m'en plains pas, s'il s'agit de M. Degas, mais je sais des sculpteurs qui font déjà du Fortuny en terre cuite. S'imagine-t-on ce que cela peut être et quelle école de la torsion, de la contorsion, de la déviation et du désossement cela peut nous donner?

—Il faut bien protester, disent-ils, contre les gens à casque, les *pompiers* de l'institut!

Et, pour fuir les pompiers, ils s'engagent dans les zéphirs et dans les compagnies *d'indiscipline*.

C. E. [CHARLES EPHRUSSI], "Exposition des artistes indépendants," *La Chronique des arts et de la curiosité*, 16 April 1881, p. 126.

Les exposants se partagent naturellement en deux groupes; ceux qui méritent réellement le nom d'indépendants parce qu'ils apportent dans l'art une note nouvelle, un accent original,

et ceux qui ne se séparent que timidement des traditions acquises. A la tête du premier groupe se place M. Degas, qui expose de saisissantes et incisives études d'assassins d'après des maîtres en ce genre, Abadie, Kirail et Knoblock, et surtout une statuette en cire, une danseuse de quatorze ans avec son jupon et tarlatane, grêle, laide à faire peur, mais campée, cambrée, mouvante, de ce mouvement anguleux ordinaire aux apprenties de la danse, d'un dessin ferme accusé et pénétrant qui indique avec une sagacité infinie les allures intimes et la profession de la personne.

Elle se présente en demi-nature, debout dans son vêtement de travail, lasse et fatiguée, détendant ses membres harassés, étirant les bras sur le dos; la tête fine et sentie, malgré son épouvantable laideur, avec un nez vulgairement retroussé, une bouche saillante et un front caché par des cheveux qui tombent presque sur de petits yeux à demi fermés. Voyez, sous un maillot de soie à plis menus, la courbure nerveuse des jambes, les solides attaches des pieds enfermés dans ses souliers usés, le torse osseux et souple comme l'acier. Ce n'est point là, certes, la Terpsichore aux lignes classiques, c'est la rat de l'opéra dans son expression moderne, apprenant son métier, avec tout sa nature et son stock de mauvais instincts et de penchants vicieux. On voudrait que l'exécution fût plus poussée, que la couleur de la cire fut mieux fondue dans ces plaques sales qui gâtent l'aspect général. Voilà vraiment une tentative nouvelle, un essai de réalisme en sculpture. Un artiste vulgaire eût fait de cette danseuse une poupée, M. Degas en a fait une oeuvre de forte saveur, de science exacte, sous une forme vraiment originale.

BERTALL, "Exposition des peintres intransigeants et nihilistes," *Paris-Journal*, 21 April 1881, p. 1.

Signalons encore un essai nouveau de sculpture, exposé en vedette au milieu d'un des salons. C'est une danseuse. Naturellement, cette danseuse est affreuse, elle est modelée en terre cuite, et vêtue d'un petit jupon en véritable mousseline blanche. Nous avons vu des groupes d'adeptes, nihilistes hommes et femmes, se pâmer d'aise devant cette danseuse et sa jupe de mousseline. C'est là du moins une innovation. Des horizons nouveaux semblent s'ouvrir pour les costumiers et les modistes. . . . Les noms de ces-gens là [the artists exhibiting], nous ne voulons même pas les répéter ici, le lecteur saura suppléer à notre silence.

ELIE DE MONT, "L'Exposition du Boulevard des Capucines," *La Civilisation*, 21 April 1881, p. 2.

Me voilà tout posté pour parler de la petite danseuse en cire de M. Degas. M. Degas passe pour un convaincu; au dire de ceux qui le connaissent, c'est un homme d'esprit, très doué, un tempérament, une nature.

Je serais bien curieux de l'entendre plaider la cause de sa marcheuse de quatorze ans, et expliquer quel peut être, au point de vue de l'art, au point de vue même du naturalisme, si en vogue de nos jours, l'intérêt d'une production de ce genre. J'admets que certains mouvements soient justes, mouvements des jambes, mouvements des bras même, mouvement général, si on veut. Et puis après? Cela ne suffit pas pour donner une chose vraie et vivante. La preuve que votre fillette de quatorze ans n'est pas vraie, c'est qu'elle n'a rien de jeune; ses maigreurs sont des sécheresses, ce sont les maigreurs, les raideurs de la vieillesse et non celles de l'enfance. Avez-vous pu, réellement, rencontrer un modèle aussi horrible, aussi repoussant? Et, en admettant que vous l'ayez rencontré, pourquoi l'avez-vous choisi? Je ne demande pas à l'art d'être toujours gracieux, mais je ne crois pas que son rôle soit de représenter de parti pris la laideur. Votre rat d'opéra tient du singe, de l'aztèque et de l'avorton. Plus petite, on serait tenté de la renfermer dans un bocal à esprit de vin.

L'intérêt est-il dans une exécution remarquable?—Non.—C'est à peine une maquette. Où se trouve-t-il, alors?

PAUL DE CHARRY, "Les Indépendants," *Le Pays*, 22 April 1881, p. 3.

M. Degas, le peintre des danseuses, s'est cette fois intitulé leur sculpteur; il nous en a donné une en cire. Celle-ci, fillette de 13 à 14 ans, est d'une constructure et d'un réel extraordinaire. Le modèle est parfait, et M. Degas peut le refaire en plâtre ou en pierre, ce sera un vrai chef-d'oeuvre.

PAUL MANTZ, "Exposition des oeuvres des artistes indépendants," *Le Temps*, 23 April 1881, p. 3.

A vrai dire, l'élément nouveau de l'exposition du boulevard des Capucines, le fait dont il faudra se souvenir, c'est l'entrée, plus ou moins triomphale, des indépendants dans un art qu'ils n'avaient pas encore songé à rajeunir, la sculpture. Et quand nous parlons de sculpture, nous ne pensons pas le moins du monde à M. Paul Gauguin.

Le véritable, le seul sculpteur de l'académie intransigeante, c'est M. Degas. Avec quelques pastels qui n'agrandiront pas sa renommée, il expose la Petite Danseuse de quatorze ans, la statuette en cire qu'il nous avait depuis longtemps promise. L'année dernière, M. Degas s'était borné à nous montrer la cage de verre destinée à servir d'asile à cette figurine; mais la sculpture ne s'improvise pas: M. Degas a voulu perfectionner son oeuvre, et nous savons tous que, pour modeler une forme et la rendre vivante, Michel-Ange lui-même demandait quelque répit.

Le morceau est achevé et, avouons le tout de suite, le résultat est presque effrayant. On tourne autour de cette petite Danseuse, et l'on n'est pas rassuré. On dira sans doute un peu de bien et beaucoup de mal de cette statuette, qui avait été annoncée, mais qui reste imprévue

dans son réalisme à outrance. La malheureuse enfant est debout, vêtue d'une robe de gaze à bon marché, un rubain bleu à la ceinture, les pieds chaussés de ces souliers souples qui rendent plus facile les premiers exercises de la chorégraphie élémentaire. Elle travaille. Cambrée et déjà un peu lasse, elle étire ses bras ramenés sur le dos. Redoutable, parce qu'elle est sans pensée, elle avance, avec une bestiale effronterie, son visage ou plutôt son petit museau, et le mot ici est tout à fait à sa place, car cette pauvre fillette est un rat commencé. Pourquoi est-elle si laide? Pourquoi son front, que ses cheveux couvrent à demi, est-il déjà, comme ses lèvres, marqué d'un caractère si profondément vicieux? M. Degas est sans doute un moraliste: il sait peut-être sur les danseuses de l'avenir des choses que nous ne savons pas. Il a cueilli aux espaliers du théâtre une fleur de dépravation précoce, et il nous la montre flétrie avant l'heure. Le résultat intellectuel est atteint. Les bourgeois admis à contempler cette créature de cire restent un instant stupéfaits, et l'on entend des pères qu'il s'écrient: Fasse le ciel que ma fille ne devienne pas une danseuse!

Dans cette désagréable figurine, il y a cependent, avec une intention dictée par l'esprit d'un philosophe à la Baudelaire, quelque chose qui vient d'un artiste observateur et loyal. C'est la parfaite verité de la pantomime, la justesse du mouvement presque mécanique, la grâce artificielle de l'attitude, la sauvage inélégance de l'écolière qui deviendra une femme et pour laquelle les diplomates feront des folies. Quant à l'expression du visage, elle est visiblement cherchée. M. Degas a rêvé un idéal de laideur. Homme heureux! il l'a réalisé. Certains détails sont étudiés fortement: les bras ont la maigreur voulue; ils ont bien l'âge indiqué, ils pourraient être plus propres.

Il n'est pas essentiel qu'une figure de cire ait la netteté reluisante et rose des poupées qui tournent aux vitrines des coiffeurs; mais, puisque le naturalisme est ici la loi suprême, il est rationnel que les formes se révêtent de colorations exactes. Comment d'ailleurs persuader aux spectateurs que les petites apprenties de la salle de danse n'ont jamais entendu parler de l'art naïf qui consiste à se laver les mains et les bras? Les maculations, les taches, les scories que M. Degas a inscrites sur les chairs de cette infortunée sont vraiment horribles à voir, et elles sont en contradiction avec les principes de l'école comme avec l'effet optique à produire, puisqu'elles aboutissent à une illusion diminuée. Que reste-il donc à la Petite Danseuse de quatorze ans? La vérité singulière du mouvement général, l'instructive laideur d'un visage où tous les vices impriment leurs détestables promesses. Le spectacle n'est pas sans éloquence; mais il est troublant. Combien les idéals diffèrent! Beaucoup, parmi les artistes, vont cherchant la grâce qui éveille le rêve et qui rassure: d'autres, moins consolants, sont séduits par l'épouvante. M. Degas est un implacable. S'il continue à faire de la sculpture et s'il conserve son style, il aura une petite place dans l'histoire des arts cruels.

NINA DE VILLARS, "Exposition des artistes indépendants," *Le Courrier du soir*, 23 April 1881, p. 2.

Mais il me tarde d'arriver au morceau capital de cette exposition: une statuette en cire de M. Degas désignée au livret: Petite danseuse de quatorze ans. En jupon de tarlatane, en corset de coutil, en chaussons roses, sa lourde chevalure nouée par un ruban vert, la maigre gamine de la classe des petits tord son frêle corps dans une pose cruelle.

Il faut souffrir pour arriver à l'aérienne légèreté qui fait la sylphide et le papillon; maintenant c'est la réalité triste du métier; la figure toute terreuse est contractée par l'effort. L'enfant est laide, mais d'exquises finesses du menton, des paupières, des attaches du pied, font présager des royautés futures.

J'ai éprouvé devant cette statuette une des plus violantes impressions artistiques de ma vie: depuis bien longtemps, je rêvais cela.

En voyant dans des églises de village, ces vierges, ces saintes en bois colorié, couvertes d'ornements, d'étoffes et de bijoux, je me disais: Comment un grand artiste n'a-t-il pas l'idée d'appliquer ces procédés si naïfs et si charmante à un oeuvre moderne et puissante, et voilà que je trouve mon idée realisée c'est une vraie joie!

Autour de moi on disait: c'est une poupée. Que de difficultés pour habituer le public à regarder sans colère, une chose qu'il n'a pas déjà vue la veille.

Mais, que l'artiste se rassure: l'oeuvre incomprise aujourd'hui sera peut-être un jour dans un Musée regardée respectueusement comme la première formule d'un art nouveau.

HENRY TRIANON, "Sixième Exposition de peinture par un groupe d'artistes," *Le Constitutionnel*, 24 April 1881, p. 2.

M. E. Degas paraît être un de ces naturalistes là.

Veut-il nous présenter une statuette de danseuse, il la choisit parmi les plus odieusement laides; il en fait le type de l'horreur et de la bestialité. Eh! oui, certes, dans les bas-fonds des écoles de danse, il est de pauvres filles qui ressemblent à ce jeune monstre, du reste bien planté et soigneusement étudié; mais à quoi ces choses-là sont-elles bonnes dans l'ordre de la statuaire? Mettez-les dans un musée de zoologie, d'anthropologie, de physiologie, à la bonne heure; mais, dans un musée d'art, allons donc!

M. Degas est un homme de talent que la maladie à la mode a saisi. Il est trop robuste pour n'en pas guérir.

COMTESSE LOUISE, "Lettres familières sur l'art," *La France nouvelle*, 1-2 May 1881, p. 3.

Quant au maître Degas, tempérament de peintre très puissant et dont le dessin est des plus

savants, il s'est simplement moqué de ses amis, de ses admirateurs et de ses jeunes collègues en exposant quelques caricatures, croquis pris à la cour d'assises. De plus, pour compléter la plaisanterie, il a étalé sous une cage de verre, une cire grandeur nature, représentant une petite Nana de quinze ans, costumée en danseuse et devant laquelle s'extasient les imbéciles.—La chose, m'-t-on assuré, doit-être transportée plus tard au Musée Dupuytren!

Joris-Karl Huysmans, "L'exposition des indépendants en 1881," *L'art moderne* (Paris, 1908), pp. 250-255.

Dans ses plus insouciants croquis, comme dans ses oeuvres achevées, la personnalité de M. Degas sourd; ce dessin bref et nerveux, saisissant comme celui des Japonais, le vol d'un mouvement, la prise d'une attitude, n'appartient qu'à lui; mais la curiosité de son exposition n'est pas, cette année, dans son oeuvre dessinée ou peinte, qui n'ajoute rien à celle qu'il exhiba en 1880 et dont j'ai rendu compte; elle est tout entière dans une statue de cire intitulée *Petite Danseuse de quatorze ans* devant laquelle le public, très ahuri et comme gêné, se sauve.

La terrible réalité de cette statuette lui produit un évident malaise; toutes ces idées sur la sculpture, sur ces froides blancheurs inanimées, sur ces mémorables poncifs recopiés depuis des siècles, se bouleversent. Le fait est que, du premier coup, M. Degas a culbuté les traditions de la sculpture comme il a depuis longtemps secoué les conventions de la peinture.

Tout en reprenant la méthode des vieux maîtres espagnols, M. Degas l'a immédiatement faite toute particulière, toute moderne, par l'originalité de son talent.

De même que certaines madones maquillées et vêtues de robes, de même que ce Christ de la cathédrale de Burgos dont les cheveux sont de vrais cheveux, les épines de vrais épines, la draperie une véritable étoffe, la danseuse de M. Degas a de vraies jupes, de vrais rubans, un vrai corsage, de vrais cheveux.

La tête peinte, un peu renversée, le menton en l'air, entr'ouvrant la bouche dans la face maladive et bisé, tirée et vieille avant l'âge, les mains ramenées derrière le dos et jointes, la gorge plate moulée par un blanc corsage dont l'étoffe est pétrie de cire, les jambes en place pour la lutte, d'admirables jambes rompues aux exercices, nerveuses et tordues, surmontées comme d'un pavillon par la mousseline des jupes, le cou raide, cerclé d'un ruban porreau, les cheveux retombant sur l'épaule et arborant, dans le chignon orné d'un ruban pareil à celui du cou, de réels crins, telle est cette danseuse qui s'anime sous le regard et semble prête à quitter son socle.

Tout à la fois raffinée et barbare avec son industrieux costume, et ses chairs colorées qui palpitent, sillonnées par le travail des muscles, cette statuette est la seule tentative vraiment moderne que je connaisse, dans la sculpture.

Je laisse, bien entendu, de côté les essais déjà osés des paysannes tendant à boire ou

apprenant à lire à des enfants, des paysannes renaissance ou grec, attifées par un Draner quelconque; je néglige également cette abominable sculpture de l'Italie contemporaine, ces dessus de pendule en stéarine, ces femmes mièvres, érigées d'après des dessins de gravure de modes, et je rappelle simplement une tentative de M. Chatrousse. Ce fut en 1877, je crois, que cet artiste essaya de plier le marbre aux exigences du modernisme; l'effort rata; cette froide matière propre au nu symbolique, aux rigides tubulures des vieux peplums, congela les pimpantes coquetteries de la Parisienne. Bien que M. Chatrousse ne fut pas un esprit subalterne, le sens du moderne et le talent nécessaire lui manquaient, cela est sûr, mais il s'était aussi trompé en faisant choix de cette matière monochrome et glacée, incapable de rendre les élégances des vêtements de nos jours, les mollesses du corps raffermies par les buscs, le gingembre des traits avivés par un rien de fard, le ton mutin que prennent des physionomies de Parisiennes avec des cheveux à la chien pleuvant sous ces petites toques qu'allume tout d'un côté une aile de lophophore.

Reprenant, après M. Henry Cros qui s'en sert pour transporter dans la sculpture les figurines peintes dans les vieux missles et, après M. Ringel dont l'oeuvre n'est d'aucune époque, le procédé de la cire peinte, M. Degas a découvert l'une des seules formules qui puissent convenir à la sculpture de nos jours.

Je ne vois pas, en effet, quelle voie suivra cet art s'il ne rejette résolument l'étude de l'antique et l'emploi du marbre, de la pierre ou du bronze. Une chance de sortir des sentiers battus lui a été jadis offerte par M. Cordier, avec ses oeuvres polychromes. Cette invite a été repoussée. Depuis des milliers d'ans, les sculpteurs ont négligé le bois qui s'adapterait merveilleusement, selon moi, à un art vivant et réel; les sculptures peintes du moyen âge, les rétables de la cathédrale d'Amiens et du musée de Hall, par example, le prouvent, et les statues qui se dressent à Sainte-Gudule et dans la plupart des églises belges, des figures grandeur nature de Verbruggen d'Anvers et des autres vieux sculpteurs des Flandres, sont plus affirmatives encore, s'il est possible.

Il y a, dans ces oeuvres si réalistes, si humaines, un jeu de traits, une vie de corps qui n'ont jamais été retrouvés par la sculpture. Puis, voyez comme le bois est malléable et souple, docile et presque onctueux sous la volonté de ces maîtres; voyex comme est et légère et précise l'étoffe des costumes taillée en plein chêne, comme elle s'attache à la personne qui la porte, comme elle suit ses attitudes, comme elle aide à exprimer ses fonctions et son caractère.

Eh bien, transférez ce procédé, cette matière, à Paris, maintenant mettez-les entre les mains d'un artiste qui sente le moderne comme M. Degas, et la Parisienne dont la très spéciale beauté est faite d'un mélange pondéré de naturel et d'artifice, de la fonte en un seul tout des charmes de son corps et des grâces de sa toilette, la Parisienne avortée de M. Chatrousse viendra à terme.

Mais aujourd'hui le bois n'est plus sculpté que par les ornemanistes et les marchands de meubles; c'est un art auquel il faut souhaiter que l'on revienne de préférence même à celui de la cire si expressive et si obéissante, mais si indurable et si fragile, un art qui devra combiner les éléments de la peinture et de la sculpture; car, en dépit de ses tons vivants et chauds, le bois à l'état de nature demeurerait trop incomplet et trop restreint, puisque les traits d'une physionomie s'atténuent ou se fortifient, selon la couleur des parures qui les assistent, puisque ce je ne sais quoi qui fait le caractère d'une figure de femme, est, en grande partie, donné par le ton de la toilette dont elle est vêtue. Forcément, cette conclusion se pose: ou bien l'inéluctable nécessité d'employer certaines matières de préférence à d'autres et le despotique besoin d'allier deux arts, reconnu dès l'antiquité puisque les Grecs mêmes avaient adopté la sculpture peinte, seront compris et reconnus par les artistes actuels qui pourront alors aborder les scènes de la vie moderne, ou bien, usée et flétrie, la sculpture ira, s'ankylosant, d'année en année, davantage et finira par tomber, à jamais paralysée et radoteuse.

Pour en revenir à la danseuse de M. Degas, je doute fort qu'elle obtienne le plus léger succès; pas plus que sa peinture dont l'exquisité est inintelligible pour le public, sa sculpture si originale, si téméraire, ne sera même pas soupçonnée; je crois savoir, du reste, que, par excès de modestie ou d'orgeuil, M. Degas professe un hautain mépris pour le succès; eh bien, j'ai grand 'peur qu'il n'ait, une fois de plus, à propos de son oeuvre, l'occasion de ne pas s'insurger contre le goût des foules.

126

BIBLIOGRAPHY

DOCUMENTS

Unpublished
1. Thirty Degas notebooks (published in part; see below)
2. Degas correspondence (published in part; see *Lettres* below)
3. Correspondence between Mary Cassatt and Mrs. Horace Havemeyer

Published: Notebooks
4. Lemoisne, Paul-André, "Les Carnets de Degas au Cabinet des Estampes," *Gazette des beaux-arts*, April 1921, pp. 219-231.
5. Boggs, Jean Sutherland, "Degas Notebooks at the Bibliothèque Nationale," *Burlington Magazine*, May 1958, pp. 163-171; June 1958, pp. 196-205; July 1958, pp. 240-246.
6. Reff, Theodore, "The Chronology of Degas's Notebooks," *Burlington Magazine*, December 1965, pp. 606-616.

Published: Correspondence
7. Guérin, Marcel (ed.), *Lettres de Degas* (pref. Daniel Halévy, Paris 1931. Revised 2nd ed., Paris 1945. Enlarged English translation by Marguerite Kay, *Degas Letters*, Oxford 1947).
8. Reff, Theodore, "Some Unpublished Letters of Degas," *Art Bulletin*, March 1968, pp. 87-94.
9. ———, "More Unpublished Letters of Degas," *Art Bulletin*, September 1969, pp. 281-289.

Published: Other
10. Venturi, Lionello, *Les Archives de l'Impressionisme*, 2 v. (Paris 1939).
11. *Huit Sonnets d'Edgar Degas* (pref. Jean Nepveu-Degas, Paris 1946).
12. Halévy, Daniel (ed.), *Edgar Degas, Album de dessins* (Paris 1949).
13. Rewald, John (ed.), *Camille Pissarro, Lettres à son fils Lucien* (Paris 1950).
14. Rouart, Denis (ed.), *Correspondence de Berthe Morisot* (Paris 1950).

BOOKS AND ARTICLES

15. C. E. [Charles Ephrussi], "Exposition des artistes indépendants," *La Chronique des arts et de la curiosité*, 16 April 1881, pp. 126-127.
16. Bertall, "Exposition des peintres intransigeants et nihilistes," *Paris-Journal*, 21 April 1881, pp. 1-2.

17. de Mont, Elie, "L'Exposition du Boulevard des Capucines," *La Civilisation*, 21 April 1881, pp. 1-2.

18. de Charry, Paul, "Les Indépendants," *Le Pays*, 22 April 1881, p. 3.

19. Mantz, Paul, "Exposition des oeuvres des artistes indépendants," *Le Temps*, 23 April 1881, p. 3.

20. de Villars, Nina, "Exposition des artistes indépendants," *Le Courrier du soir*, 23 April 1881, p. 2.

21. Trianon, Henry, "Sixième exposition de peinture par un groupe d'artistes," *Le Constitutionnel*, 24 April 1881, pp. 2-3.

22. Comtesse Louise, "Lettres familières sur l'art," *La France nouvelle*, 1-2 May 1881, pp. 2-3.

23. Claretie, Jules, *La Vie à Paris: 1881* (Paris, n.d.).

24. Moore, George, "Degas: the Painter of Modern Life," *Magazine of Art*, 1890, pp. 416-425 (this article was published in German as "Degas," *Kunst und Künstler*, v. VI [1907-1908], pp. 98-108, 138-151, and again in English as "Memories of Degas," *Burlington Magazine*, January 1918, pp. 22-29; February 1918, pp. 63-65).

25. Huysmans, Joris-Karl, "L'Exposition des indépendants en 1881," *L'Art moderne* (Paris 1908), pp. 249-282.

26. Sickert, Walter, "Degas," *Burlington Magazine*, November 1917, pp. 183-191.

27. Thiébault-Sisson, François, "Edgar Degas: l'homme et l'oeuvre," *Le Temps*, 18 May 1918, p. 3.

28. Gsell, Paul, "Edgar Degas, statuaire," *La Renaissance de l'art français*, December 1918, pp. 373-378.

29. Michel, Alice, "Degas et son modèle," *Mercure de France*, 1 February 1919, pp. 457-478; 16 February 1919, pp. 623-639.

30. Anon., "Edgar Degas, a Sculptor as Well as a Painter," *Vanity Fair*, March 1919, p. 50.

31. Lemoisne, Paul-André, "Les Statuettes de Degas," *Art et décoration*, September–October 1919, pp. 109-117.

32. Cortissoz, Royal, "Degas as He was Seen by His Model," *New York Tribune*, 19 October 1919, section IV, p. 9. (This material was rewritten by Cortissoz for the section "As a Sculptor" in the essay "Degas" in his book *Personalities in Art* [New York 1925], pp. 245-248. It was also used by him for his article "Degas and Forain," *New York Herald Tribune*, 5 May 1935, section V, p. 10.)

33. Lafond, Paul, *Degas*, 2 v. (Paris 1919).

34. Thiébault-Sisson, François, "Degas sculpteur," *Le Temps*, 23 May 1921, p. 3.

35. Alexandre, Arsène, "Les Sculptures de Degas," *Le Figaro*, 24 May 1921, p. 2.

36. Fosca, François [Georges de Traz], "Degas, sculpteur," *L'Art et les artistes*, June 1921, pp. 373-374.

37. Janneau, Guillaume, "Les Sculptures de Degas," *La Renaissance de l'art français*, July 1921, pp. 352-355.

38. Fosca, François [Georges de Traz], *Degas* (Paris 1921. English translation by James Emmons, Geneva, 1954).

39. Glaser, Curt, "Degas als Bildhauer," *Kunst und Künstler*, 1921-1922, pp. 123-128 (reprinted in *Das plastische Werk von Edgar Degas*, catalogue of an exhibition held at the Galerie Flechtheim, Berlin, May 1926, the Galerie Thannhauser, Munich, July–August 1926, and the Galerie Arnold, Dresden, September 1926).

40. Anon., "The World of Art: Degas at the Grolier Club and the Architectural League," *New York Times*, 29 January 1922, section III, p. 20.

41. Hertz, Henri, "Degas et les formes modernes: son dessin—sa sculpture," *L'Amour de l'art*, April 1922, pp. 105-111.

42. Hausenstein, Wilhelm, "Degas der Plastiker," *Ganymed*, 1922, pp. 273-276.

43. Grimschitz, Bruno, "Bronzen von Renoir und Degas," *Wiener Jahrbuch für bildende Kunst*, 1922, pp. 45-58.

44. Hoppe, Ragnar, *Degas, och hans Arbeten i nordisk Ägo* (Stockholm 1922).

45. Sickert, Walter, "The Sculptor of Movement," *Works in Sculpture of Edgar Degas*, catalogue of an exhibition held at the Leicester Galleries, London, February–March 1923 (reprinted in Oliver Brown, *Exhibition*, London 1968, pp. 179-181).

46. Fry, Roger, "Degas' Sculpture," *The New Statesman*, 3 March 1923, pp. 630-631.

47. Tatlock, R. R., "Degas Sculptures," *Burlington Magazine*, March 1923, pp. 150-153.

48. J. B. "Sculptures by Degas on Loan," Metropolitan Museum of Art *Bulletin*, March 1923, p. 59.

49. Anon., "A Group of Bronze Dancers by Edgar Degas, the Painter," *Vanity Fair*, June 1923, p. 43.

50. Jamot, Paul, *Degas* (Paris 1924).

51. Hausenstein, Wilhelm, "Einige Anmerkungen über die Plastiken des Edgar Degas," *Die Kunst*, January 1925, pp. 112-120 (reprinted in *Das plastische Werk von Edgar Degas*, catalogue of an exhibition held at the Galerie Flechtheim, Berlin, May 1926, the Galerie Thannhauser, Munich, July–August 1926, and the Galerie Arnold, Dresden, September 1926).

52. Anon., "The Little Dancer," *Vanity Fair*, March 1925, p. 44.

53. Cortissoz, Royal, "Degas, His Seventy-two Achievements as a Sculptor," *New York Herald Tribune*, 25 October 1925, section v, p. 8.

54. Anon., "Degas Sculpture Exhibited Here," *New York Times*, 1 November 1925, section VIII, p. 14.

55. Zorach, William, "The Sculpture of Edgar Degas," *The Arts*, November 1925, pp. 263-265.

56. Zweig, Arnold, "Degas als Plastiker," *Der Querschnitt*, March 1926, pp. 175-179.

57. F. T., "Berlin," *Art News*, 19 June 1926, p. 11.

58. de Fiori, Ernesto, "Degas der Bildhauer," *Der Querschnitt*, June 1926, p. 495.

59. Štech, V. V., "Degas Sochar," *Volné Směry*, v. XXIV (1926), pp. 121-124.

60. Troendle, Hugo, "Die Tradition im Werke Degas," *Kunst und Künstler*, 1926-1927, pp. 242-248.

61. Meier-Graefe, Julius, "Die Französen in Berlin," *Cicerone*, January 1927 (part 2), pp. 43-59.

62. W. M. [Wilhelm Michel?], "Das plastische Werk von Edgar Degas," *Deutsche Kunst und Dekoration*, May 1927, pp. 96-99.

63. Anon., "A Few Bronzes by Degas," *The Sportsman*, May 1928, pp. 30-31.

64. Štech, V. V., "Kritikův Osud," *Volné Směry*, v. XXVIII (1929-30), pp. 69-74.

65. Blanche, Jacques-Emile, "Bartholomé et Degas," *L'Art vivant*, 15 February 1930, pp. 154-156.

66. Zillhardt, Madeleine, "Souvenirs et portraits (Degas, Fantin-Latour, le Comte R. de Montesquieu)," *La Revue de Paris*, 1 July 1930, pp. 95-115.

67. Konody, P. G., "A Note on Degas's Sculpture," *Bronzes by Edgar Degas*, catalogue of an exhibition held at the galleries of Messrs. Abdy and Co., London, November 1930.

68. Parkes, Kineton, "Racehorses and Ballet Dancers: the Bronzes of Degas," *Apollo*, December 1930, pp. 468-469.

69. Raunay, Jeanne, "Degas: souvenirs anecdotiques," *La Revue de France*, 15 March 1931, pp. 263-282; 1 April 1931, pp. 469-483; 15 April 1931, pp. 619-632.

70. Vitry, Paul, "Les Sculptures de Degas," *Degas, portraitiste, sculpteur*, catalogue of an exhibition held at the Orangerie, Paris, 1931, pp. 123-127.

71. Vauxcelles, Louis, "Edgar Degas, portraitiste sculpteur et graveur," *Excelsior*, 12 July 1931, pp. 1, 2.

72. Bazin, Germain, "Degas sculpteur," *L'Amour de l'art*, July 1931, pp. 293-301.

73. Vitry, Paul, "L'Exposition Degas au Musée de l'Orangerie," *Bulletin des Musées de France*, July 1931, pp. 149-152.

74. Kahn, Gustave, "Art: Rétrospective Edgar Degas, portraitiste et sculpteur: Musée de l'Orangerie . . . ," *Mercure de France*, 1 August 1931, pp. 710-712.

75. Roger-Marx, Claude, "Degas sculpteur, à l'Orangerie," *L'Europe nouvelle*, 1 August 1931, pp. 1049-1050.

76. Anon., "Degas, portraitiste et sculpteur," *Art et décoration*, August 1931, pp. iv-v.

77. Lécuyer, Raymond, "Degas, portraitiste et sculpteur," *L'Illustration*, 12 September 1931, pp. 38-41.

78. Romanelli, Piero and Marie Van Vorst, "Degas," *The Catholic World*, October 1931, pp. 50-59.

79. Jeanniot, Georges, "Souvenirs sur Degas," *La Revue universelle*, 15 October 1933, pp. 152-174; 1 November 1933, pp. 280-304.

80. Alexandre, Arsène, "Degas, nouveaux aperçus," *L'Art et les artistes*, February 1935, pp. 145-173.

81. Žákavec, Frantisek, "Stoletý Degas," *Uměni*, v. VIII (1935), pp. 64-80, 125-130.

82. Rivière, Georges, *Mr. Degas, bourgeois de Paris* (Paris 1935).

83. Barazzetti, S., "Degas et ses amis Valpinçon," *Beaux-Arts*, 21 August 1936, pp. 1, 3; 28 August 1936, pp. 1, 4; 4 September 1936, pp. 1, 2.

84. Grappe, Georges, *Degas* (Paris 1936).

85. Blanche, Jacques-Emile, "Edgar Degas," *Marianne*, 10 March 1937, p. 5.

86. Fierens, Paul, "Il contributo dei pittori alla scultura francese (da Géricault a Picasso)" (tr. Lamberto Vitale), *Emporium*, March 1937, pp. 127-139.

87. Gillet, Louis, "A L'Exposition Degas," *Revue des deux mondes*, 1 April 1937, pp. 686-695.

88. Saunier, Charles, "Degas," *Revue bleue politique et littéraire*, 17 April 1937, pp. 283-286.

89. Vanbeselaere, Walter, "Degas in de Orangerie," *Elsevier's Geillustreerd Maandschrift*, July 1937, pp. 1-9.

90. Mauclair, Camille, *Degas* (Paris 1937. English translation, New York 1941).

91. Anon., "Degas in Bronze," *The Art Digest*, 1 January 1939, pp. 5, 34.

92. Roger-Marx, Claude, "Préface," *Degas, peintre du mouvement*, catalogue of an exhibition held at the Galerie André Weil, Paris, 9-30 June 1939, pp. 3-8.

93. Lalo, Pierre, "Edgar Degas," *Le Temps*, 22 October 1941, p. 3 (reprinted in *De Rameau à Ravel*, Paris 1947, pp. 403-412).

94. Graber, Hans, *Edgar Degas—nach eigenen und fremden Zeugnissen* (Basel 1942).

95. Cogniat, Raymond, "Sculptures de peintres," *Formes et couleurs*, no. 2 (1943), unpaginated.

96. Shipley, Sylvia, "Bronze and Tulle," Baltimore Museum of Art *News*, May 1943, pp. 4-5.

97. Rewald, John, "Degas Dancers and Horses Seen in Two and Three Dimensions," *Art News*, 15-31 October 1944, pp. 20-23.

98. Rewald, John, *Degas, Works in Sculpture, A Complete Catalogue* (New York 1944. Revised edition, New York 1957. German translation by Walter Fabian, *Degas: das plastische Werk*, Zurich 1957).

99. Anon., "Secret Sculptor," *Time*, 15 January 1945, p. 65.

100. Breuning, Margaret, "The Penetrative Power of Edgar Degas," *Art Digest*, 15 January 1945, p. 16.

101. Greenberg, Clement, "Art Notes," *Nation*, 20 January 1945, p. 82.

102. Besnault, Pierre, *Degas, peintre de chevaux* (Paris 1945).

103. Gardner, Albert Ten Eyck, "Arabesques in Bronze," Metropolitan Museum of Art *Bulletin*, January 1946, pp. 131-135.

104. Rewald, John, "Degas's Sculpture, a Reply to 'Arabesques in Bronze,'" Metropolitan Museum of Art *Bulletin*, Summer 1946, pp. 46-48.

105. Roger-Marx, Claude, "Degas et la danse," *Style en France*, April–June 1946, pp. 50-54.

106. Lemoisne, Paul-André, *Degas et son oeuvre*, 4 v. (Paris 1946).

107. Foote, Helen S., " 'Dancer Looking at the Sole of her Right Foot,' " Cleveland Museum of Art *Bulletin*, September 1947, pp. 180-181.

108. Rostrup, Haavard, "Forord," *Edgar Degas*, catalogue of an exhibition held at the Ny Carlsberg Glyptotek, Copenhagen, 4-26 September 1948, pp. 5-9.

109. Engwall, Gustaf, untitled introduction, *Edgar Degas*, catalogue of an exhibition held at the Galerie Blanche, Stockholm, 9 October–7 November 1948.

110. Alfons, Sven, "Om Degas," *Konstrevy*, no. 6 (1948), pp. 215-223.

111. C. V., "Sculture di Degas," *Emporium*, July 1949, pp. 15-17.

112. Holm, Arne E., "Litt om Skulptøren Edgar Degas," *Bonytt*, July–August 1949, pp. 126-129.

113. Zillhardt, Madeleine, "Monsieur Degas, mon ami (1885-1917)," *Arts*, 2 September 1949, pp. 1, 4-5; 9 September 1949, pp. 4-5; 16 September 1949, pp. 4-5.

114. Borel, Pierre, *Les Sculptures inédites de Degas* (Geneva 1949).

115. Fèvre, Jeanne, *Mon Oncle Degas* (Geneva 1949).

116. Levinson, André, "Le Ruban de velours noir ou Degas chorégraphe," *Figaro artistique illustré*, November 1950, pp. 10-15.

117. E. W., "Een Laat Brons van Degas," Museum Boymans, Rotterdam, *Bulletin*, November 1950, pp. 61-65.

118. Rostrup, Haavard, "De moderne Samlingers vaext 1945-49," Ny Carlsberg Glyptotek, Copenhagen, *Meddelelser*, 1950, pp. 1-34.

119. Antonsson, Oscar, "Nyförvärv av Äldre Skulptur," Nationalmusei *Årsbok*, 1949-1950 (Uppsala 1952), pp. 68-69.

120. Jedlicka, Gotthard, *Pariser Tagebuch* (Berlin 1953).

121. Fierens, Paul, "Sculptures de peintres: Degas et Renoir," Musées Royaux des Beaux-Arts, Brussels, *Bulletin*, December 1954, pp. 163-168.

132

122. Gyllenstein, Lars, "Friketsdressyr," *Konstrevy*, v. 30 (1954), no. 5-6, pp. 226-227.

123. Schmidt, Georg, "La Sculpture au XIX^e siècle de Canova à Maillol," *Les Sculpteurs célèbres* (ed: Pierre Francastel, Paris 1954), pp. 270-273.

124. Brest, Jorge Romero, "Les Peintres sculpteurs: Degas, Renoir, Daumier, Gauguin," *Les Sculpteurs célèbres* (ed: Pierre Francastel, Paris 1954), pp. 282-285.

125. Devree, Howard, "Braque and Degas," *New York Times*, 9 October 1955, section II, p. 12.

126. Anon., "Movement Molded in Wax," *Life*, 31 October 1955, pp. 121-122.

127. Rewald, John, "Foreword," *Edgar Degas, Original Wax Sculptures*, catalogue of an exhibition held at M. Knoedler and Co., New York, 9 November–3 December 1955.

128. Preston, Stuart, "Both Old and New," *New York Times*, 13 November 1955, section III, p. 14.

129. Anon., "Degas in Wax," *Time*, 21 November 1955, p. 99.

130. Adhémar, Jean, "Before the Degas Bronzes" (tr. Margaret Scolari), *Art News*, November 1955, pp. 34-35, 70.

131. Breuning, Margaret, "Margaret Breuning Writes: Wax Sculpture by Degas . . . ," *Arts*, December 1955, p. 47.

132. Anon., "Degas' Waxes," *Dance*, January 1956, pp. 42-43.

133. Anon., "Sculpture by Degas," Virginia Museum of Fine Arts *Members' Bulletin*, March 1956.

134. M. C. R. [Merrill C. Rueppel], "Sculpture by Painters: "Degas," Minneapolis Institute of Arts *Bulletin*, May–June 1956, p. 27.

135. Anon., "Degas perdu et retrouvé," *Jour de France*, 10 September 1956, pp. 70-71.

136. Bardi, Pietro Maria, *The Arts in Brazil* (Milan 1956).

137. Payne, Elizabeth H., "A Little Known Bronze by Degas," Detroit Institute of Arts *Bulletin*, no. 4 (1956-1957), pp. 82-85.

138. Pradel, Pierre, "Quatre cires originales de Degas," *La Revue des arts*, January–February 1957, pp. 30-31.

139. Kramer, Hilton, "Month in Review," *Arts*, September 1957, pp. 51-54.

140. Cabanne, Pierre, *Edgar Degas* (Paris 1957).

141. Guerre, Pierre, "Classicisme de Degas," *Critique*, January 1959, pp. 58-65.

142. Novotny, Fritz, *Painting and Sculpture in Europe, 1780 to 1880* (Harmondsworth, England 1960).

143. Muller, Joseph-Emile, "Degas, Edgar (1834-1917)," *Dictionnaire de la sculpture moderne* (Paris 1960. English translation, New York n.d.).

144. Leymarie, Jean, "Degas," *Encyclopedia of World Art*, v. IV, pp. 273-279.

133

145. Johnson, Lincoln, "Four Paris Painters," *Manet, Degas, Berthe Morisot, and Mary Cassatt*, catalogue of an exhibition held at the Baltimore Museum of Art, 18 April–3 June 1962, pp. 11-26.

146. Selz, Jean, *Découverte de la sculpture moderne* (Lausanne 1963. English translation by Annette Michelson, *Modern Sculpture: Origins and Evolution*, New York 1963).

147. Raumschussel, Martin, "Die Vierzehnjährige Tänzerin von Edgar Degas," *Dresdener Kunstblätter*, 1965, no. 7, pp. 107-109.

148. Bouret, Jean, *Degas* (tr. Daphne Woodward, New York 1965).

149. Tannenbaum, Libby, "Degas: Illustrious and Unknown," *Art News*, January 1967, pp. 50-54, 73-77.

150. de Bonnafos, Edith, "Au Musée de Jeu de Paume, Degas Sculpteur," *Degas* (no. 41 in the series "Chefs-d'oeuvre de l'art–grands peintres," Paris 1967).

151. Licht, Fred, *Sculpture, Nineteenth and Twentieth Centuries* (London 1967).

152. Vitale, Lamberto, *Edgar Degas* (no. 81 in the series "I Maestri della Scultura," Milan 1968).

153. Burnham, Jack, *Beyond Modern Sculpture* (New York 1968).

154. Beaulieu, Michèle, "Sculptures," *Degas, Oeuvres du Musée du Louvre*, catalogue of an exhibition held at the Orangerie, Paris, 27 June–15 September 1969, p. 43.

155. ———, "Une Tranquille sensualité," *Les Nouvelles littéraires*, 3 July 1969, p. 9.

156. ———, "Les Sculptures de Degas: essai de chronologie," *Revue du Louvre*, no. 6 (1969), pp. 369-380.

157. de Bonnafos, Edith, "Mouvement et formes chez Degas sculpteur," *Degas* (no. 143 in the series "Chefs-d'oeuvre de l'art–grands sculpteurs," Paris 1969).

158. Burollet, Thérèse, "Degas, oeuvres du Musée du Louvre, peintures, pastels, dessins, sculptures," *Revue de l'art*, no. 7 (1970), pp. 103-104.

159. Reff, Theodore, "Degas' Sculpture, 1880-1884," *Art Quarterly*, Autumn 1970, pp. 276-298.

160. Russoli, Franco, and Fiorella Minervino, *L'Opera completa di Degas* (Milan 1970).

161. *Nineteenth-Century French Sculpture*, catalogue of an exhibition held at the J. B. Speed Art Museum, Louisville, 2 November–5 December 1971.

162. Rheims, Maurice, *La Sculpture au XIX^e siècle* (Paris 1972).

163. Tucker, William, "Gravity, Rodin, Degas," *Studio International*, July–August 1973, pp. 25-99 (reprinted, with alterations, as the chapter "Gravity" in Tucker's *Early Modern Sculpture*, New York 1974, pp. 144-159).

164. Elsen, Albert E., *Pioneers of Modern Sculpture*, catalogue of an exhibition held at the Hayward Gallery, London, 20 July–23 September 1973 (enlarged and altered as *Origins of Modern Sculpture: Pioneers and Premises*, New York 1974).

165. Barron, Stephanie, "Edgar Degas: Rearing Horse," Toledo Museum of Art *Museum News*, v. XVII, no. 3 (1974), pp. 56-58.

134

INDEX

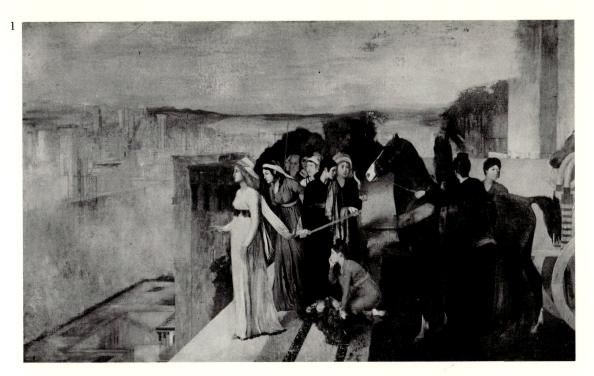

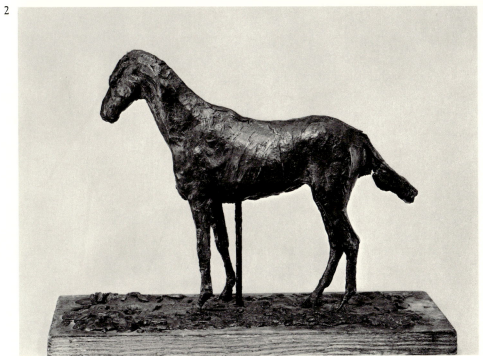

1. DEGAS, *Semiramis Building Babylon*
2. DEGAS, *Mustang*

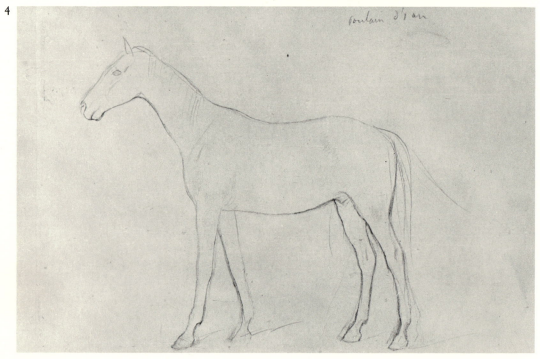

3. Cuvelier, *Horse*
4. Degas, *Colt*, Louvre notebook RF 5634[ter], page 27

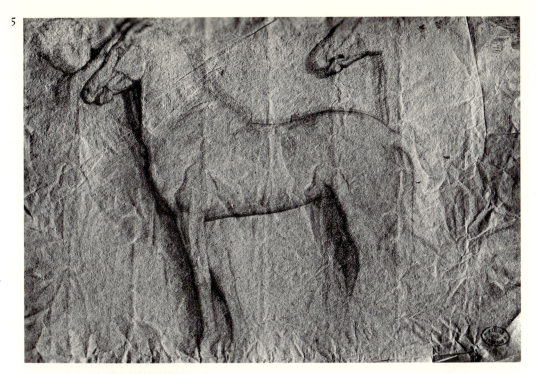

5. DEGAS, Study of Classical relief
6. DEGAS, Study for *Semiramis*

7

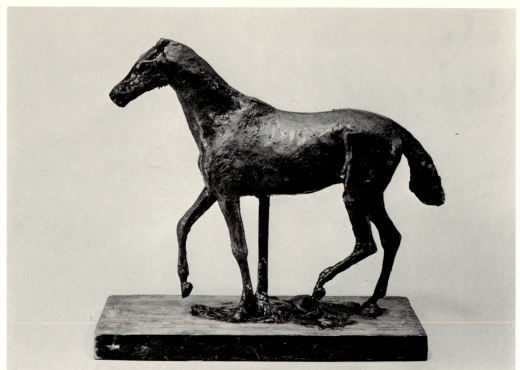

8

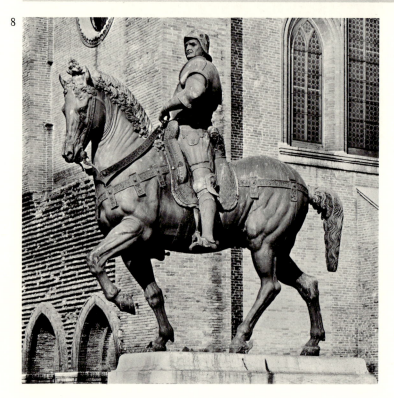

7. Degas, *Horse Walking*
8. Verrocchio, *Colleoni.* Venice

9

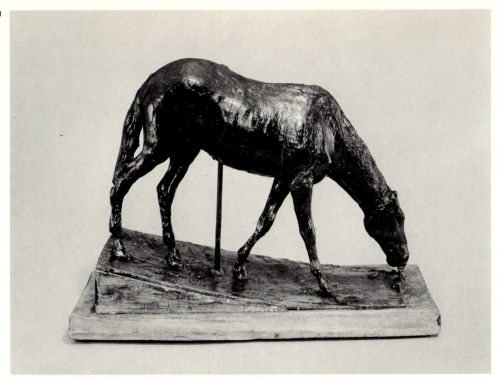

10

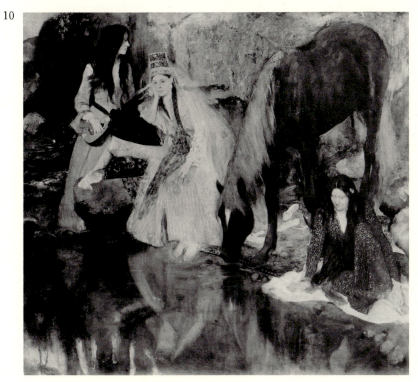

9. DEGAS, *Horse at Trough*
10. DEGAS, *Mlle. Fiocre in the Ballet "La Source"*

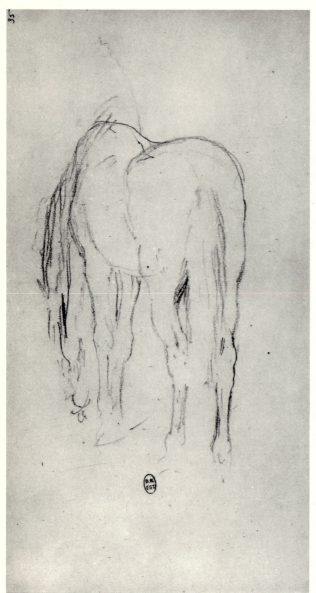

11

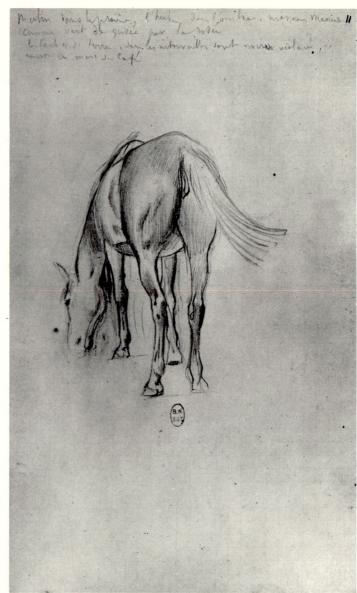

12

11. DEGAS, Study of horse, notebook 19, page 35
12. DEGAS, Study of horse, notebook 24, page 11

13

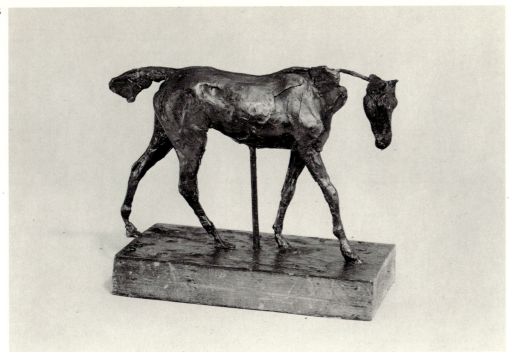

14

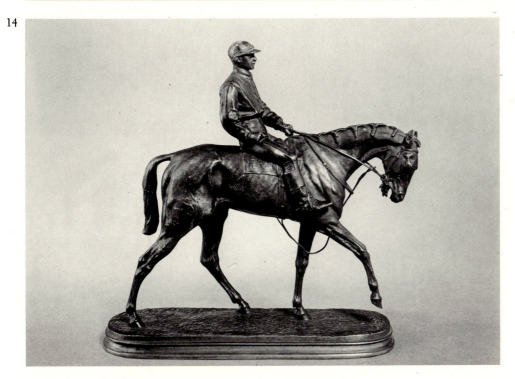

13. DEGAS, *Thoroughbred*
14. MÈNE, *Derby Winner*

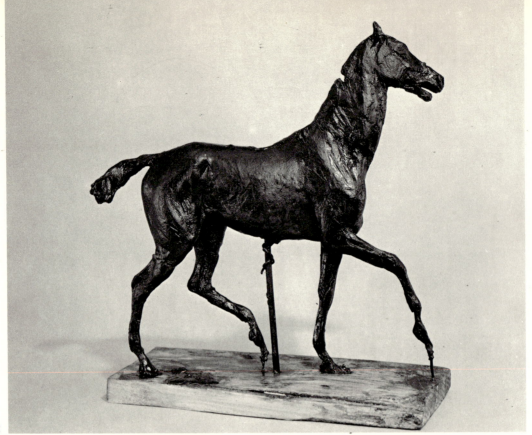

15

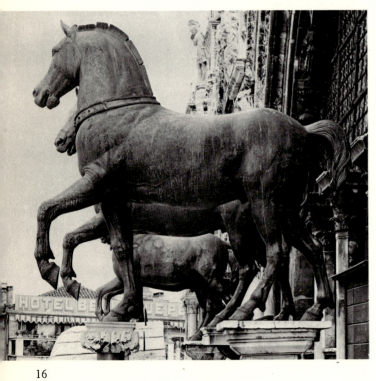

16

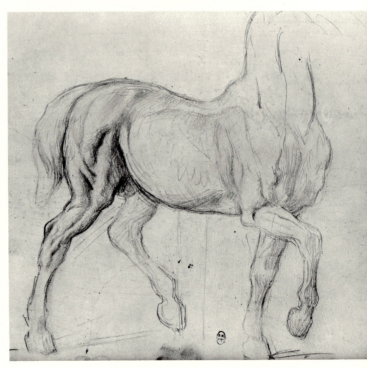

17

15. DEGAS, *Horse Walking*
16. Classical *Horses*. Venice, S. Marco
17. DEGAS, Study of Géricault's *écorché* horse, notebook 1, page 93

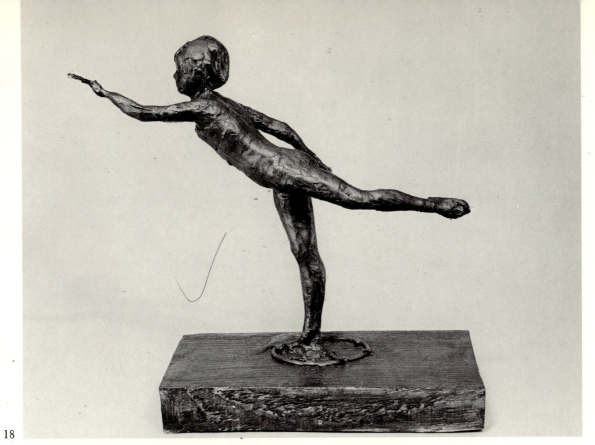

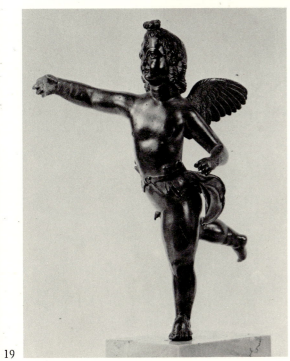

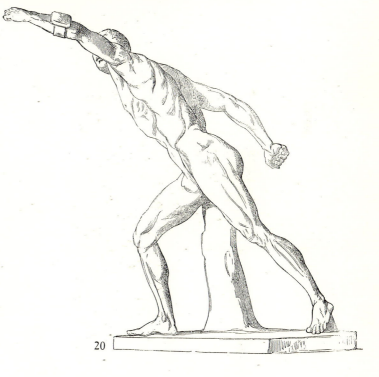

18. DEGAS, *Arabesque over the Right Leg*
19. Classical *Eros*
20. Classical *Borghese Warrior*

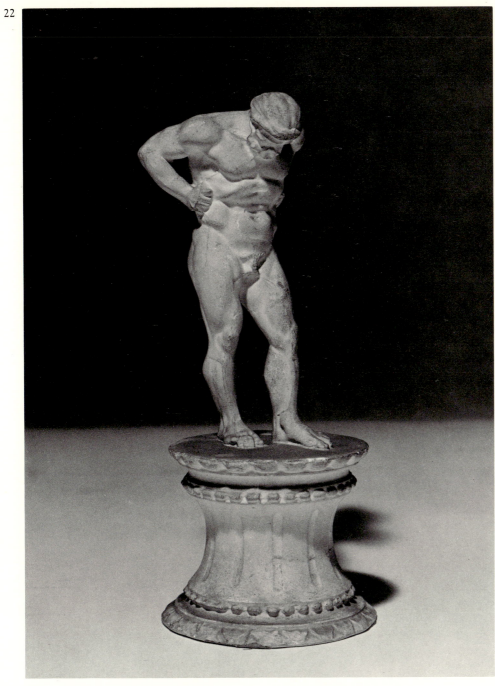

21. DEGAS, *Dancer at Rest*
22. Classical *Hercules* (plaster cast)

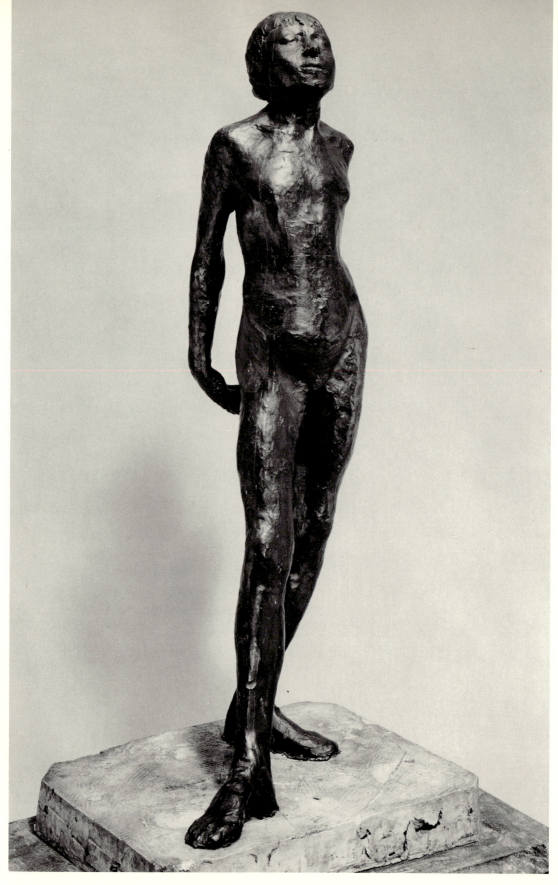

23

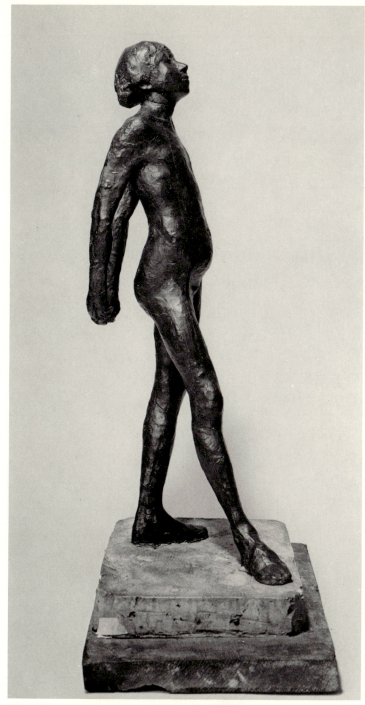

24

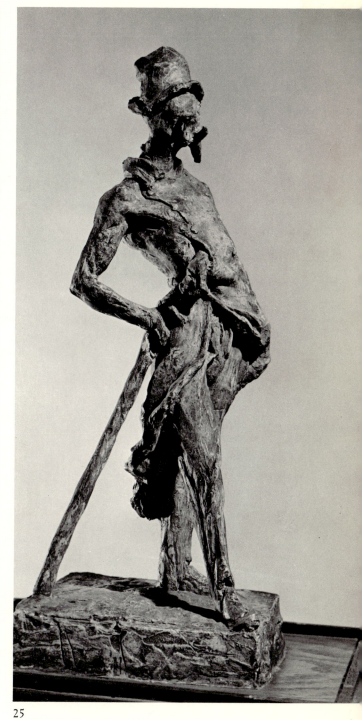

25

23. DEGAS, *Little Dancer* (nude)
24. DEGAS, *Little Dancer* (nude) side view
25. DAUMIER, *Ratapoil*

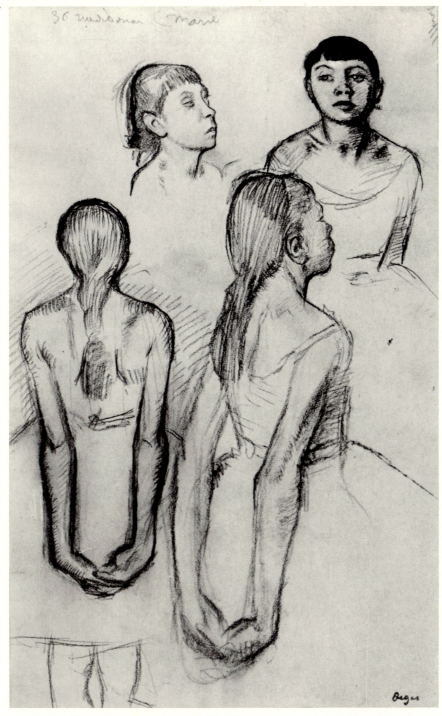

26. DEGAS, *Little Dancer* (clothed)
27. DEGAS, Study for *Little Dancer*

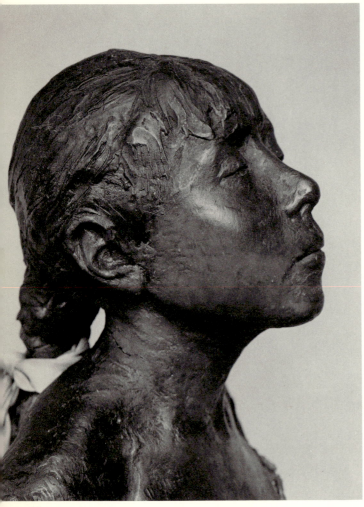

28

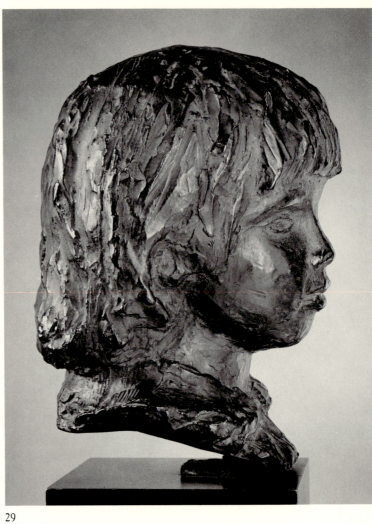

29

28. DEGAS, *Little Dancer* (clothed), detail
29. RENOIR, *Coco*

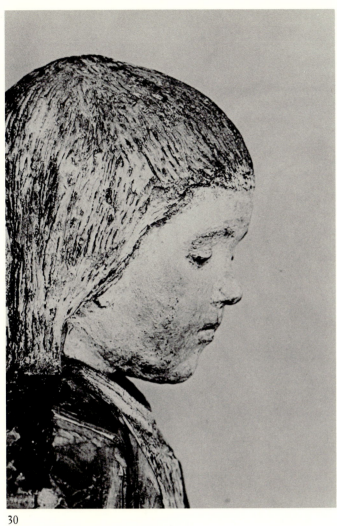

30

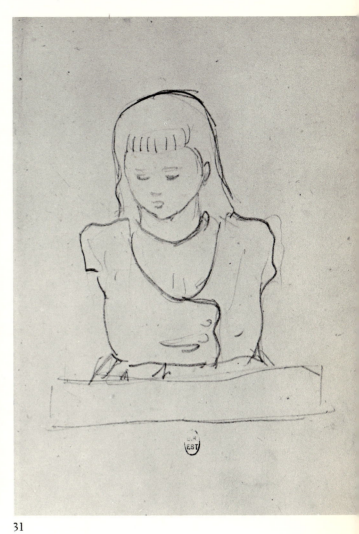

31

30. GAUGUIN, *Clovis*, detail
31. DEGAS, Study of Gauguin's *Clovis*, notebook 2, page 208

32

33

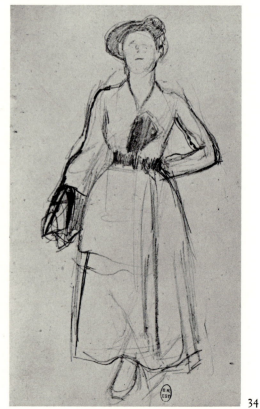

34

32. DEGAS, *Schoolgirl*
33. DEGAS, Study of Donatello's *David*
34. DEGAS, Study for *Schoolgirl*, notebook 2, page 13

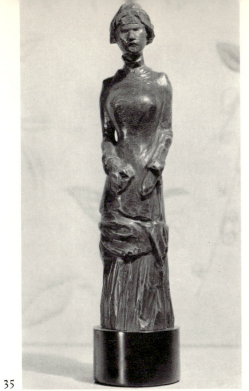
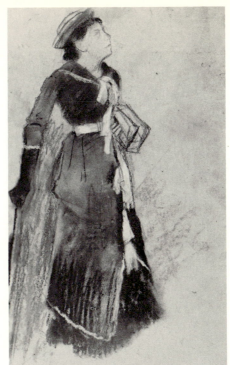

35

36

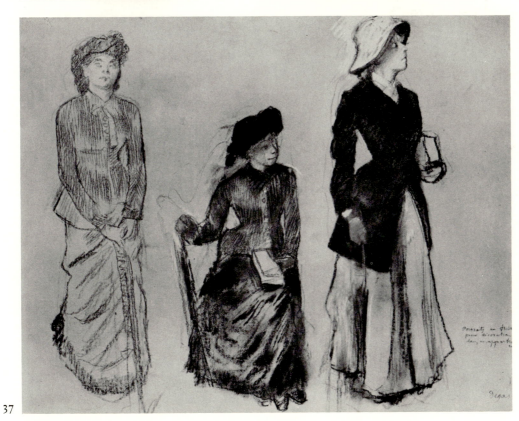

37

35. GAUGIN, *Little Parisian*
36. DEGAS, *Woman in a Purple Dress*
37. DEGAS, *Portraits in Frieze for Decoration of an Apartment*

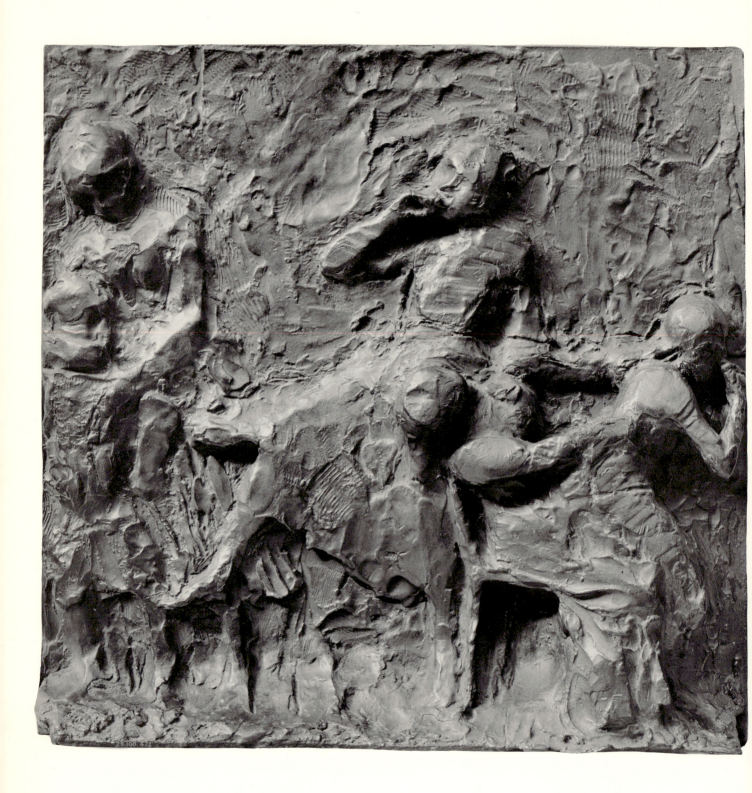

38. DEGAS, *Gathering Apples* (bronze cast)

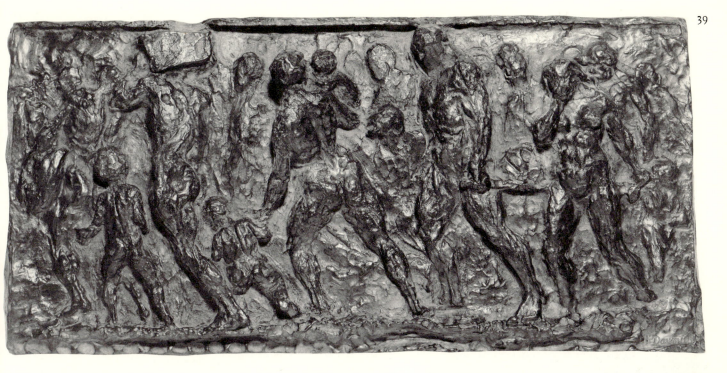

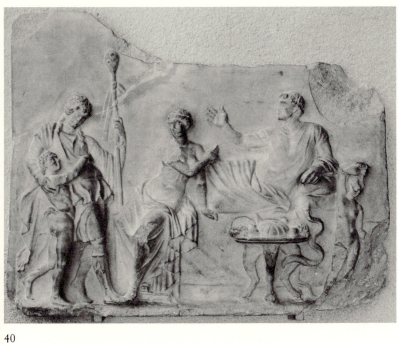

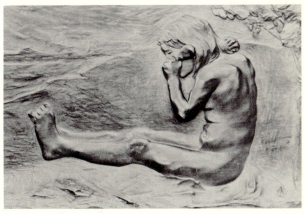

41

40

39. Daumier, *Refugees*
40. Classical Bacchic relief
41. Gauguin, *The Toilet*

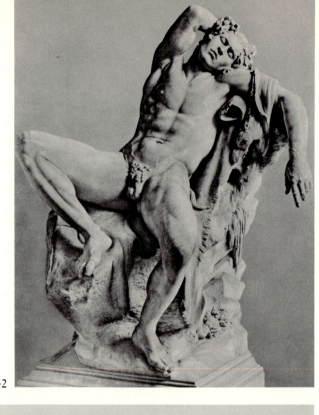

42

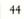

43

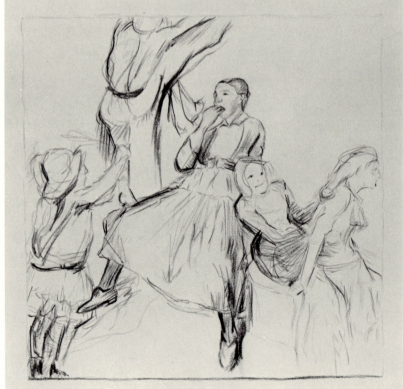

44

42. Classical *Sleeping Faun* (former position)
43. DEGAS, Study for figure in *Gathering Apples*, notebook 2, page 15
44. DEGAS, *Gathering Apples* (reconstruction of original composition)

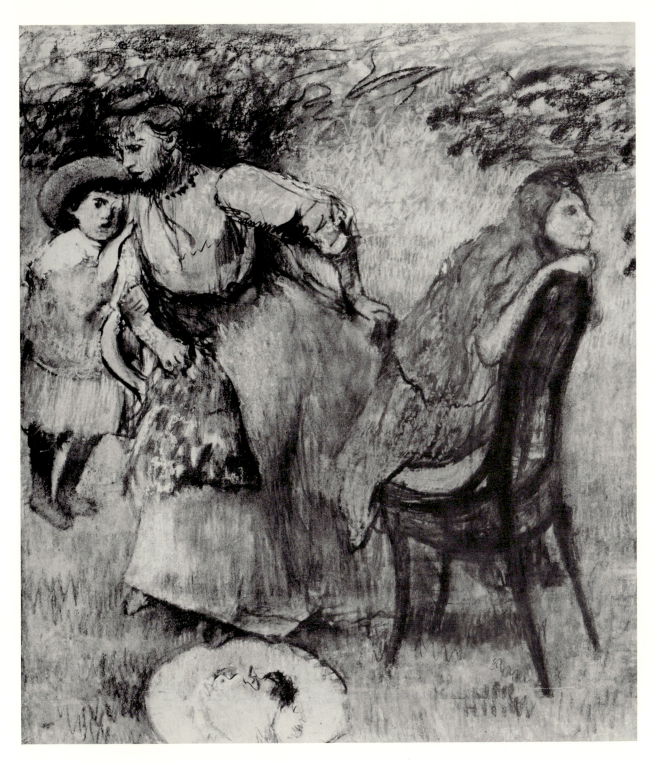

45. DEGAS, *Mme. Henri Rouart and Her Children*

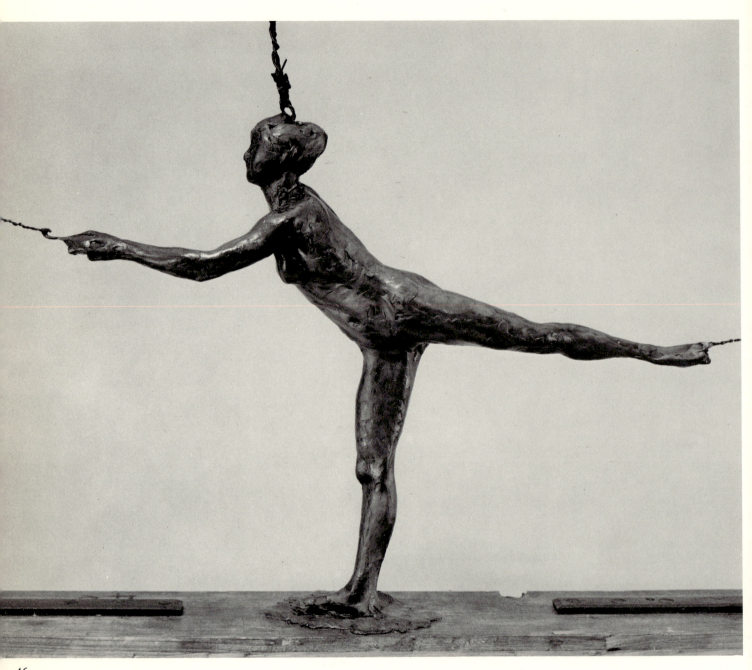

46

46. DEGAS, *Arabesque over the Right Leg*
47. DEGAS, *Dancer at Rest*

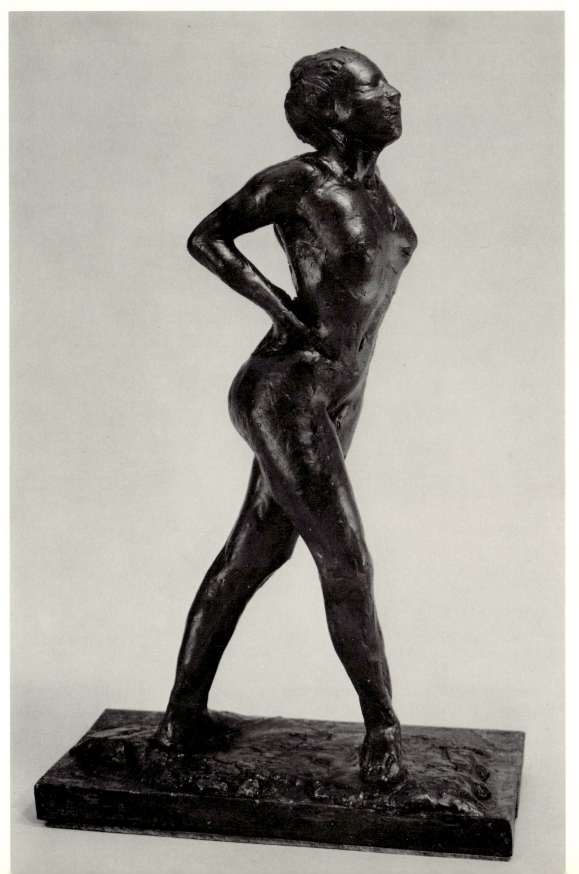

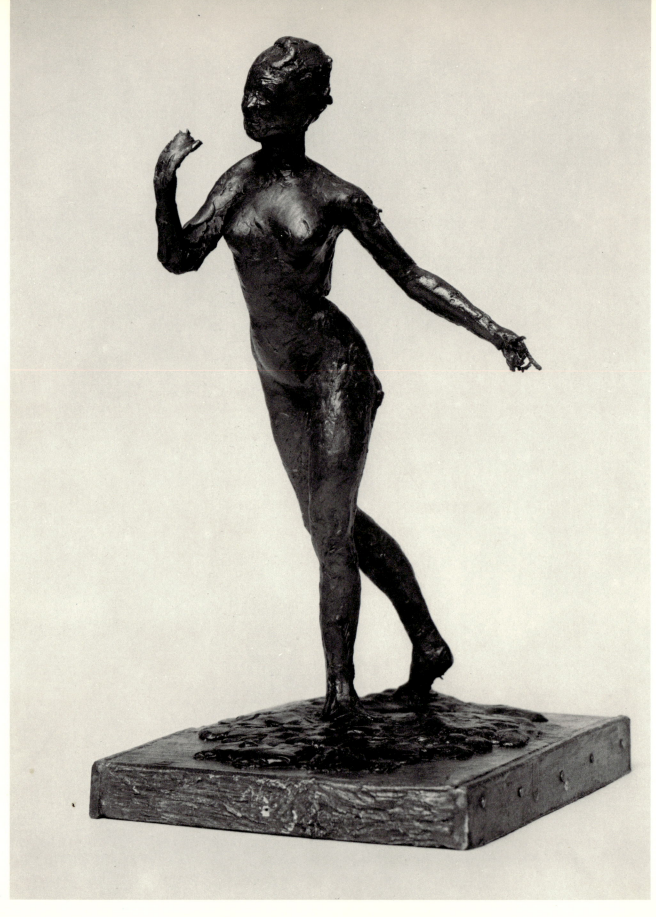

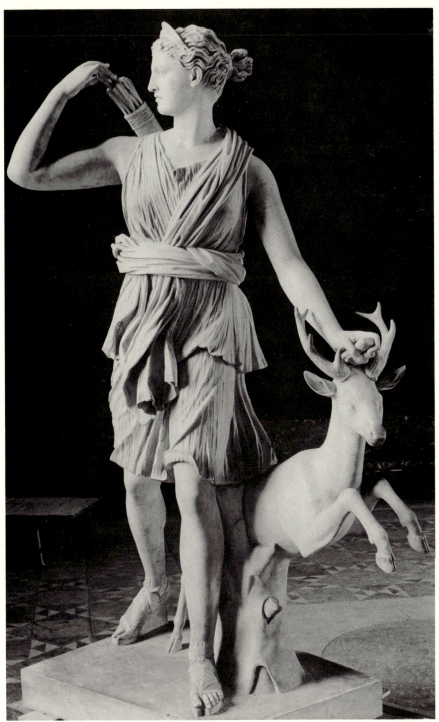

49

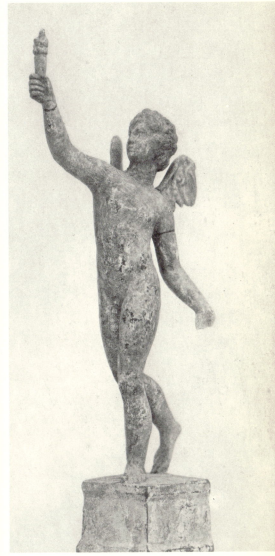

50

48. DEGAS, *The Bow*
49. Classical *Diana*
50. Classical *Eros with a Torch*

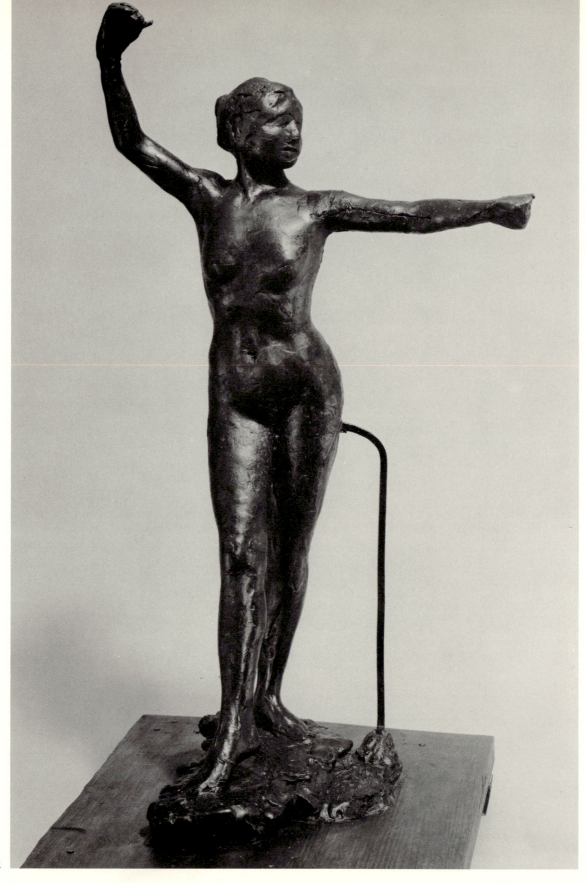

51

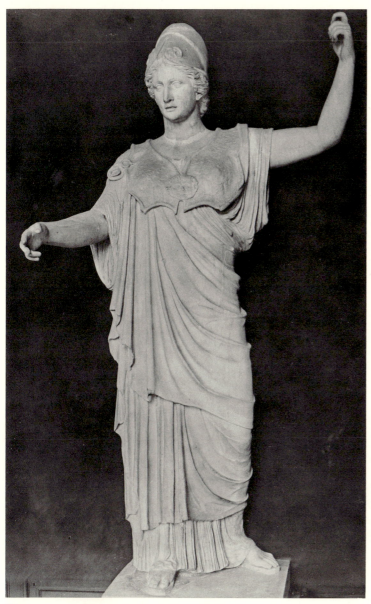

52

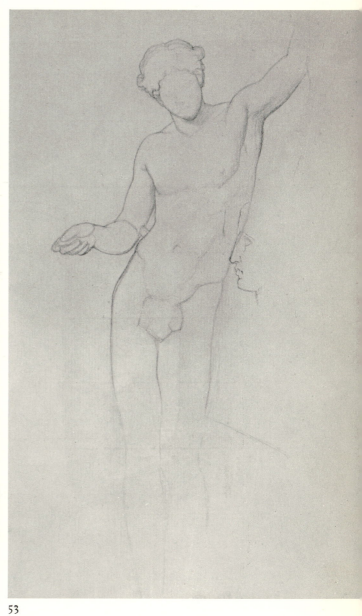

53

51. DEGAS, *Dancer Ready to Dance*
52. Classical *Minerva*
53. DEGAS, Study of Vatican *Apollo Sauroktonous*, Louvre notebook RF 5634, page 64

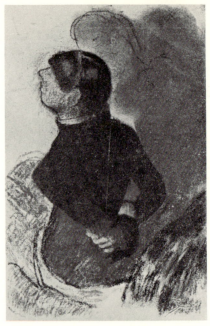

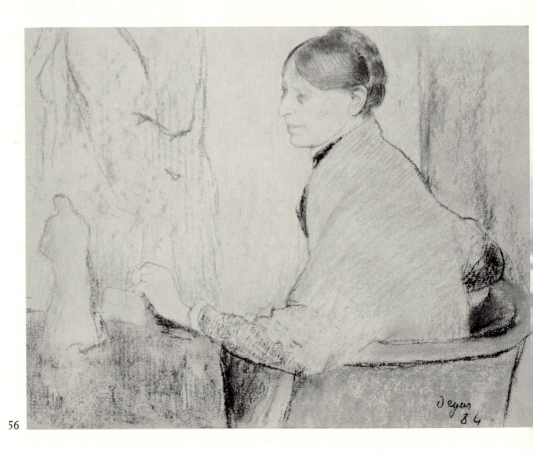

54. Degas, Sketch of portrait of Hortense Valpinçon
55. Degas, *Girl in Blue*

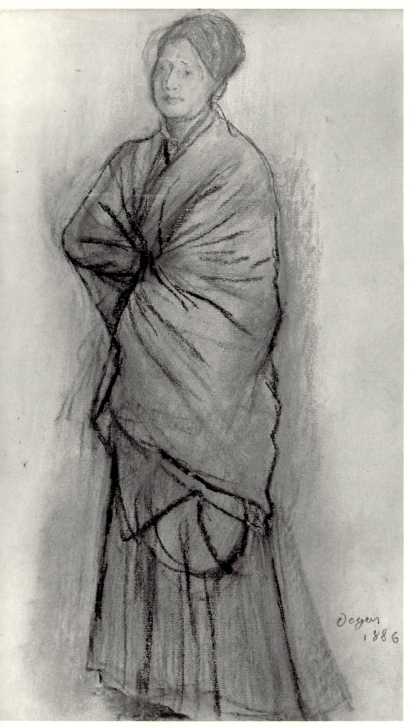

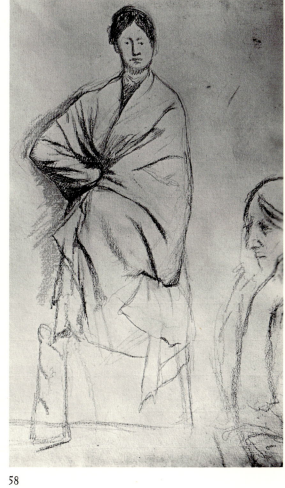

56. Degas, *Mme. Henri Rouart*
57. Degas, *Hélène Rouart*
58. Degas, *Hélène Rouart and Her Mother*

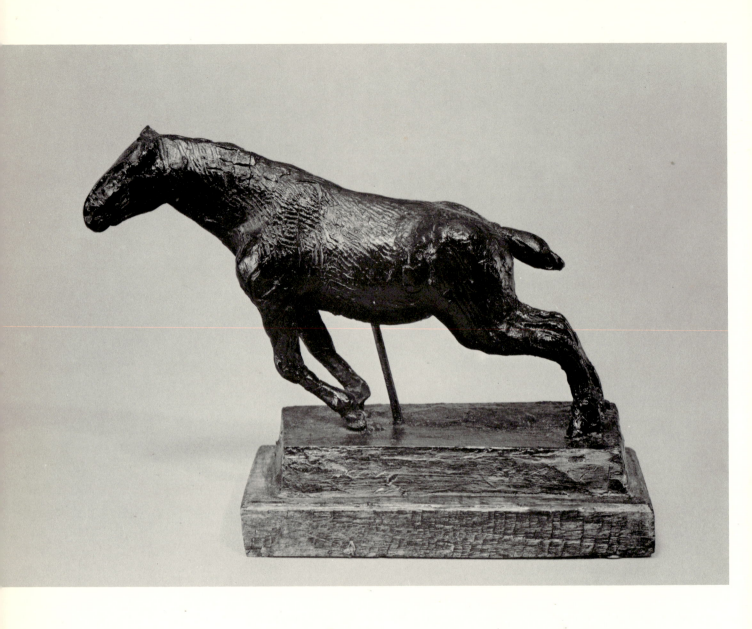

59. DEGAS, *Draught Horse*

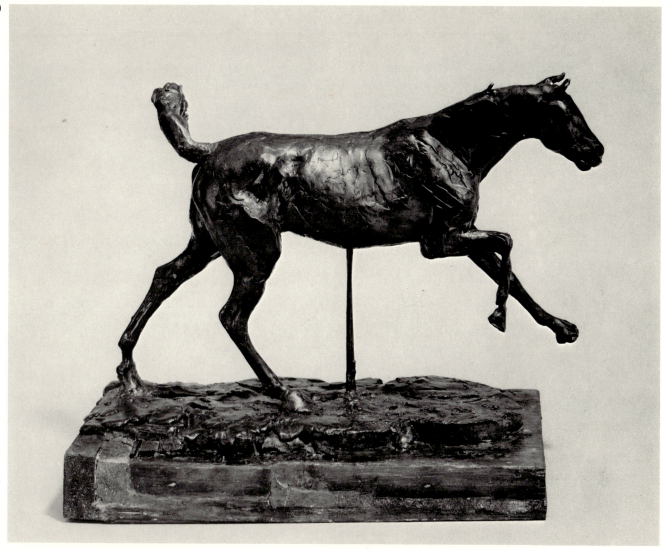

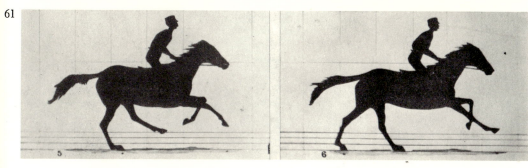

60. DEGAS, *Horse Galloping*
61. MUYBRIDGE, *Sallie Gardner Running*

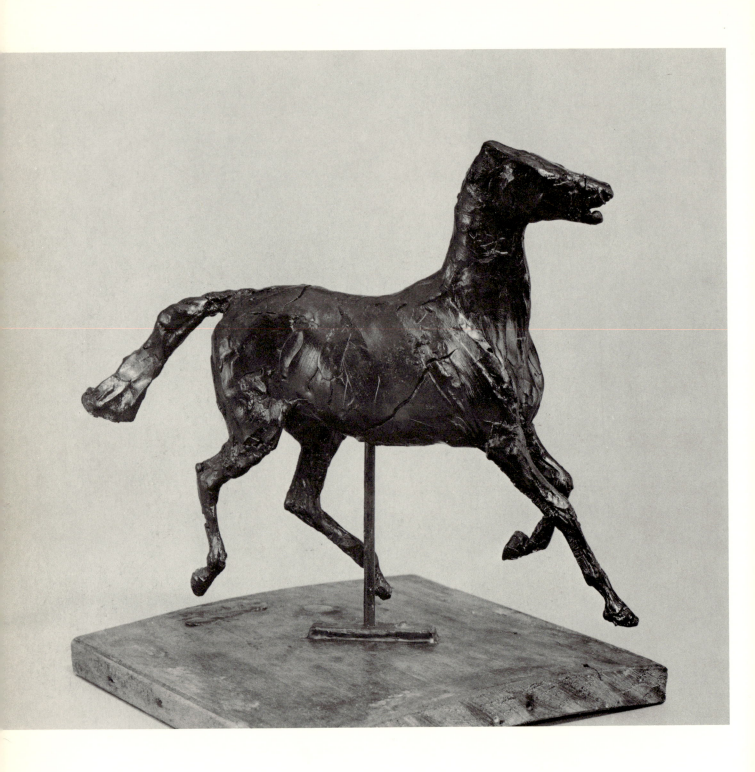

62. DEGAS, *Horse Trotting*

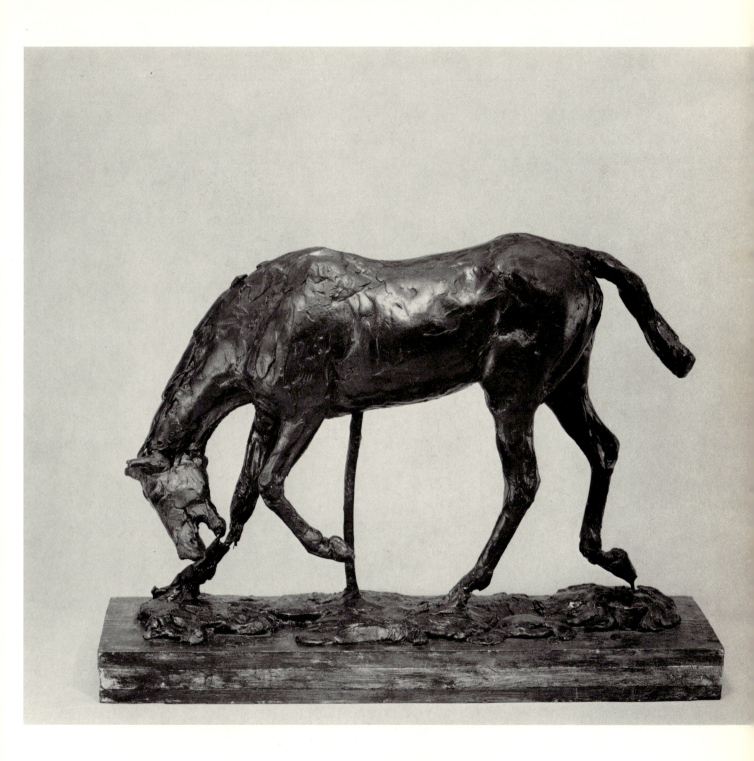

63. DEGAS, *Horse with Head Lowered*

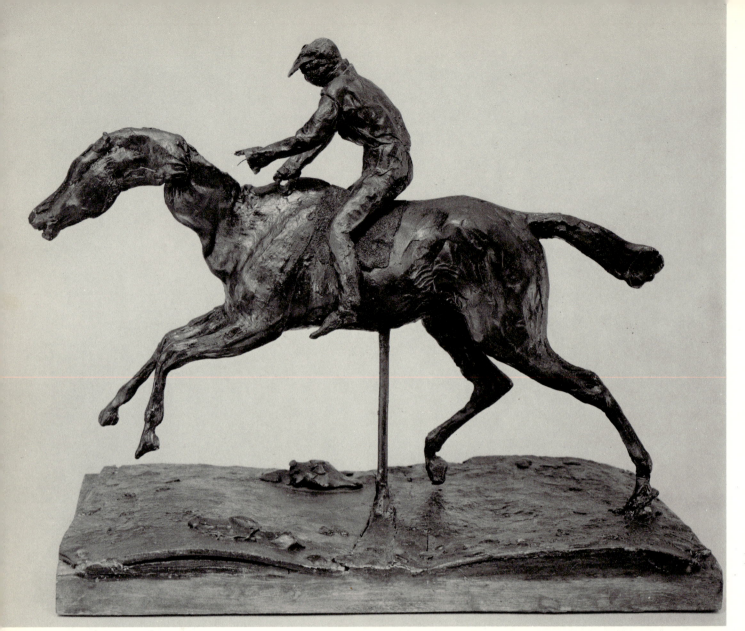

64

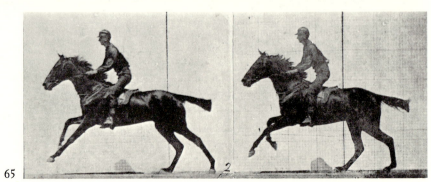

65

64. DEGAS, *Horse with Jockey, Galloping*
65. MUYBRIDGE, *Bouquet with Rider*
66. DEGAS, *Horse Clearing an Obstacle*
67. DEGAS, Study of horse from Parthenon frieze
68. MUYBRIDGE, *Horse Jumping*

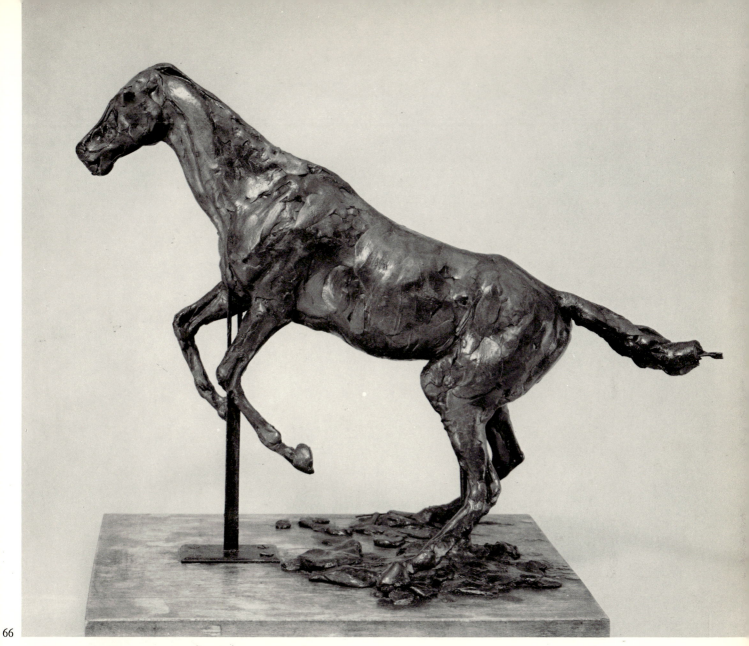

66

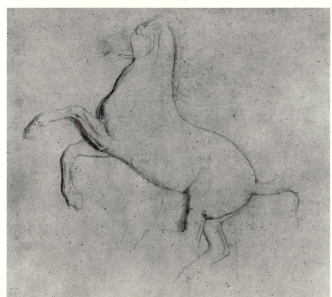

67

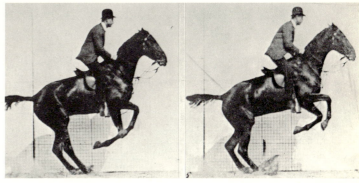

68

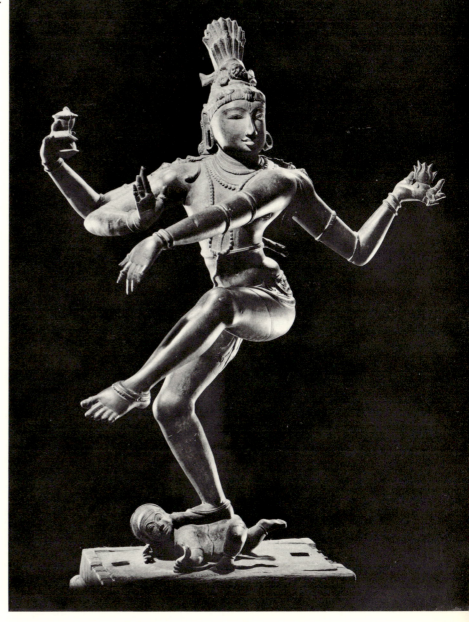

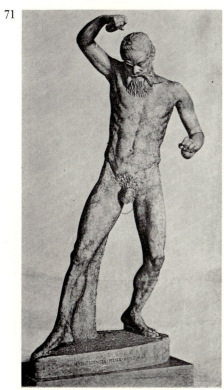

69. DEGAS, *Spanish Dance*
70. Classical *Herculaneum Dancer*
71. Classical *Marsyas*
72. Indian (Chola), *Dancing Siva*

73. DEGAS, *Spanish Dance* (plaster cast)

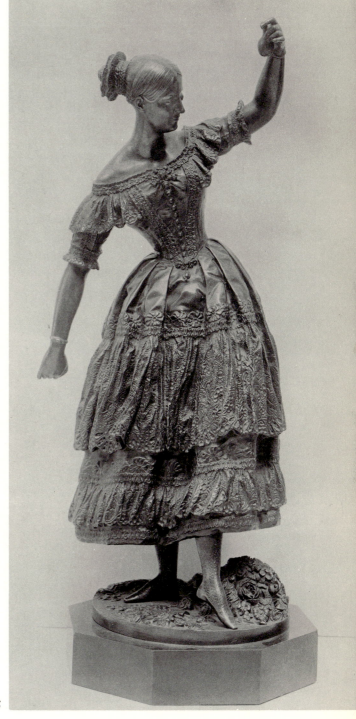

74. Degas, Study for *Spanish Dance*
75. Barre, *Fanny Elssler*

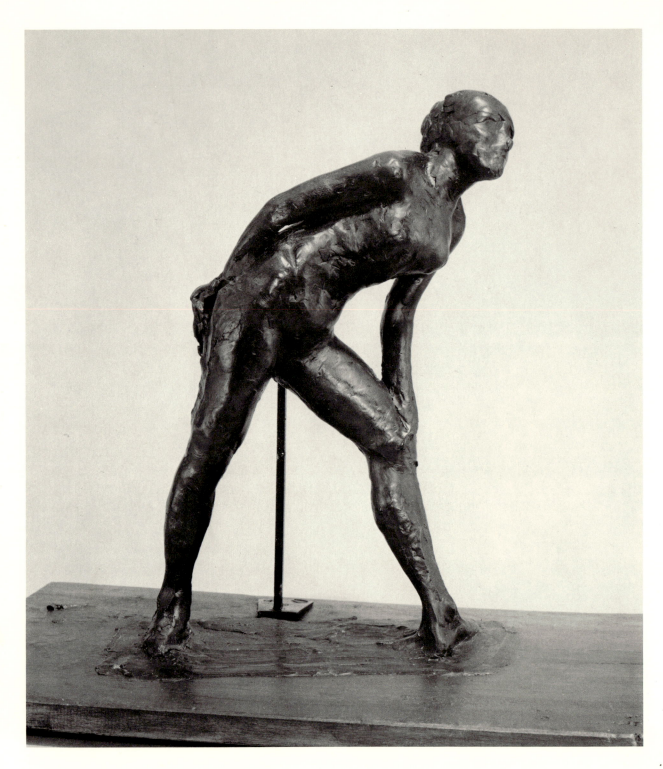

76. Degas, *Dancer Rubbing Her Knee*

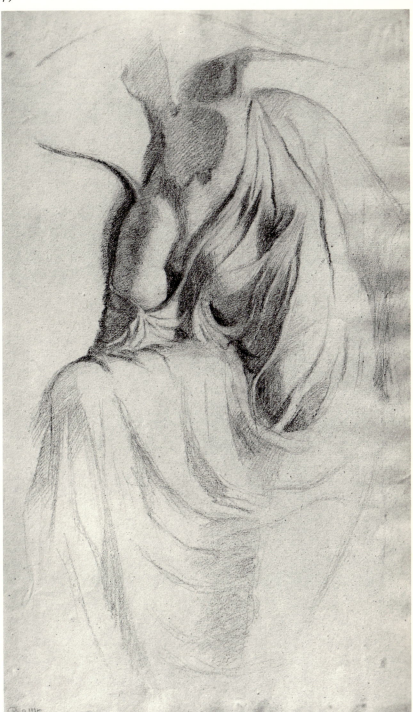

79

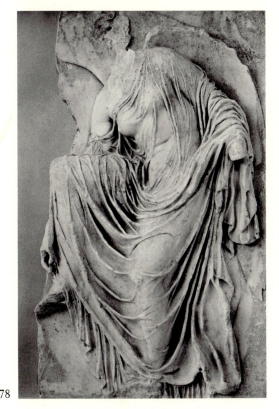

77. Classical *Woman Fastening Her Sandal*
78. Classical *Victory Fastening Her Sandal*
79. DEGAS, Study of *Victory Fastening Her Sandal*

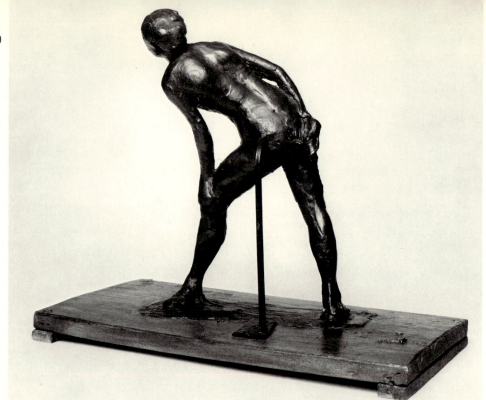

80

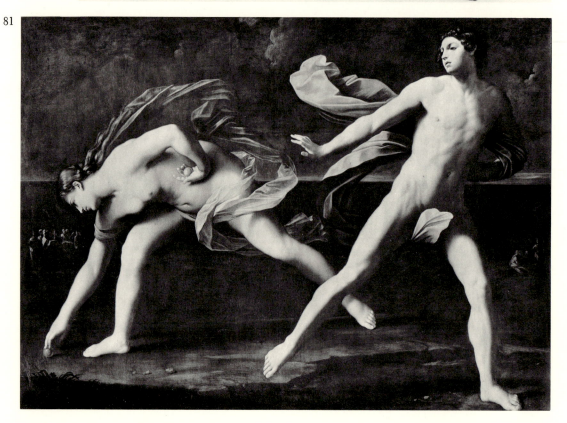

81

80. DEGAS, *Dancer Rubbing Her Knee*
81. RENI, *Atalanta and Hippomenes*

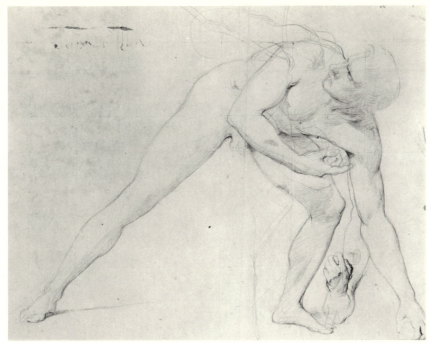

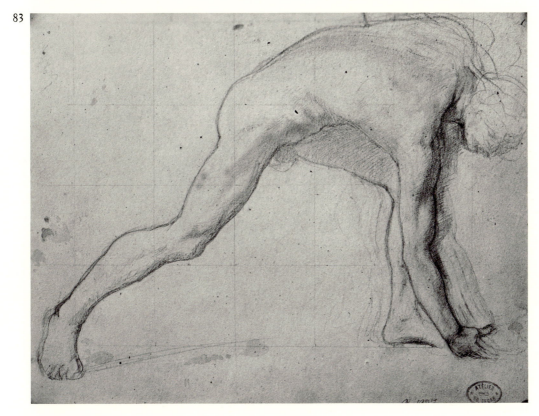

82. INGRES, Study for *Martyrdom of St. Symphorien*
83. DEGAS, Study for *Daughter of Jephtha*

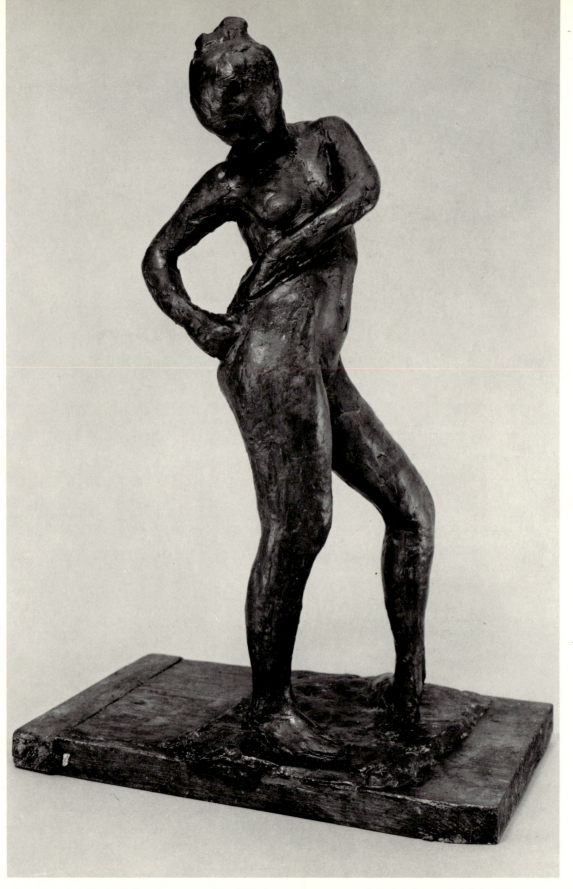

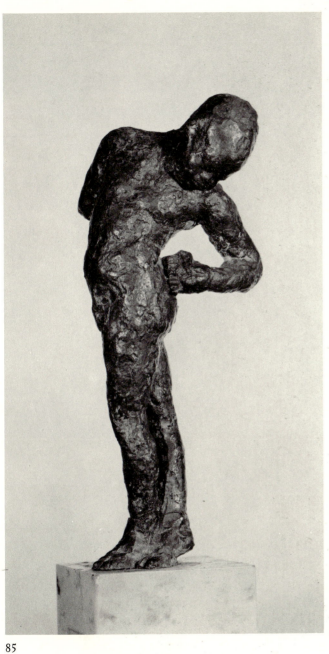

85

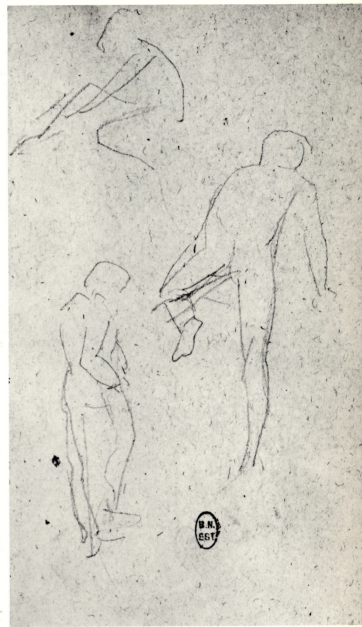

86

84. DEGAS, *Dancer Fastening the String of Her Tights*
85. Classical(?) *Satyr*(?)
86. DEGAS, Study after Michelangelo's *Battle of Cascina*, notebook 17, page 17

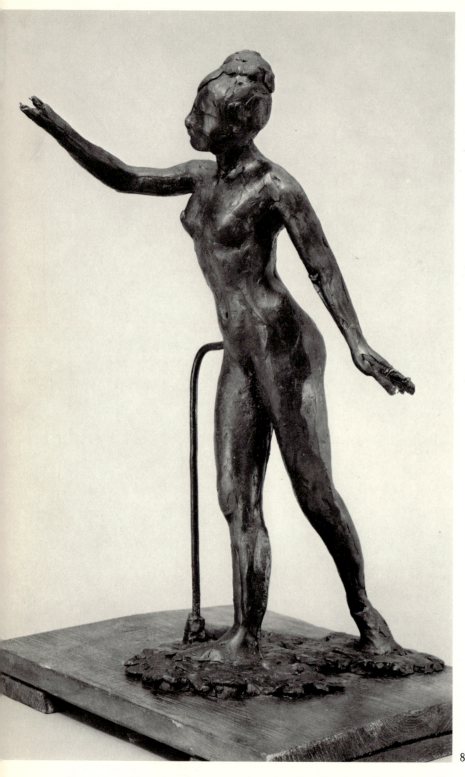

87

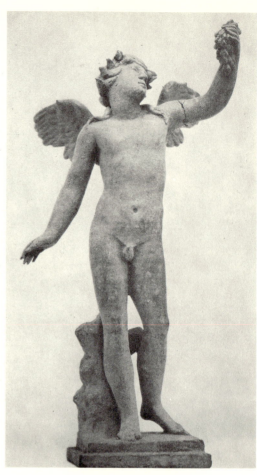

88

87. Degas, *Grand Arabesque*
88. Classical *Bacchic Eros*
89. Degas, *Fourth Position Front*

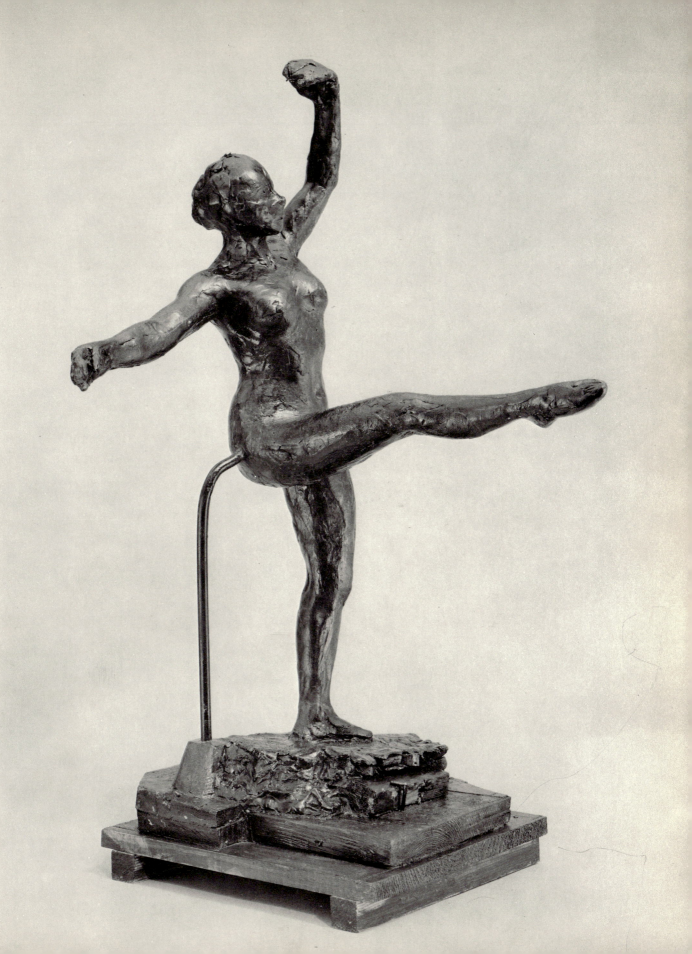

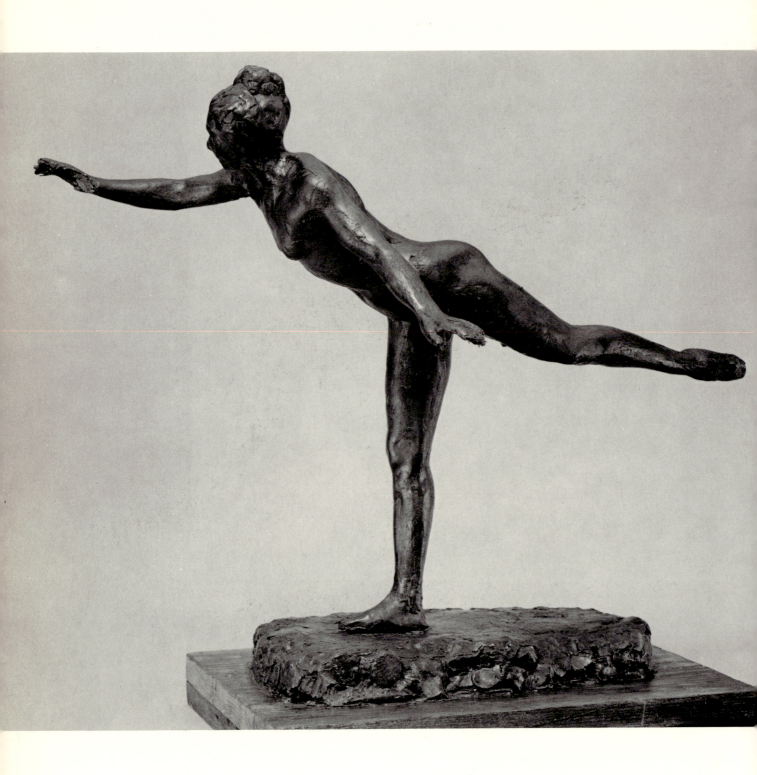

90. Degas, *Grand Arabesque*

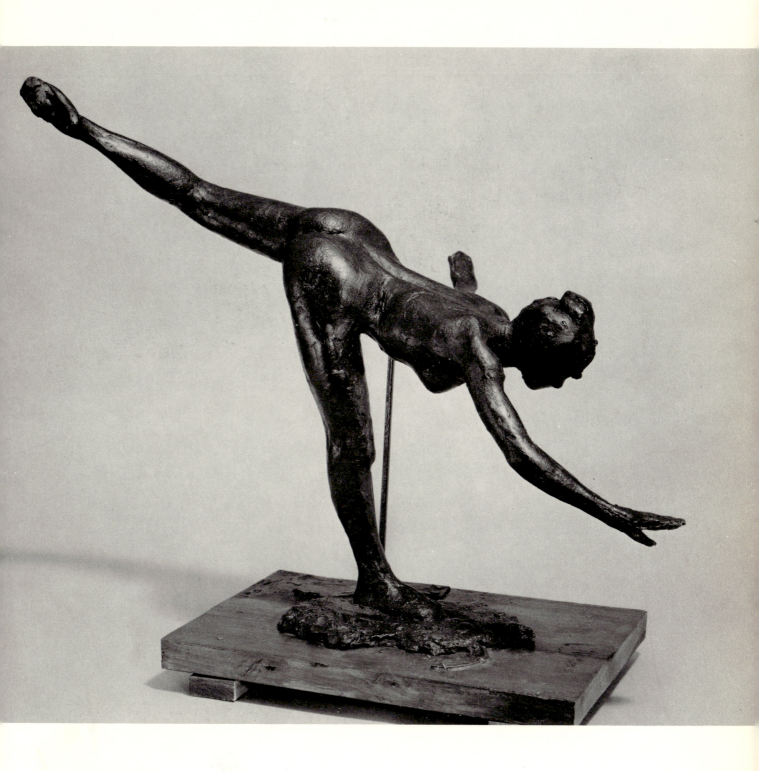

91. Degas, *Grand Arabesque*

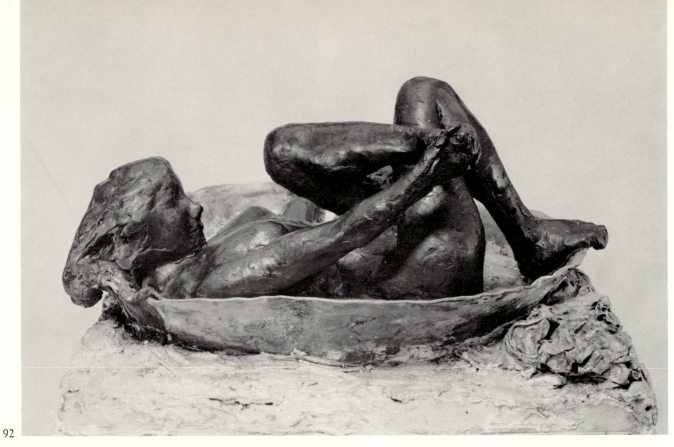

92

93

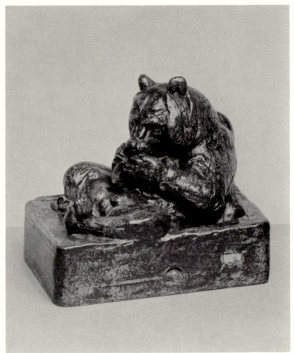

94

92. DEGAS, *The Tub*
93. MOREAU, *Moses*
94. BARYE, *Bear Playing in Its Trough*

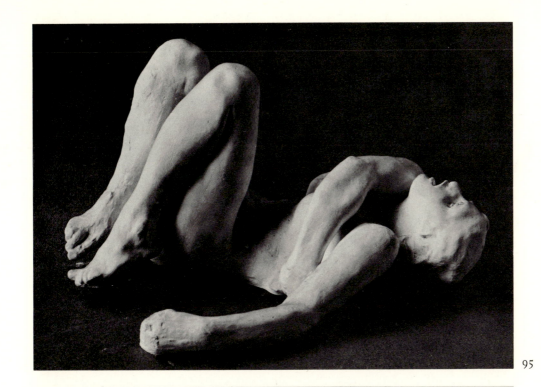

95

96

95. RODIN, Study for *Gates of Hell*
96. ZANDOMENEGHI, *Nude*

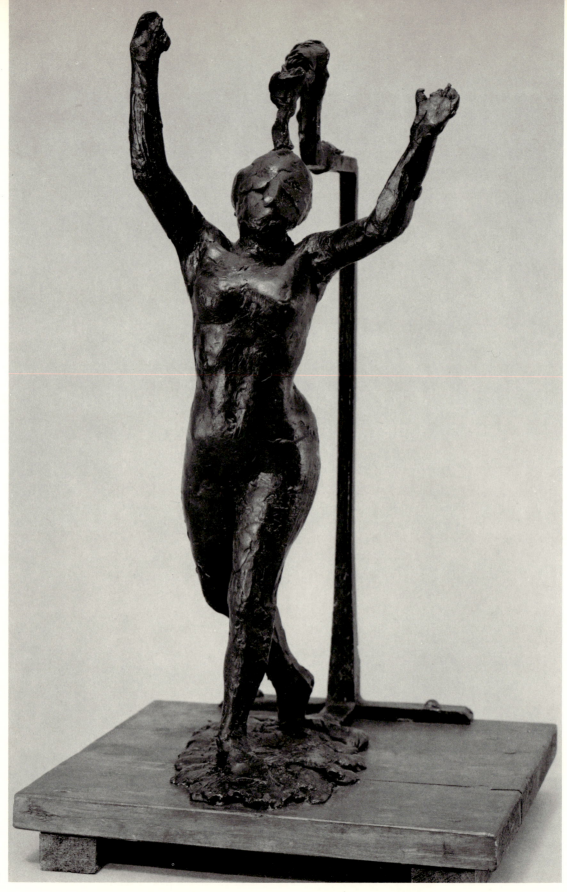

97

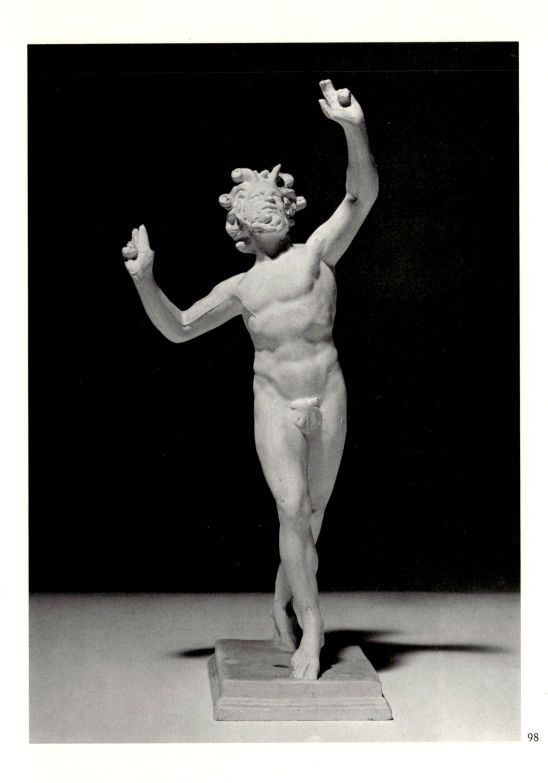

98

97. DEGAS, *Dancer Moving Forward*
98. Classical *Dancing Faun* (plaster cast)

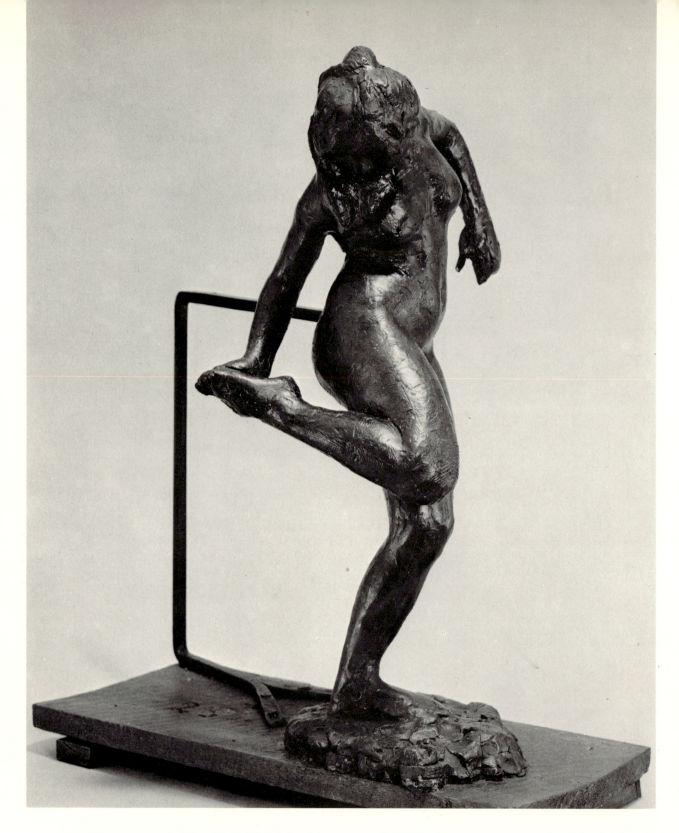

99. DEGAS, *Dancer Looking at the Sole of Her Right Foot*

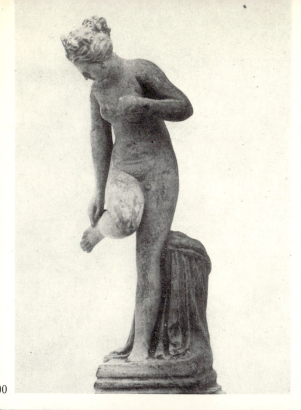

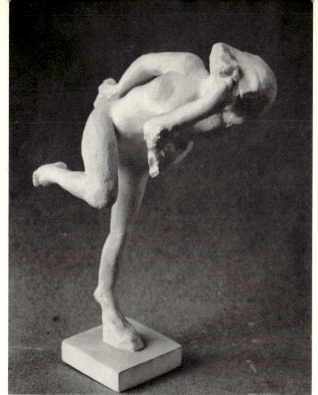

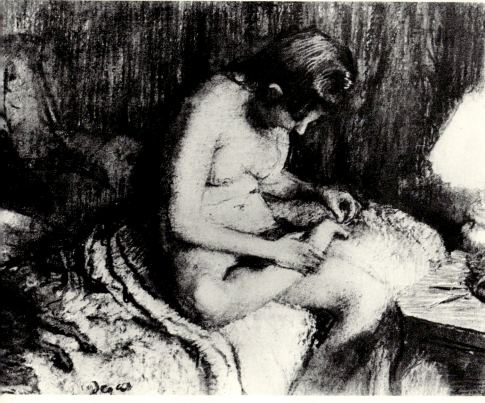

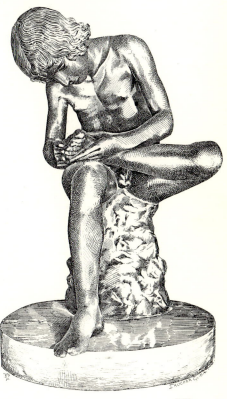

100. Classical *Aphrodite*
101. RODIN, Study for *Gates of Hell*
102. DEGAS, *The Thorn*
103. Classical *Spinario*

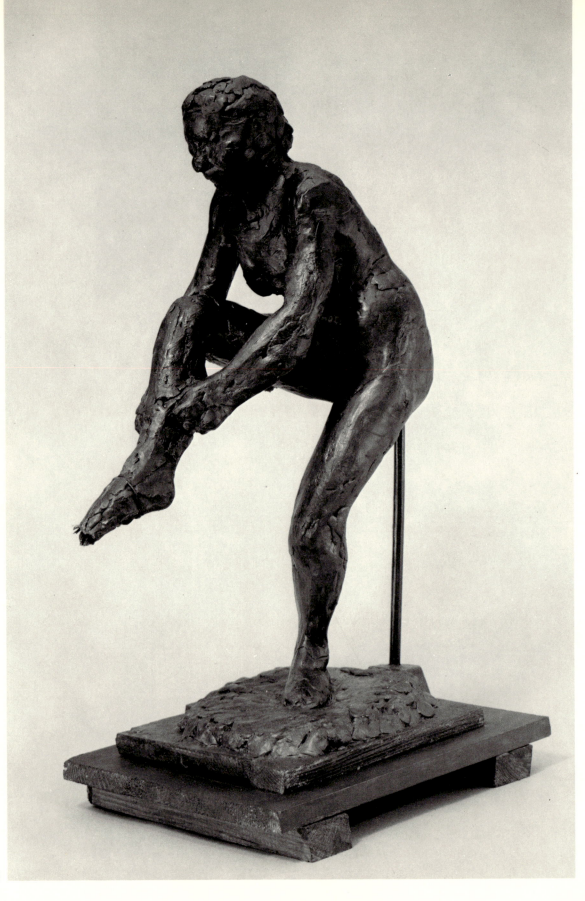

104

105

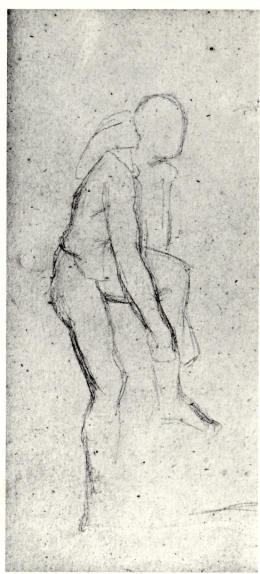

106

104. DEGAS, *Dancer Putting on Her Stocking*
105. Attributed to THOMIRE, *Dancing Faun*
106. DEGAS, Study of Classical figure, notebook 20, page 78, detail

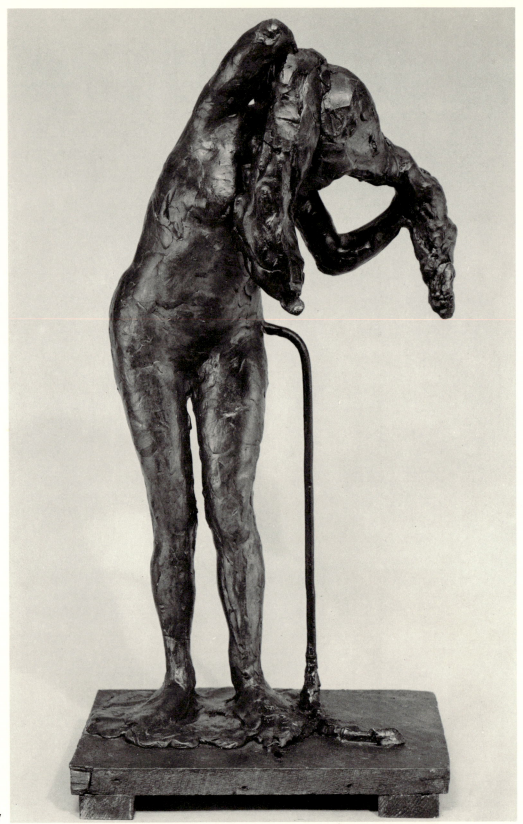

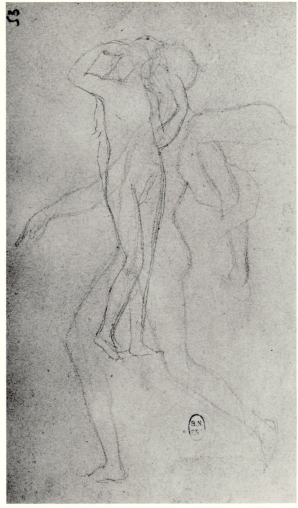

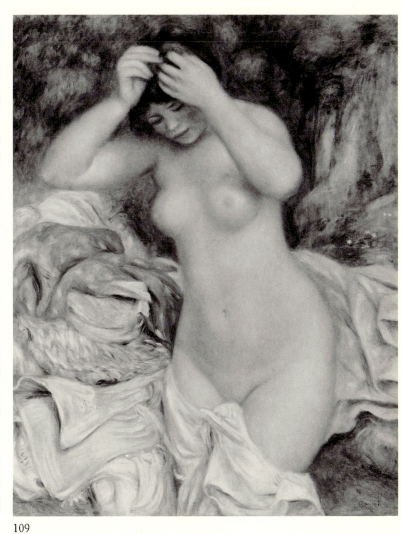

108

109

107. DEGAS, *Woman Arranging Her Hair*
108. DEGAS, Study of woman arranging her hair, notebook 11, page 53
109. RENOIR, *Bather Arranging Her Hair*

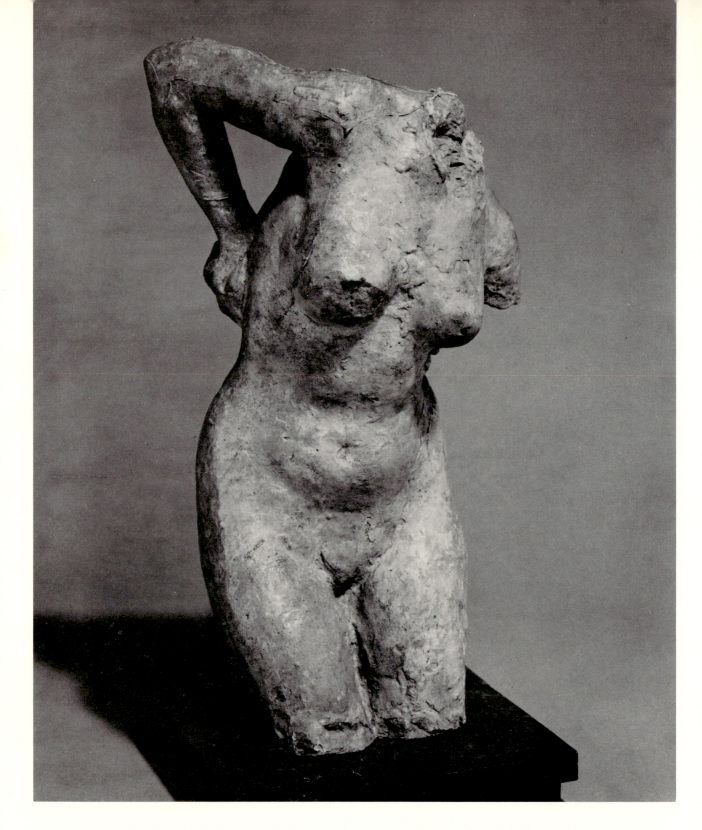

110. DEGAS, *Torso* (plaster)

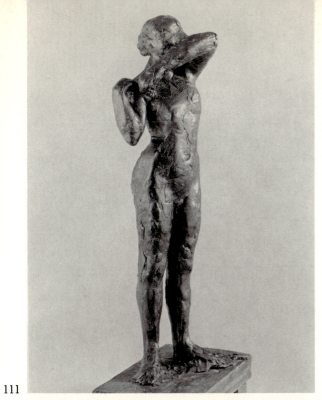

111

112

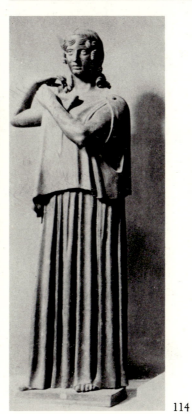

113

114

111. DEGAS, *Dancer Adjusting the Shoulder Strap of Her Bodice*
112. DEGAS, Study of figure from Parthenon frieze, notebook 10, page 37
113. Classical *Dancing Boy* (plaster cast)
114. Classical *Herculaneum Dancer*

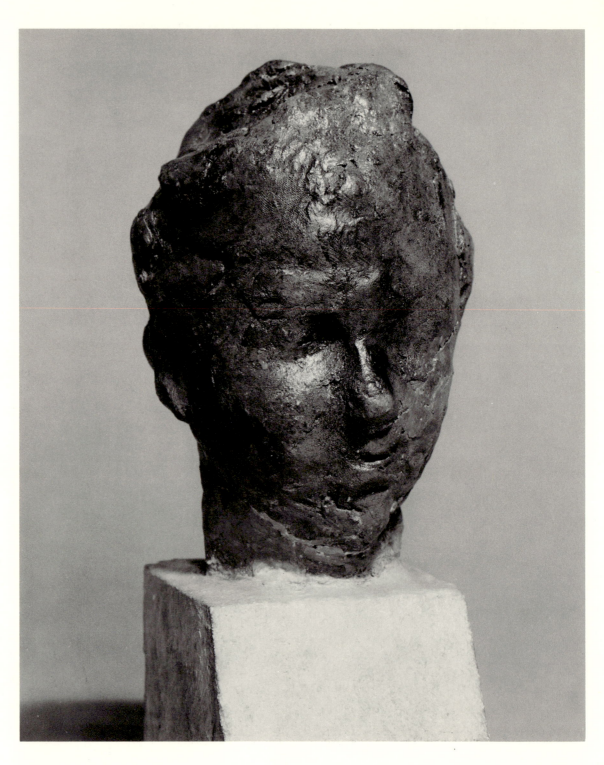

115. Degas, *Portrait Head*

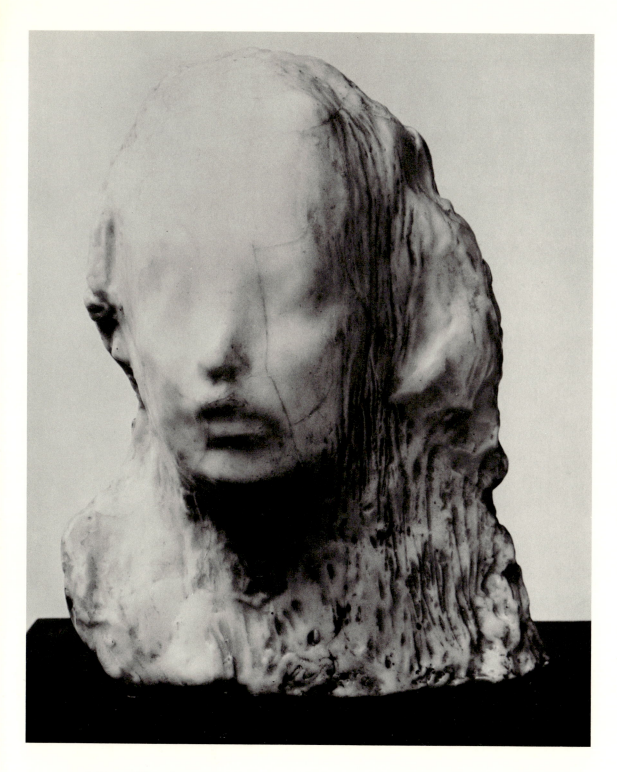

116. Rosso, *Ecce Puer*

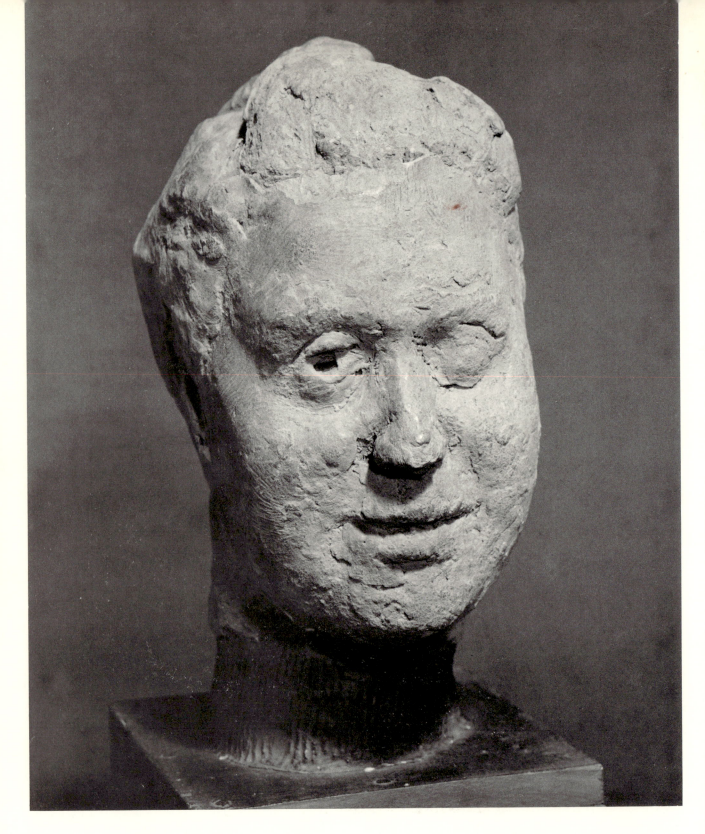

117. Degas, *Mlle. Salle*

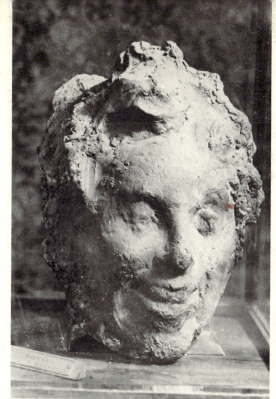

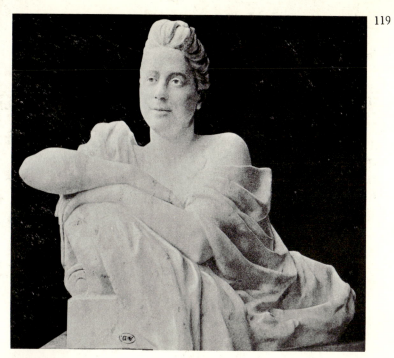

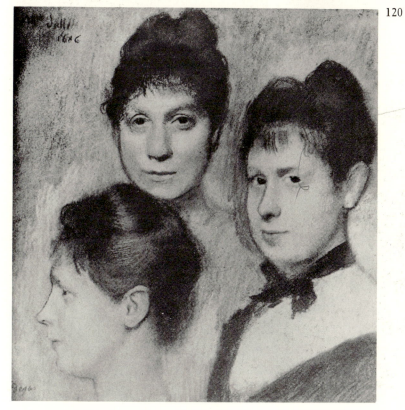

118. Rosso, *Large Laughing Woman*
119. Bartholomé, *Mlle. Salle*
120. Degas, *Mlle. Salle*

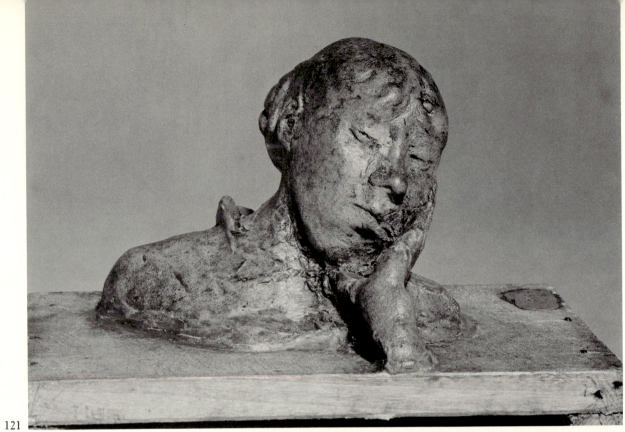

121

122

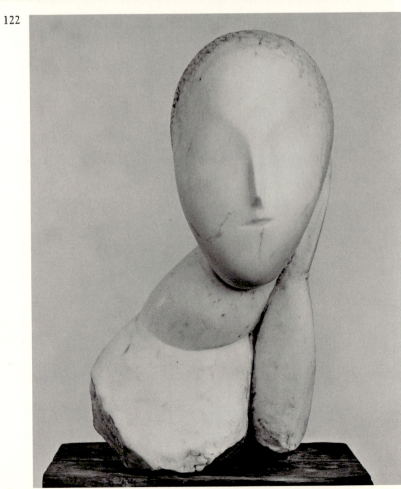

121. DEGAS, *Rose Caron*
122. BRANCUSI, *Muse*

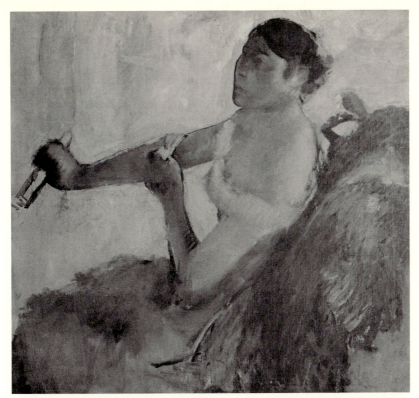

123

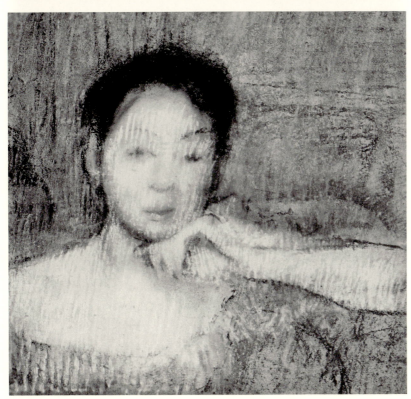

124

123. DEGAS, *Rose Caron*
124. DEGAS, *Bust of a Woman*

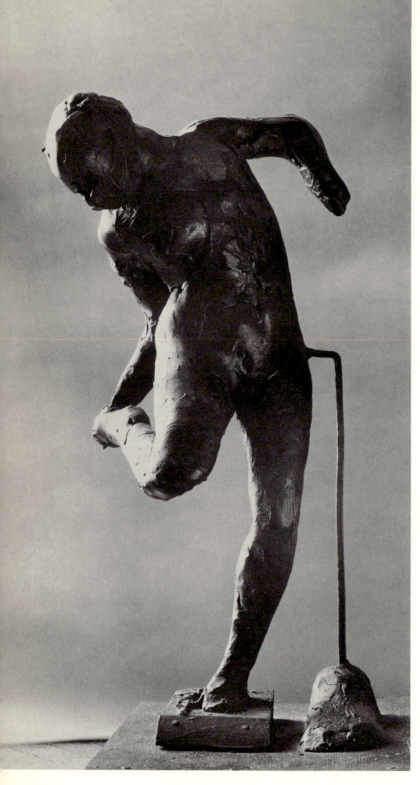

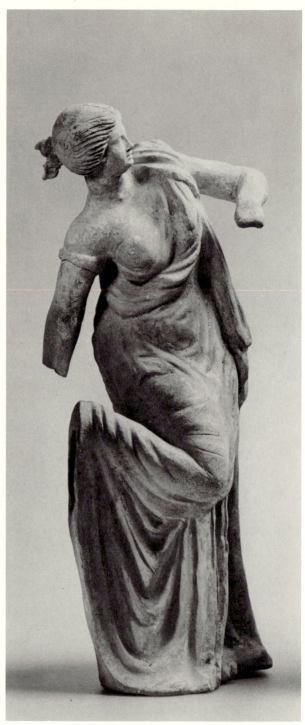

125. DEGAS, *Dancer Looking at the Sole of Her Right Foot*
126. Classical *Dancer*

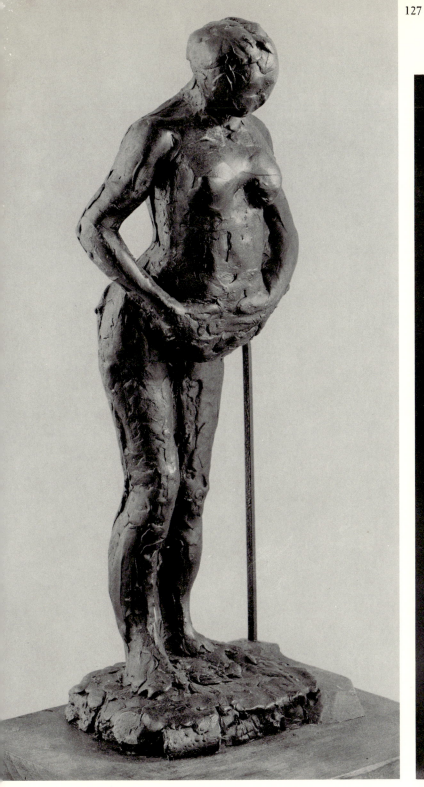

127. Degas, *Pregnant Woman*
128. Rodin, *Study of a Woman*

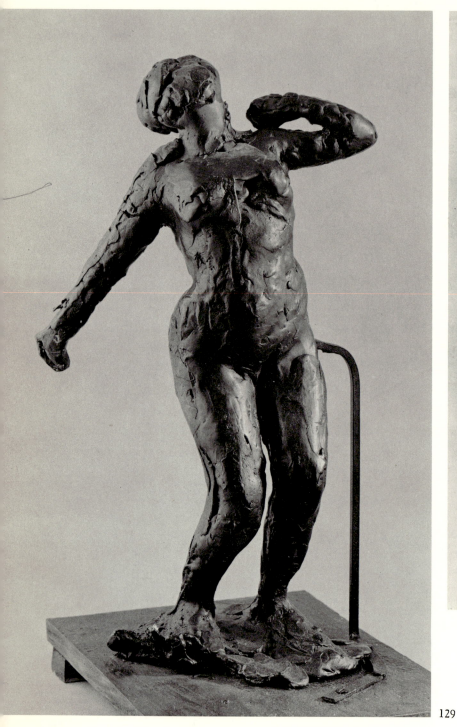

129

130

129. DEGAS, *Woman Stretching*
130. ZANDOMENEGHI, *Woman Stretching*

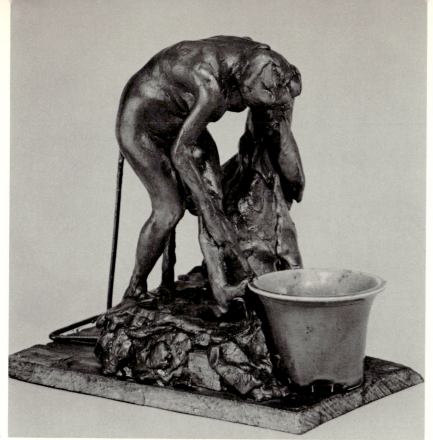

131

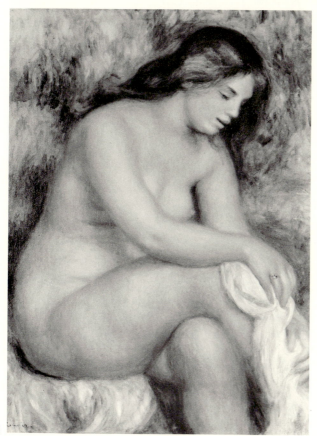

132

131. Degas, *Woman Washing Her Left Leg*
132. Renoir, *Bather Wiping Her Right Leg*

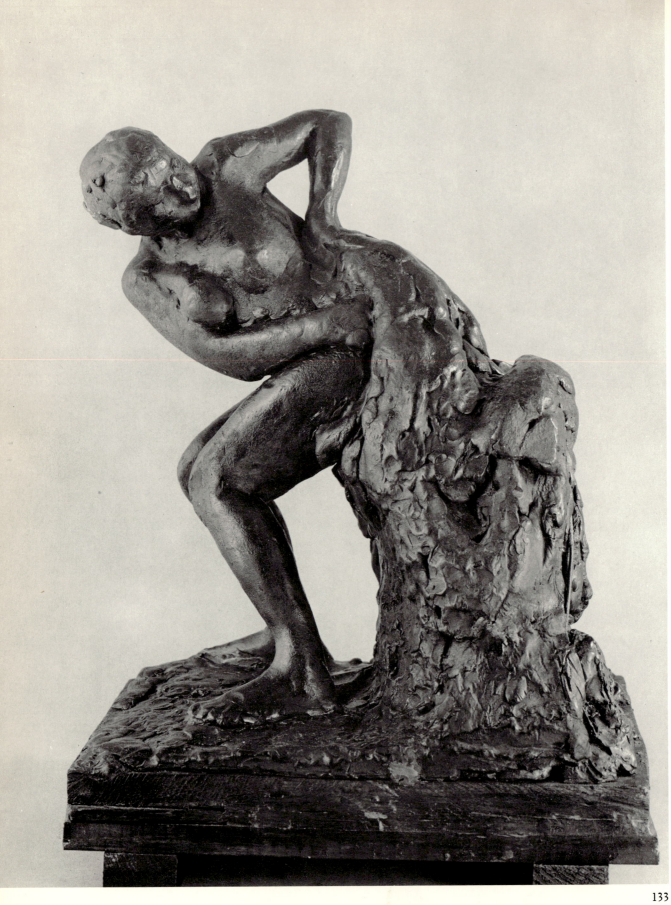

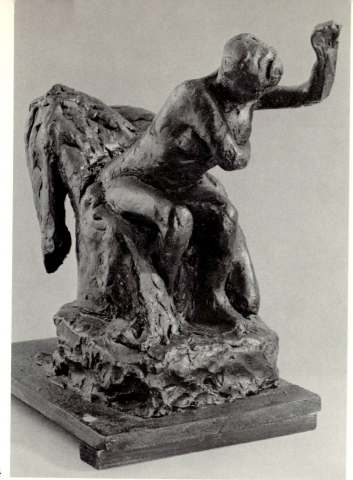

134

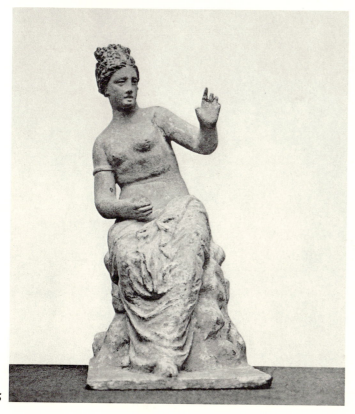

135

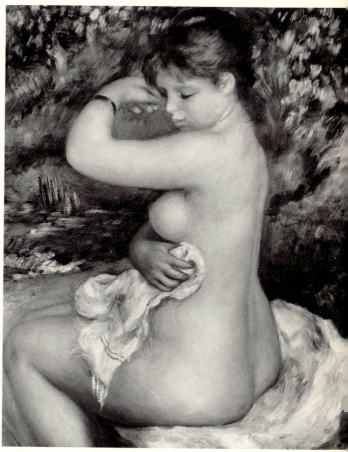

136

133. DEGAS, *Seated Woman Wiping Her Left Side*
134. DEGAS, *Seated Woman Wiping Her Left Armpit*
135. Classical *Ball Player*
136. RENOIR, *After the Bath*

137. Degas, *Seated Woman Wiping Her Left Hip*

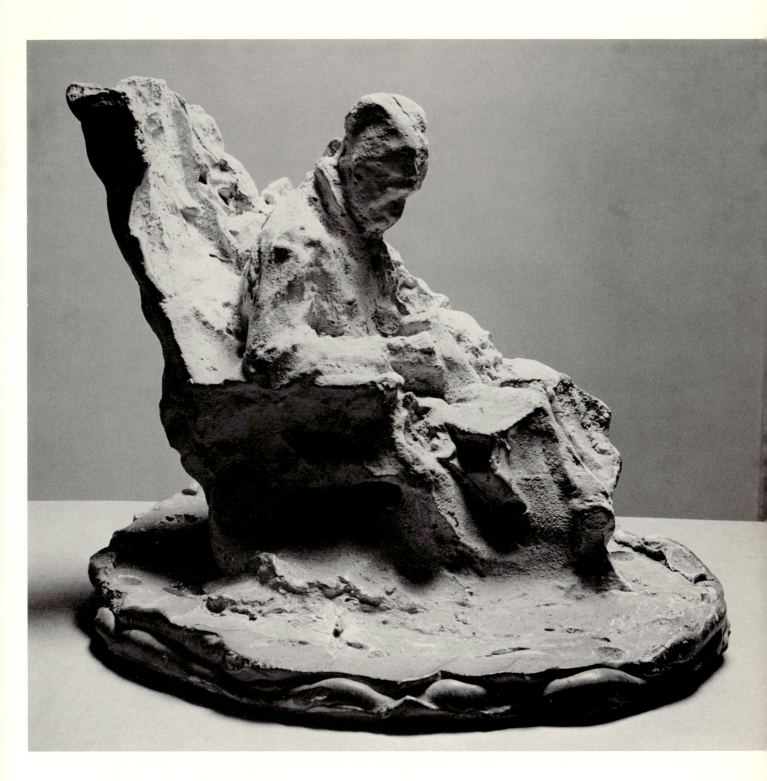

138. Rosso, *Man in the Hospital*

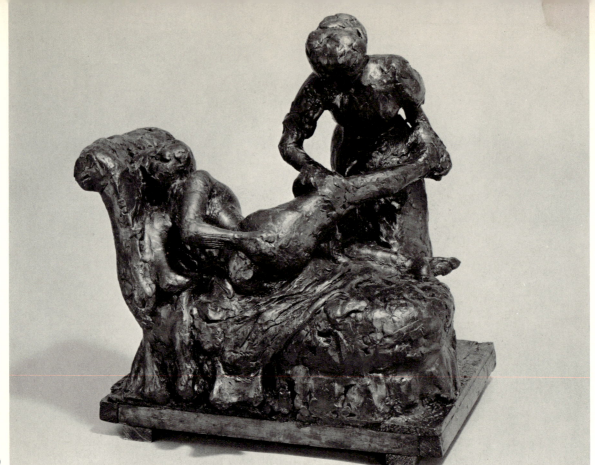

139

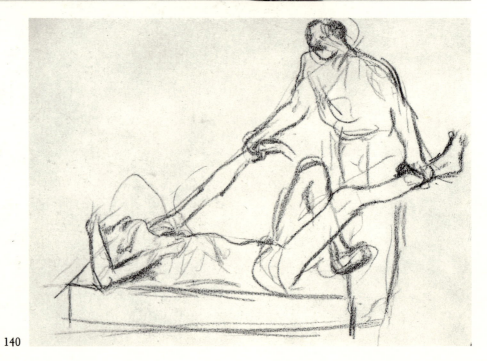

140

139. DEGAS, *The Masseuse*
140. DEGAS, detail from the Halévy Album

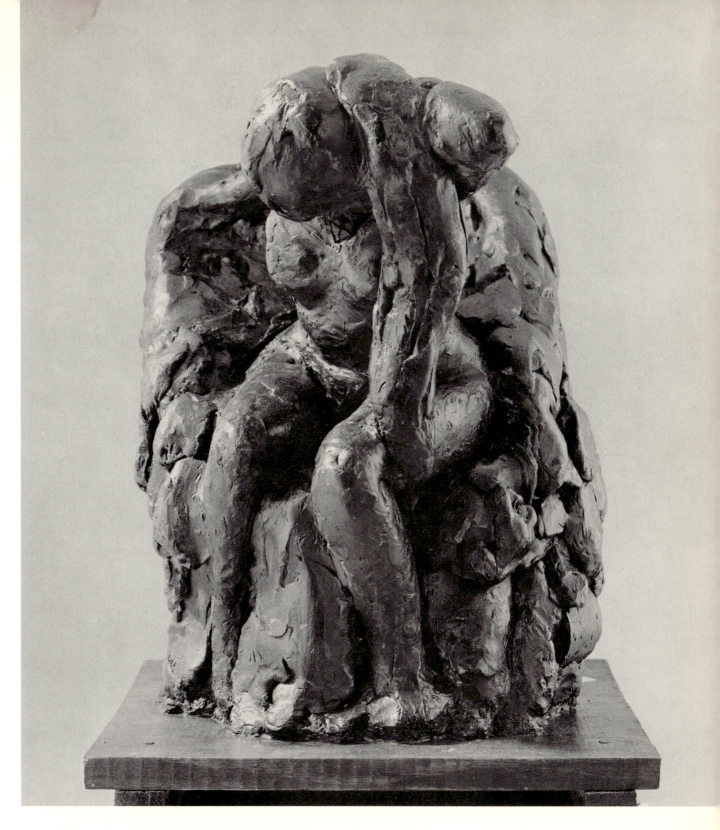

141. DEGAS, *Seated Woman Wiping Her Neck*

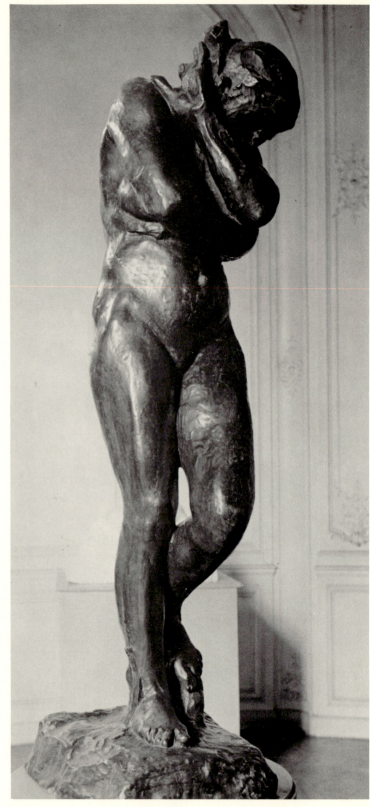

142. DEGAS, *Bather*
143. RODIN, *Eve*